# THE COMPLETE IDIOT'S GUIDE® TO

# Drawing Manga

# Drawing Manga

## Illustrated

by John Layman and David Hutchison
for Idea + Design Works, LLC
(www.ideaanddesignworks.com)

ALPHA

A member of Penguin Group (USA) Inc.

## ALPHA BOOKS

Published by the Penguin Group

Penguin Group (USA) Inc., 375 Hudson Street, New York, New York 10014, U.S.A.

Penguin Group (Canada), 10 Alcorn Avenue, Toronto, Ontario, Canada M4V 3B2 (a division of Pearson Penguin Canada Inc.)

Penguin Books Ltd, 80 Strand, London WC2R 0RL, England

Penguin Ireland, 25 St Stephen's Green, Dublin 2, Ireland (a division of Penguin Books Ltd)

Penguin Group (Australia), 250 Camberwell Road, Camberwell, Victoria 3124, Australia (a division of Pearson Australia Group Pty Ltd)

Penguin Books India Pvt Ltd, 11 Community Centre, Panchsheel Park, New Delhi—110 017, India

Penguin Group (NZ), cnr Airborne and Rosedale Roads, Albany, Auckland 1310, New Zealand (a division of Pearson New Zealand Ltd)

Penguin Books (South Africa) (Pty) Ltd, 24 Sturdee Avenue, Rosebank, Johannesburg 2196, South Africa

Penguin Books Ltd, Registered Offices: 80 Strand, London WC2R 0RL, England

## Copyright © 2005 by Idea + Design Works, LLC

International Standard Book Number: 1-59257-335-5
Library of Congress Catalog Card Number: 2005920505

07    06    05        8    7    6    5    4    3    2    1

Interpretation of the printing code: The rightmost number of the first series of numbers is the year of the book's printing; the rightmost number of the second series of numbers is the number of the book's printing. For example, a printing code of 05-1 shows that the first printing occurred in 2005.

*Printed in the United States of America*

**Note:** This publication contains the opinions and ideas of its authors. It is intended to provide helpful and informative material on the subject matter covered. It is sold with the understanding that the authors and publisher are not engaged in rendering professional services in the book. If the reader requires personal assistance or advice, a competent professional should be consulted.

The authors and publisher specifically disclaim any responsibility for any liability, loss, or risk, personal or otherwise, which is incurred as a consequence, directly or indirectly, of the use and application of any of the contents of this book.

Most Alpha books are available at special quantity discounts for bulk purchases for sales promotions, premiums, fund-raising, or educational use. Special books, or book excerpts, can also be created to fit specific needs.

For details, write: Special Markets, Alpha Books, 375 Hudson Street, New York, NY 10014.

**Publisher:** *Marie Butler-Knight*
**Product Manager:** *Phil Kitchel*
**Senior Managing Editor:** *Jennifer Bowles*
**Senior Acquisitions Editor:** *Mike Sanders*
**Development Editor:** *Lynn Northrup*
**Production Editor:** *Janette Lynn*
**Copy Editor:** *Kelly Henthorne*
**Illustrator:** *David Hutchison*
**Cover Designer:** *Robbie Robbins for Idea + Design Works, LLC*
**Book Designer:** *Trina Wurst*
**Indexer:** *Brad Herriman*
**Layout:** *Trina Wurst, Becky Harmon*

# Contents at a Glance

# Contents

# Introduction

Thanks for picking up *The Complete Idiot's Guide to Drawing Manga Illustrated*. This book is created by manga fans, for manga fans, although we've tried to write in a simple and easy-to-follow style that can be understood by people new to comics in general and manga in particular. We want this book to be useful—and enjoyable—to artists, aspiring artists, and even people aspiring to be aspiring artists!

In the following pages we'll give you a better understanding of what manga is, why it is so popular, and why it is growing ever *more* popular in Japan, the United States, and all around the world. We'll look at different manga characters, archetypes, themes, and genres popular in manga. We'll give you advice on what to do and what not to do, along with timesaving shortcuts, in order for you to make the best manga comic book you can make.

Most importantly, we'll show you how to draw in the manga style, with simple, step-by-step illustrations and instructions and literally hundreds of manga drawings and figures you can use for reference, all supplied by our resident manga artist extraordinaire, David Hutchison.

We can't guarantee you'll be a great artist after reading this book, but if you take our advice to heart and are willing to put in long hours at the drawing board practicing and challenging yourself, this book will definitely put you on the right track.

But first, for those of you coming in clueless about what all the fuss is about … what *is* manga? Read on!

## What You'll Find in This Book

This book is organized into five parts. We've designed the book to start with simple stuff, though it will become increasingly complex as we move on.

**Part 1, "Manga Basics,"** looks at the most fundamental aspects of manga: what it is and its characteristics. Then we move to drawing very basic body shapes, giving you a foundation for the rest of the art that follows.

**Part 2, "Making Faces,"** focuses on the most important part of a character: the face. We explore every part of the face, including where to put and how to make each component. Then we show you how to use these components to bring your characters to life as expressive and emotional beings.

**Part 3, "Character Types,"** explores the various characters that are popular in manga. We talk about heroes and villains, sidekicks and tough guys, sexy spies, not-so-innocent school kids, and even animals, robots, and monsters.

**Part 4, "Manga Nuts and Bolts,"** shares various artistic approaches to making your pages and panels more exciting and dynamic. We show you ways to give your art more dimension, flair, and realism. We also look at some artistic aspects that make manga so unique.

**Part 5, "Round Out Your World,"** explores everything else that goes into populating the world you create, from modes of transportation and weapons to cities and landscapes and all things mechanical.

You'll also find three helpful appendixes: a handy glossary of the terms we've introduced in this book that you may be unfamiliar with; books we recommend for delving even deeper into the world of art, comics, and manga; and a listing of online resources.

## Extras

Throughout this book you'll find boxes of information designed to enhance your manga experience, define new terms, and alert you to cautions.

### Manga Meanings

In this box you'll find definitions of words that may be unfamiliar to you. Some of these words are unique to manga; others can be found in the worlds of comics, art, and cinema.

### Sketchbook Savvy

These boxes offer tips and tricks to help make your manga-making experience trouble-free. Sometimes we offer shortcuts, other times we just point you in a direction to help you make your art even stronger.

### Mangled Manga

In these boxes we warn you of the "do not's" to making manga. We've made all the mistakes already—so you don't have to!

### Say What?

Check these boxes for quotes culled from various wise and articulate individuals who offer words that are applicable to our discussion, and sometimes even inspirational.

## Acknowledgments

Thanks to Kris Oprisko and the good folks at IDW for shepherding this book and giving me the opportunity to work on it and explore my great love for manga. Special thanks to David Hutchison for being a brilliant collaborator. Thanks to my wife, Kim Peterson; Marvel editors Mike Marts and Stephanie Moore; and drinking buddy Tom Peyer for their patience as I buried my head in manga and nothin' but and did not come up for air for weeks at a time. Thanks to magna experts Maki Yamane, Rich Amtower, C.B. Cebulski, Mark Paniccia, and Jake "The Snake" Tarbox for being cheerfully willing to lend their expertise and advice. Thanks, too, to Herkimer Coffee; Apple Computer; and the soothing, soothing writing music of Alice Donut, Frank Black, and The Cramps.

—John Layman

Of course, thanks to Kris Oprisko and IDW for giving me the opportunity to work on such a great project. Special thanks to John Layman for bringing so much thought and imagination to this book. Thanks to my editors at Antarctic Press, Joe Weltjen and Lee Duhig, who made it possible for me to work on this book; and thanks to Joseph Wight, Sherard Jackson, Kelsey Shannon, Gary D. Francis, Robby Bevard, and all the Antarctic Press staff. And very special thanks to my mother, Ruth Hutchison, for all of her support and feedback over the years.

—David Hutchison

## Trademarks

All terms mentioned in this book that are known to be or are suspected of being trademarks or service marks have been appropriately capitalized. Alpha Books and Penguin Group (USA) Inc. cannot attest to the accuracy of this information. Use of a term in this book should not be regarded as affecting the validity of any trademark or service mark.

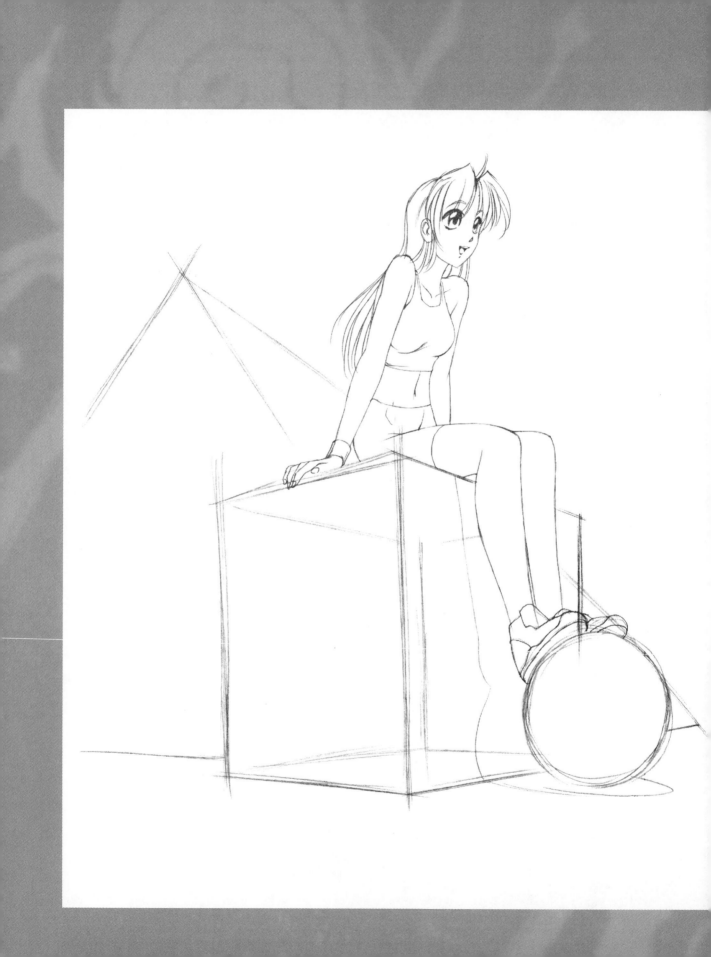

# Part

# 1

# Manga Basics

Manga comics are originally from Japan, but they've become a full-fledged phenomenon here in the United States. Before you pick up a pencil and get started making your own contributions to the wide world of manga, we'll spend a short time talking about exactly what manga is, how to read manga, and the ways it differs from traditional American comics. But we won't spend too much time on the talkie-talk. We know what you're here for—to draw!

Whether you are a fledgling artist or a seasoned vet, you start drawing figures the same way. Even if all you can draw is a simple stick figure, you're off to a good start, because that is literally the first step in figure building. In this part, we look at all the steps in figure building—from that first skinny stick figure to the final image, and all the components in between. We examine what goes into building a figure, and then explore different types of figures and ways to build different body shapes.

Eventually, we show you that your figure can tell a story. Your faceless figures can still let you know what they are doing and what they are thinking, just by their poses, actions, and body language. Most of the lessons in this section are universal to *all* comics and art, not just manga. But what you take from part of the book will give you a crucial foundation for the manga-specific instructions and examples that follow.

# In This Chapter

# Meet Manga!

If you've just picked up this book, clearly you've got some interest or curiosity about the subject of manga, even if you don't know what it is. Maybe you've got an interest in comic books and would like to learn more about the genre called manga—a genre growing in popularity every day in America. Maybe you're already a fan of manga—or even anime—and want to try your hand at drawing in this distinctive visual style, but you don't know where to begin.

Or *maybe* you haven't got the slightest idea what manga is but were drawn to artist David Hutchison's pretty pictures or writer John's compelling text in this book. For whatever reason, no matter what your background or previous knowledge of manga is, you're here now, and in the pages to follow, I'm going to lay out for you a primer of the principles of manga in terms that even an idiot could figure out—and everybody else, too!

## Manga? What's That?

*Manga* isn't just a style of comics from Japan; it *is* comics from Japan. Manga has been enjoyed for decades in Japan, just as comic books have been enjoyed for decades in America. However, in recent years, American audiences have discovered manga, its unique visual style and vocabulary, and more and more English-speaking comic readers are embracing manga. As this is happening, more than a

few of these English readers would like to learn some of the tricks and techniques to drawing manga for themselves. If you're one of those readers, you've come to the right place!

Oh, and just so we're clear: As much as we love Jerry Seinfeld and Chris Rock, for the purposes of this book, when I talk about *comics*, I'm not talking about stand-up comedians or any other type of funnymen (or funnywomen, for that matter). "Comics" is shorthand for comic *books*, sequential art, printed periodicals of picture and words combined on a page to tell a story. What's the difference between manga and comic books? We'll get to that in a moment.

### Manga Meanings

**Manga** is a type of comic and comic visual style native to Japan, which is growing increasingly popular in America. A **comic** or **comic book** is a periodical or book of sequential art; a story told in a combination of pictures and words. Think of it this way: Manga is a category of comics. *All* manga are comic books, but not all comic books are manga.

## Manga in Japan

Manga's ancestry can be traced back to drawings on walls of Japanese temples in the sixth century, and narrative picture scrolls in the twelfth century. While not manga per se, this was early evidence of Japanese artists trying to tell stories with pictures. Manga's more recent development parallels that of American comics; both developed out of newspaper and magazine cartoons in the late nineteenth century. Cartoons featuring social and political commentary paved the way for reoccurring characters, featured in comic *strips*. Eventually publishers saw a market for people to follow the exploits of these characters beyond newspapers and magazines, other publishers introduced new and original characters, and the comic book was born.

But manga in Japan is very different from comics in America. Whereas American comic book readership is much smaller, currently less than one person in a thousand—mostly confined to males between the ages of 18 and 35—manga readership is a huge part of Japanese life, and its readership comprises the majority of its citizens. Manga readers are of all ages and from all walks of life. Popular manga storylines or digests sell in the hundreds of thousands; some reprints even eventually millions; and top-selling manga creators often reach the sort of celebrity that Americans reserve for movie stars and pop singers (and, someday, *Complete Idiot's Guide* writers!). It's quite common to see commuters in Japan reading manga to and from work like Americans might digest the morning paper. In short, manga is more socially acceptable in Japan, not just as a hobby or phenomena, but as a way of life. Literally *millions* of manga books are printed and sold every year. And worldwide, that number is growing.

## So, What's the Diff?

There's a big difference in art styles between manga, which is more stylized, and American comics, which tend to be more realistic. And we'll spend the majority of this book examining the manga art style. However, several other crucial differences exist between the two types of comics.

Manga is created and presented differently than American comics. Where American comics are primarily in color, manga is printed in black and white. Manga is smaller than traditional American comic books, usually digest-sized and roughly one half to one third the size of American comics. But where the American comics are generally thin, running 32 pages with 22 pages of story, manga comic books are thick and can be hundreds of pages in length. This puts manga, in page count, more akin to *graphic novels*, which are often just collections of the serialized American comic book. But unlike American graphic

novels, which usually collect monthly comics into a single unified story or story arc, manga digests are often serialized into even *bigger* stories, and a complete manga storyline can run *thousands* of pages.

### Manga Meanings

A term often used to make comic reading seem less juvenile and more respectable, the **graphic novel** is, essentially, a thick comic book, sometimes a lengthy original comic book "novel," other times a collection of traditional American comics repackaged to be appropriate for the bookshelf. All graphic novels are comic books, but not all comic books are graphic novels.

Here's another amazing difference between traditional American comics and manga: Mainstream American comics are often done in a sort of assembly-line fashion. They have a writer and a penciler and an inker and a letterer and a colorist. Most manga books are done by a single creator, who combines all those chores (except for coloring, that is, since manga is black and white).

Manga story lines usually move at a faster pace, too. Because of their hefty page count, one reads a manga book at an accelerated pace. Manga books almost always have fewer panels and less dialogue per page than their American comic counterparts. And although the price is more than the average comic book, and a bit more than a standard paperback novel, the small size of manga and black-and-white printing rather than color keeps the books affordable—particularly when you take into account the beefy page count in manga.

## What's the *Matter* with Manga?

Subject matter, that is. Anyone familiar with American comic books knows that what you first think of when you think of comics in the United States are superheroes. Those heroic, super-fit, spandex-clad do-gooders who have been bitten by a radioactive spider or who come from other planets to pursue justice and knock super-powered villains through walls. Of course, not *all* American comic books are about superheroes, but the vast majority are, and that is what they have primarily been associated with, and will likely primarily *be* associated with.

Not manga, however. One of the strengths of manga, and one of the reasons it appeals to such a diverse cross-section of readership, is its vast subject matter. Manga has comics for boys (called *Shonen* manga), comics for girls (called *Shojo* manga), and comics meant for adults—and adults only!—(called *Hentai* manga). A wealth of manga subject matter is available for everyone and all tastes in between. Manga has books about giant robots, futuristic societies, contemporary societies, ancient societies, Samurais, schoolgirls in love, sport heroes, spies, wizards and warriors, cooks, criminals, computer hackers, businessmen, *Mah-Jonng* players, pilots, and princes, and much, much more. Clearly, just about any story imaginable can be told in manga—and is!

Oddly, *one* genre is not all that popular in Japanese manga: American-style superheroes.

### Manga Meanings

Manga in Japan is not considered just "for kids," the way the general American public (erroneously) presumes that comic books are for kids. There's a manga for everyone:

- **Shonen** manga literally means "boy's comics," comics that showcase primarily action and adventure.
- **Shojo** manga, "girl's comics," is geared toward the opposite gender and are often more cerebral stories.
- **Hentai** manga is adults-only manga, sexually explicit or adult-themed books. Fair warning: John, this book's author, is far too much of a gentleman to go into detail on this subject. You want a book on Hentai, look elsewhere!

# Mangamerica: Manga in the United States

In recent years, manga has been making huge inroads in the United States and other English-speaking countries, both culturally and commercially. Manga has succeeded in something that American superhero comics have never been able to do: attract a female readership. This is likely due to the fact that there is such a wide range of subject matter, beyond the male power fantasies of American superheroes, and that a large portion of manga is outright geared toward females.

As manga's popularity has grown in America, it's taken up a large section of both comic book stores and traditional bookstores. In fact, the American bookstore graphic novel section continues to expand every year, and much of this is because of manga's increasing presence and popularity.

As more people discover manga, it continues to grow. More publishers and creators are appearing every day; more translated Japanese works are making their way into the United States, and more Americans are discovering a love for creating comics in a manga style. (Hopefully, there will be even more, thanks to the readers of this book!) Even traditional American superhero publishers have jumped on the bandwagon, offering "manga-ized" version of traditional American superheroes. And, as this is written, there is no end in sight. Go manga!

### Mangled Manga

Don't make the mistake of thinking manga automatically means "comics from Japan." That was once true, but no longer. There is plenty of manga produced here in the good ol' U.S.A.

# Anime: Manga's Cartoon Cousin

Also gaining in popularity is *anime*, which is, essentially, Japanese animated cartoons that share a lot of the stylistic tropes and visual cues of manga. Is it wrong to call anime animated manga? I don't think so. And, it should be noted, many anime cartoons are based directly on manga comics.

The strides manga has made into the book-stores of America is similar to the leaps anime has made onto the U.S. television airwaves. Japanese cartoons such as *Pokemon* and *Yu-Gi-Oh* can be found playing after school on boob tubes across America. The Cartoon Network regularly fills its prime-time slots with translated Japanese anime, and toys and collectible trading card games based on anime are all the rage on playgrounds across the country. Many anime feature films have achieved mainstream success in America, or at least a cult following. And you can even see manga's influence in American cartoons like *The Powerpuff Girls*, *Samurai Jack*, and even *Star Wars: The Clone Wars*.

If you're interested in drawing for anime, you could do worse than read this book, since manga and anime share many of the same visual cues, such as speed lines, extreme fore-shortening, and dynamic angles. The characters also share similar designs, with small noses, humongous eyes, and big feet. (By the way, if you are sitting there wondering what speed lines and foreshortening are, or what the deal is with the big feet and eyes … read on, grass-hopper. All will be explained.)

### Manga Meanings

**Anime** is Japanese animation, which shares most of the elements and visual style of its printed counterpart, manga.

# Reading Manga Right ... or Left?

In Japanese, text characters are read top to bottom, right to left. This is the opposite of English, where characters are read left to right, across one line and then down to the next. This means reading *true* Japanese manga (assuming you can read the Japanese!) requires some getting used to, like driving in England on the "wrong" side of the road.

For the purposes of this book, we're going to discuss an American type of manga, read left to right like regular American books and comics. Many U.S. publishers, when translating Japanese manga for an American audience, "flip" the pages for the American readership. As we'll explore later in the book, there is an art to making a comic book page "flow," and a need for proper flow is universal among all types of comics, no matter what the originating country. It is necessary to flip the pages to maintain the flow of the story, to keep your eye moving from panel to panel in the correct order.

After the pages are flipped, they are then reversed, so the first page of an English manga is in the place of the last page of the Japanese manga (and so on). When the final product is in your hands, you would read it the same way you would read any other book in English, and, ideally, never be any the wiser that in the production phase of the book, the art was flipped and the pagination reversed.

Of course, some American publishers are striving for a more authentic Japanese manga reading experience. They do not flip the art, and they keep the pages in a reading order from right to left. And, boy, if you've never read manga in this fashion, does it take some getting used to!

There's no "right" way to do manga; no pun intended. If you want to do the more authentic type of right-to-left manga, there's nothing to stop you. However, keep in mind that when you reach chapters in this book in which we discuss storytelling, we're going to stick to the good old-fashioned American left–to-right way of doing things.

# What You Bring to the Table

Hey, it's up to you how seriously you want to take this book. If you want to be the next Osamu Tesuka, more power to you. If you're content to just doodle with a crayon or a pencil in a manga style, that's fine, too. I'm not gonna judge!

**Sketchbook Savvy**

Perhaps the most famous and influential manga creator, Osamu Tezuka (1928–1989), brought a cinematic style to manga and helped popularize it for all ages. He was the creator of *Tetsuwan Atomu*, better known as "Astro Boy" in the United States, as well as *Jungle Taitei*, or "Kimba the White Lion," among many, many other popular and beloved manga and anime works.

With that in mind, there's no reason to run out to your local art supply store and load up on a bunch of expensive art tools, doodads, and doohickeys. But if you want to use what the professional manga artists use, here's what our esteemed artist David Hutchison recommends:

◆ Paper: 11" × 17" two-ply Bristol board.
◆ Pencil: David uses one mechanical pencil with a 5mm 2h lead and one lead holder with 3h lead for details.

◆ Erasers: David has a kneaded eraser, which can be molded by hand into whatever shape is required and lasts longer than common erasers. He also uses an eraser stick, which is a holder that contains a length of eraser that can be pushed out of the end as the eraser is used up.

◆ Ink: Nearly any India ink will do. David prefers Bombay black India ink. It covers well, and it costs almost half the price of other inks.

◆ Quills: David uses Hunt 102 pen nibs from Speedball. These are basically all-purpose nibs you can use for a variety of inking jobs.

◆ Brushes: Windsor and Newton Series 7 number 2 brushes. These brushes are versatile and long lasting. After you get the hang of them, you can use them to ink almost any image.

◆ Computer: Macintosh G4, OSX. Running Photoshop 7.0. David uses a Wacom tablet to tone and color because of the great range of input available.

**Say What?**

Art is the most intense mode of individualism that the world has known.
—Oscar Wilde (1854–1900), writer

Now your crash course in manga is complete, and we can get to what you are really after. It's the reason you bought this book, after all, isn't it? You're here to draw, to make art, to make comics, and to do so in the manga style. So what are you waiting for? Let's get to it!

## The Least You Need to Know

◆ Manga are comics from Japan. Manga has been popular for decades, but in recent years, it has grown increasingly popular in America.

◆ The subject matter of manga is much more diverse than traditional American comics. Manga books are written for girls, for boys, and for people of all ages and walks of life.

◆ Manga books are smaller than American comics and have a much higher page count.

◆ Anime are cartoons from Japan, which share many of the same visual traits as manga.

◆ The Japanese read manga right to left, while American manga is printed right to left *and* left to right, depending on the publisher.

◆ Manga artists use a variety of art supplies, but a pencil and paper are all you really need to get started.

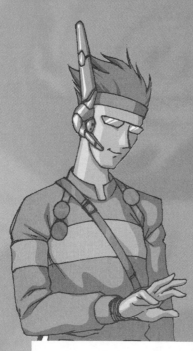

## In This Chapter

- ◆ Shapes as basic body building blocks
- ◆ Body building fundamentals
- ◆ Sketching, penciling, and inking
- ◆ Drawing the torso
- ◆ Body language

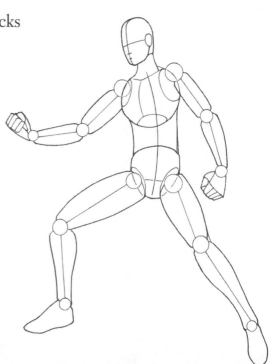

# Beginning Body Building

As eager as you might be to jump into things and start drawing manga faces and figures, panels and pages, one thing you are going to realize is that becoming a good artist does not happen overnight. It takes practice, and lots of it. Not only that, but it's rare that even a talented and seasoned artist sits down and whips out the perfect page or picture. Planning goes into every single page, from the design of the character's costume, to subtleties of a character's body language, to the number of panels on a page and the way a page is composed.

So naturally, we're going to start at the beginning. We're going to look first at the steps to creating a manga figure. Some of it might seem elementary, but it's part of a larger, more important whole. And it's something that every artist needs to know.

## The Shape of Things to Come

Now, I know what you're thinking. "I just paid how much for this book, and they want to teach me to draw *circles!?!*" Yes, it's true that just about any idiot can draw a circle or a square, but it's also true that you can look at just about any picture and break it down into very simplistic geometric shapes. And after you understand shapes and their relationships to each other, you will have a better handle on how to draw figures.

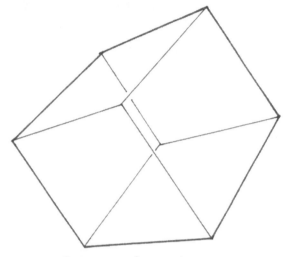

**Squares are also very important
in composing your page.**

Squares aren't valuable in the way circles and cylinders are for building bodies, but they come in handy for many other objects, such as vehicles, buildings, even humanoid-shaped nonhumans such as robots.

# Everything in Order

There is an order to doing things in comics, and this goes for both American comics and Japanese manga. Artists will usually start with a basic outline of what they intend to draw, done in pencils or even blue pencil (the color blue does not reproduce when photocopied). They will continue to develop this outline into a rough sketch. And they will tighten and add detail to the sketch until it is a finished and fully realized pencil drawing.

Up until this point, if you don't like what you've drawn, if you want to try a different angle or go at the picture from a different approach, you are free to erase the penciled drawing and start again from the top. But when you are satisfied with your pencil drawing, the next step is to go over it in ink (and erase the pencils after the ink is dry). But be sure you are satisfied with the pencils, because there is no

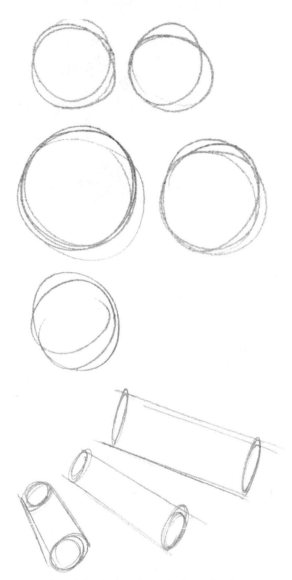

**Circles and cylinders form the basis for figures.**

When drawing bodies, circles and cylinders are your best friends. As you will see, you can make a rough outline of your character using only circles and cylinders. You can create a figure that looks human-shaped and make sure you have that character in the pose you want, using the body language you desire.

erasing if you are unhappy with the inks. Your choice is either to live with it or throw out the page and start all over again.

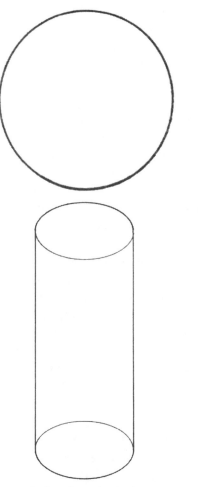

Inked circle and cylinder.

### Sketchbook Savvy

Follow this drawing order:

◆ Outline

◆ Sketch or "rough"

◆ Finished pencils, adding detail and definition to the rough

◆ Ink over finished pencils

◆ Erase pencils after ink is dry

Many American comics are put together in an assembly-line fashion. The writer, penciler, and inker are different people, and after the page goes to pencil and inks and is finished being drawn, it goes to a letterer and a colorist. Most manga is a single-person labor of love (or labor, anyway, as the case may be). So, for this book, we're going to assume you are doing it all yourself, or, at least, doing the pencils and the inks.

Whether you're drawing something simple like a cylinder, or a complex series of figures, you should not commit it to ink until you are satisfied with your pencils. As you gain confidence as an artist, you might choose to add detail to your drawing in the inking stage. But always remember, ink does not erase. If you ink something and don't like it, you're pretty much up the river without a paddle—or back to square one.

### Manga Meanings

A **blue line drawing** is literally done with a blue pencil and will not reproduce when photocopied in black and white. A **rough** is a page or figure that is penciled in a preliminary stage. **Penciling** a page is to draw it in pencils, to elaborate and expand upon the rough, making it into a finished drawing. **Inking** a page is to go over the pencils in ink, making the art permanent and un-erasable.

# Figure It Out

The most basic step: a single line.

The first step in drawing a figure is a simple line. This line follows the path of the character's spine, based on the pose the character will be in. In this case, we're going to draw a figure standing forward and upright.

Defining the shoulders and hips.

Next you add two lines to denote where the shoulders and the hips will be. You are defining your character's torso here, even if you can't see it at this point.

Now the character takes shape. We'll show in great detail in future chapters how to flesh out your character, how to add faces, clothes, and features. Here, we simply want to present a body.

As you can see, the figure is built primarily out of circles and cylinders. The head, chest, and joints are circular, whereas the limbs, neck, midsection, and fingers are cylindrical. Of course, not everything is a perfect circle or cylinder, and some differently shaped objects, such as the feet, pelvis, and elements of the hands, will simply take practice. But in general, the body consists of circles and cylinders put together in a human shape.

Finally, we see the finished body. That is, as finished as it is going to get in this chapter. It still needs to be fleshed out, and there is a lot more to do to this figure before an artist would ink it. But at this point we want to make sure the figure's body parts are in the correct proportions and that the figure is in the pose or stance that we want.

Of course, this is not a particularly natural stance, just one that best illustrates the human form. Most of the time your character will be doing something, and it's the action pose that you will want to capture accurately.

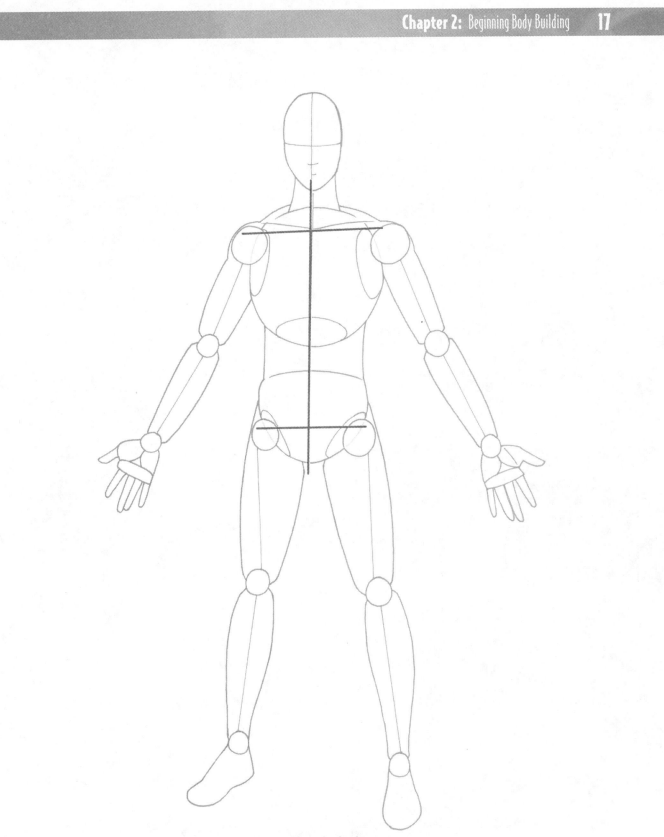

Adding the body.

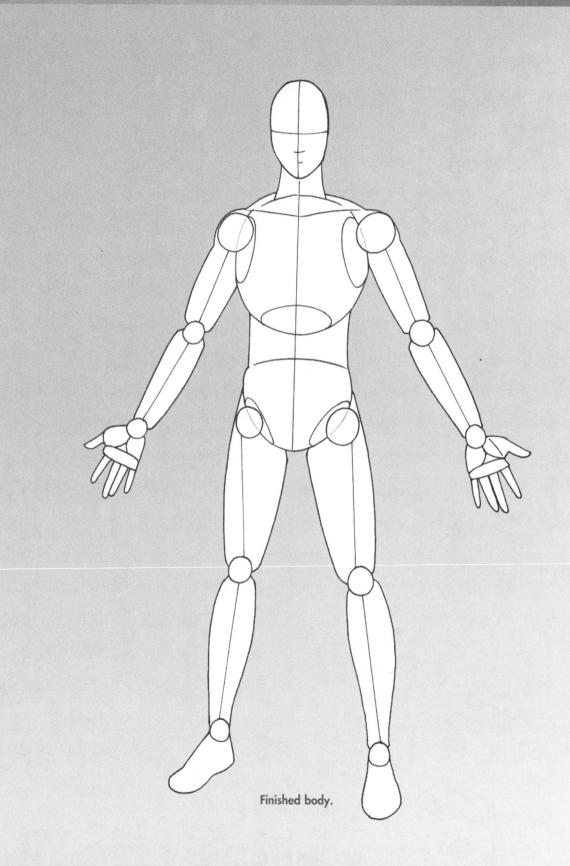

**Finished body.**

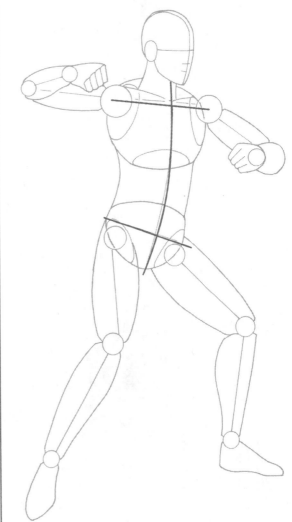

**Adding the body.**

Now, with the body added, we see exactly why the spine was curved and why the hips and shoulder lines were drawn at an angle. In this shot, the character is in a stance drawing back or throwing a punch. His shoulders are straight, but his back is arched. His legs are not straight; the figure's knees are bent and his weight is on his left (front) leg, to support his weight as he throws the blow.

**The start of an action pose.**

We'll next tackle a character in more of an active pose. In this step, all we see is a curved line, and we can't tell too much about the figure other than the spine is not perfectly straight.

**Defining the shoulders and hips.**

Lines to mark the shoulders and hips are added next. And we still don't have a clear idea of what the character's pose will be. Consider this a very basic skeleton, a wire frame or foundation to build your character around. As you are drawing this, the figure should be taking shape in your head. The hard part will be getting it onto paper the way you want it, but this outline should help.

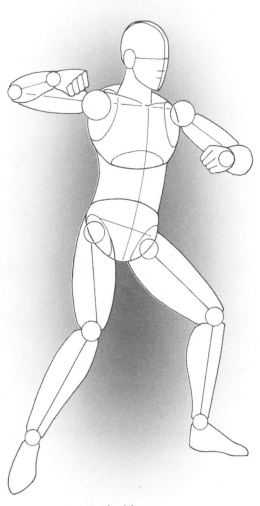

**Finished figure.**

Here we have the figure, sans outline. As we saw in the last figure, the way the body moves will affect the direction and curve of the spine, shoulders, and hips, even their lengths. Keep this in mind, because your characters' bodies will often be in motion and active. At least, they *should be*, if you want your story to be interesting.

# More So with the Torso

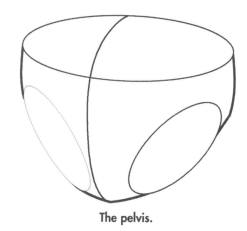

**The pelvis.**

Before we get too deep into our discussion of body language, let's take a step back and look at some of the trickier body parts. This is a figure of a pelvis, the lower half of the torso.

The overall figure is that of a half oval, bisected by a wide oval so we see only the lower half. Two other tall, tilted ovals mark the place of the legs.

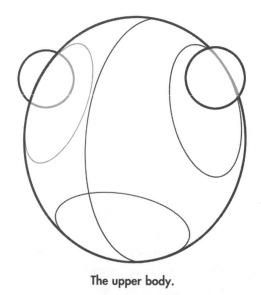

**The upper body.**

The chest is more of a perfect circle, with smaller circles high on each side to denote the joints to the arms.

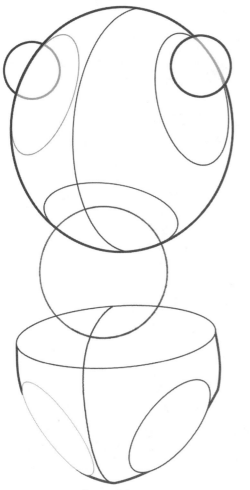

**The complete torso.**

And finally, here is the pelvis and upper body together, united by a circle (sometimes a cylinder) to denote the stomach and rib cage area. Recall the natural movement of your own body. The chest may pivot forward or side-to-side on the "ball" that represents the stomach, but it won't lean too far back (not, that is, unless your character has a broken back).

# Bodies and Language

We're going to be talking a lot, through the course of this book, about pictures telling the story. That, after all, is the fundamental difference between comics and prose. While books describe things and help you to form a picture in your head, comics show things. Pictures often are in place of words, which makes it all the more important to show things the way you intend, to best get the point of your story across.

Body language is an important aspect of that. The correct body language can, and should, help tell your character's story. Sometimes it's a slumped posture to show a character is depressed. Sometimes it's the way a character walks to show he or she is in a good mood, angry, or in a hurry. In this case, it's a guy coming at us, throwing a punch.

### Sketchbook Savvy

Small poseable wooden mannequins are available at most art supply stores. You can manipulate them into the pose you desire and use the mannequin for visual reference.

In the subsequent chapters, we're going to look at different types of bodies, and how to flesh out a character's figure and face. But don't underestimate the importance of body language. If your characters can tell a story or some aspect of their stories with just the way they are posed, think how effective your storytelling will be when you add the correct facial expression and body elements to that perfect pose!

This next drawing is another action stance, a character moving forward, ready for a fight.

Capturing a character's body language does not mean capturing them in action. Not necessarily. This figure shows a character relaxing in a chair and lost in deep thought. It is possible, and preferable, to give your character interesting poses, even if they don't appear to be doing anything particularly interesting.

We see another inactive pose of a figure squatting, looking at something or waiting for something.

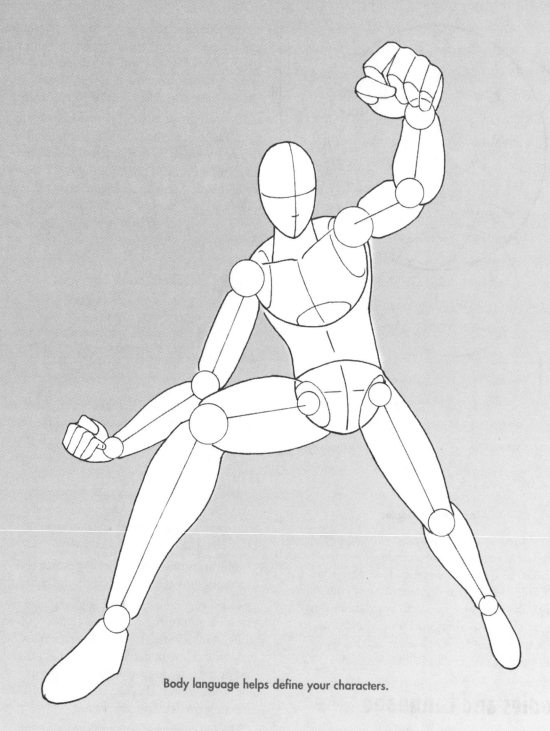

Body language helps define your characters.

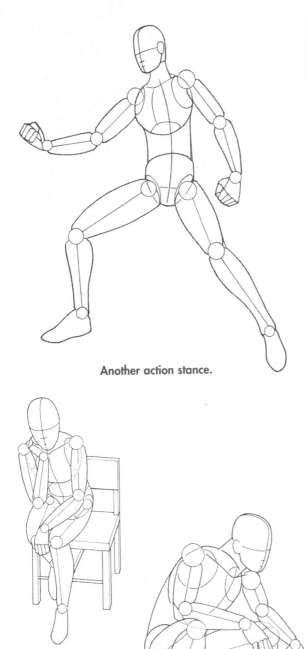

**Another action stance.**

**Figure in repose.**

**Another figure in inaction.**

Try being aware of your own body language and watching the body language of friends and people nearby. People rarely do nothing, even if they aren't doing much. We scratch, we stretch, we rub, we fidget. Be aware of these things, watch for them, and try to re-create them. A reader should be able to thumb through your book and get a feel for your character and the situations he or she is in, even without reading a word. Body language is an important part of that.

Faces and facial expressions are the other part, but we're going to spend a few more chapters talking about bodies and figures before we get into *that*.

## The Least You Need to Know

◆ Figures and pages take planning and preparation.

◆ Figures and objects can be broken down into simple geometric shapes. They can also be *built* using simple geometric shapes.

◆ Characters usually start as an outline, then a rough, and then finished pencils, before the artist commits the figure to ink.

◆ Don't ink a figure with which you are not happy. Erase and redraw with pencil until you are satisfied, and only then should you ink.

◆ The torso is literally your character's physical center. It consists primarily of a circular chest above a half-oval pelvis. A smaller circle unites the two and represents the stomach; this is the point where the torso's flexibility is greatest.

◆ Use body language to help your characters tell their stories. Try to keep body language interesting, even if the character you are drawing is not active.

## In This Chapter

◆ Svelte and sporty

◆ Head of the class

◆ Beefcake bodybuilders

◆ Large and in charge

◆ Boys will be boys

Chapter **3**

# Man Alive: Some Basic Male Body Shapes

No two people are alike, and although we've discussed in Chapter 2 ways to make a basic male body type, keep in mind that male body shapes can vary widely (no pun intended). Just as in real life, people come in all shapes and sizes—slim and fat, short and tall, and every combination in between. Even age has an effect on body type. I mean, when is the last time you've seen a six-foot-tall toddler?

In this chapter we're going to look at the differences that go into creating different male body shapes, and talk about what sort of character is the best match for a particular size and shape.

# The Athletic Male

We begin with the athletic male. This isn't to say that the average male is athletic, but, like movies and TV, heroes and protagonists are, in general, better looking than the average Joe on the street—and in better shape, too. This is why there aren't a lot of ugly movie stars. It's just a fact of life that we would rather look at pretty people than, uh, more realistic people, and this applies to comics as well, whether it's an American superhero or Japanese manga character.

So we begin with the athletic male, which is in fact the *average* male, at least as far as manga is concerned.

In this case, we start with a stick figure of our male-to-be. In this figure, we just get the basics of the character's posture and skeleton but can't really tell too much about the character. The shoulders are not particularly wide, so this is likely not a strong or heroic figure. The character does not seem short, nor the head particularly large, so this is very likely just an average male, or teen male, or maybe even a female, at this point.

Just by adding some cylinders to represent the limbs and circles for the joints, the chest, and mid-section, our character comes into view much more easily. And he looks distinctly like a human male—one who either hits the gym regularly or at least keeps away from the potato chips and Big Macs.

The chest is more circular than the head and about one and a half times the head's height and width. The forearm cylinder is larger than the upper arm (we'll explore the foreshortening of the outreached arm in Chapter 18). For the legs, instead of seeing them as two cylinders representing the calves and thighs, visualize them as one unit, getting progressively bigger and wider the closer it gets to the hips.

Stick figure for athletic male body type.

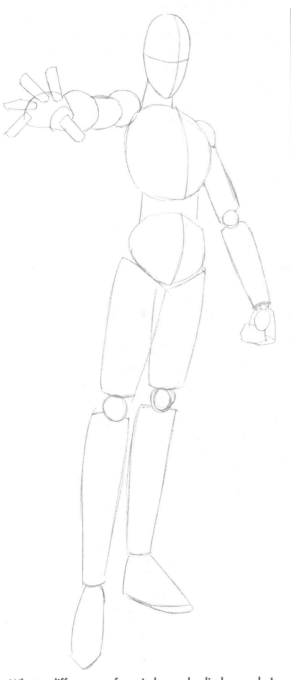

What a difference a few circles and cylinders make!

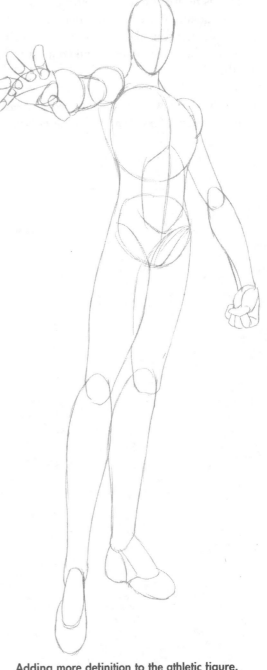

Adding more definition to the athletic figure.

In this figure, the body is getting more definition, looking more like an actual human than a man-shaped compilation of circles and cylinders. The limbs curve more and connect to one another. We see the outline of a stomach. We also see a little more evidence of dimension to the body, in the wrist of the lowered hand as well as the upper back and the upraised arm.

In this figure, we see outlines defining the musculature. In males, this is most obvious in the abdomen, as the characters are routinely given the washboard abs that most comics and manga readers only dream of having. We see some definition as well to the ribs, the pecs, the clavicle, and the biceps.

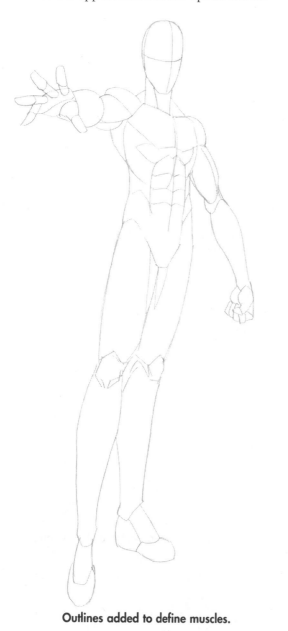

**Outlines added to define muscles.**

**The athletic figure is taking shape.**

In the previous figure, what was outlined previously is more realistically rendered. In addition to the abdominal muscles and the chest, we see some lines to denote the upper rib cage and others to define the neck, the thighs, and the calves.

Please note that although the chest is well defined, it is not particularly large. We'll be comparing this chest with the muscular chest in a bit.

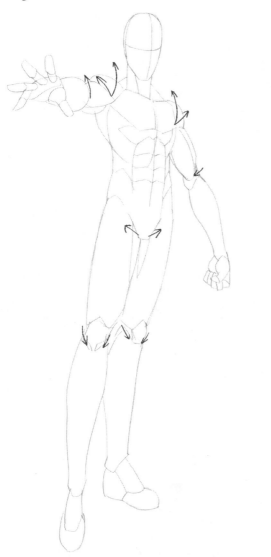

**Arrows indicate points of articulation.**

In this figure, David uses arrows to identify some of the key *points of articulation* (or *anchor points*) on the character. This is something to

take into consideration when drawing your character; the points that have the most movement on a character consequently will have the most clothing folds. These points are around the joints—the shoulders, neck, elbows, crotch, and knees—all areas of articulation on a character.

### Manga Meanings

If articulation is the connection of different parts by joints, **points of articulation** (also known as **anchor points**) are the areas on a body that move, such as the elbow, knee, or neck. The hand, for example, has many joints and, therefore, many points of articulation.

In the next figure, the character is now garbed in some sort of jumpsuit. Since manga books shy away from the skintight spandex found on most American super-characters (at least the manga males shy away from spandex) a lot of the muscle definition we've just been exploring is for naught. (Better you know it and not use it than not know it and need it is my philosophy.)

In the case of this figure and his naturally fitting clothes, we see the outline of the chest, and most of the rest of the body is lost to folds in the clothes. As you can see, this character's outfit of choice is not particularly tight, as it would be on a more muscular character.

Also, note that at this point David is satisfied enough with the character's body language and body type that he begins working on another equally important aspect to the character: the face.

### Sketchbook Savvy

Nobody actually thinks Superman or Spider-Man's costumes are made out of the skintight gym clothes' fabric spandex, but the word has become convenient shorthand among comic book readers to describe the outfits of the American superhero set.

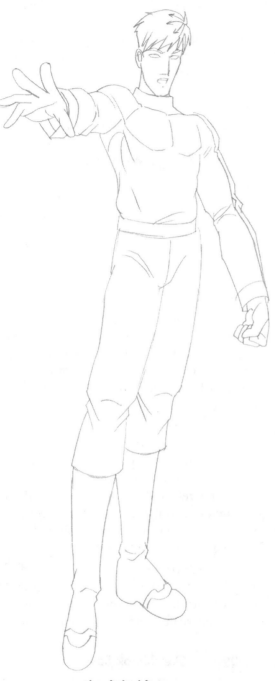

The clothed figure.

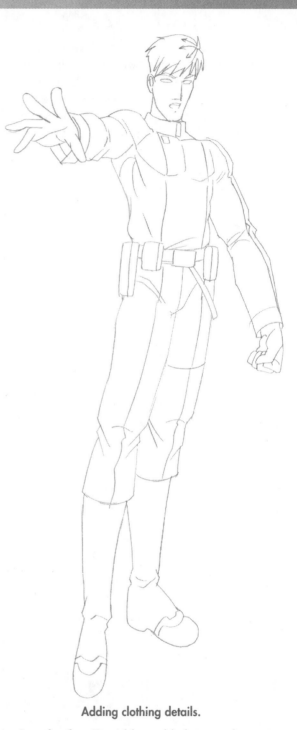

Adding clothing details.

Just for fun, David has added some elements to this character's outfit to make the character more visually interesting. In this case, we see some miscellaneous pockets to add to the character's belt and some lines down his outfit, which will make his clothing appear less like a jumpsuit and more like a uniform.

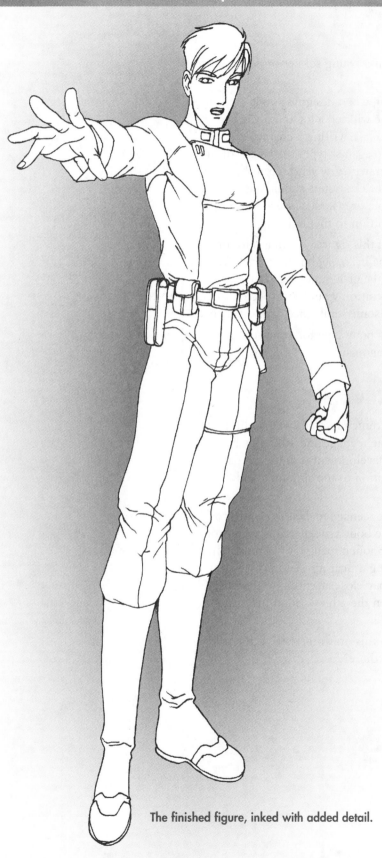

The finished figure, inked with added detail.

Clearly, this is a young soldier or perhaps a pilot.

Keep in mind, when designing your character, its body type will tell a lot about the character. Unless you are writing a character specifically to go against type (the fat misfit in the army, the scrawny guy yearning to be a prizefighter) your characters should have the proper body type, or else they are going to bring undo attention to themselves.

In the case of this figure, a young pilot or soldier should be in shape, but there is no reason for them to be grotesquely muscular. A person in this position would be expected to keep himself in some semblance of good shape.

Consider this body type for your young adult male protagonist.

## The Teenage Male

There is not a tremendous amount of difference between the teenage and athletic male, except for less development of muscles (particularly less definition to the abdomen and chest).

However, the teenage male is as popular as the athletic male body type, perhaps even more so, since boys' Shonen manga is the most popular type of manga. Bearing that in mind, it's worthwhile to pay close attention to design differences between the athletic adult male and the teenage male.

Of course, in this drawing, there is not a lot of difference, is there?

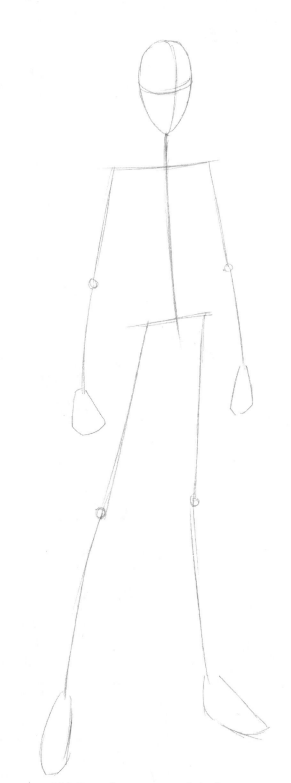

Stick figure for teenage male body type.

The largest difference is the chest, which is smaller at the bottom, and less circular than the athletic male would be. Again, this is because this chest will ultimately be less developed. Maybe Junior needs to do a few bench presses!

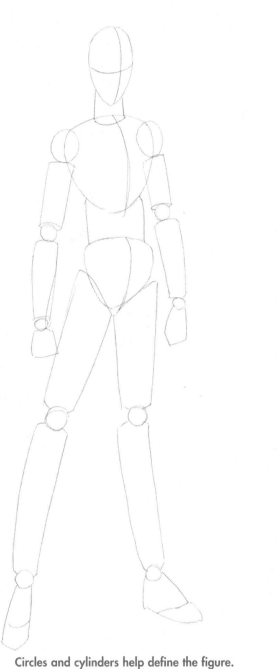

**Circles and cylinders help define the figure.**

Still not a lot of difference, as we see the placement of circles and cylinders to give us a better idea of what the body will look like.

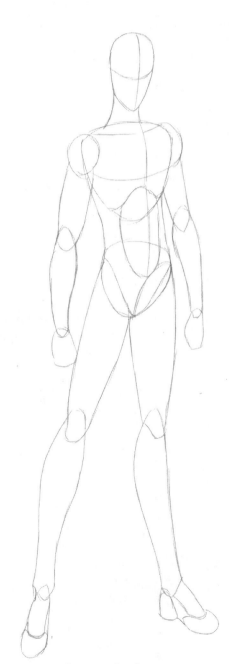

**Smoothing out the shape.**

The limbs have changed from cylindrical to smooth in this picture, and the mid-section is wide, making the chest appear smaller. The legs are a bit thinner, too, compared to the athletic figure shown earlier. We will see that the arms are less muscular, too, although that becomes much more obvious in the next figure.

Here we see the outline of the musculature. Keep in mind, although everybody might not *show* that they have these muscles, a quick flip through an anatomy book will confirm that everybody indeed *has* these muscles. Much like the athletic figure shown earlier, we see the outline of the abdomen and chest, as well as a much less pronounced bicep.

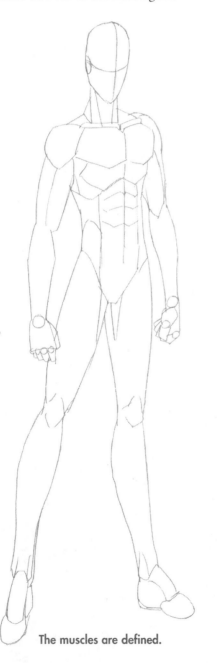

The muscles are defined.

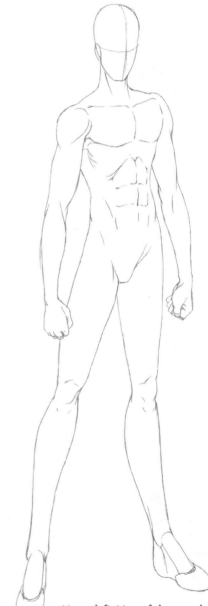

More definition of the muscles.

Now, with the muscles more defined, we see that this is a figure with some upper-body definition, but not a lot in the way of muscles in the arms and legs.

Again, based on the natural movement of the body and the limbs, David identifies the points on the character's body where there are most likely to be folds in the clothes. And, as before, these are the areas of the body with the most movement—the neck and the joints of the upper and lower limbs.

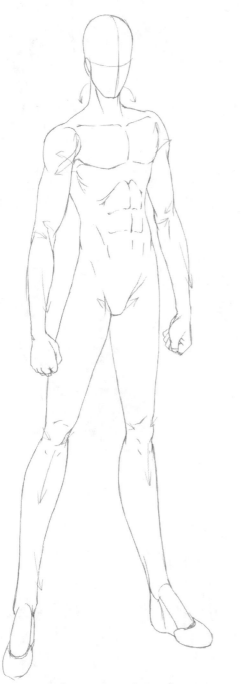

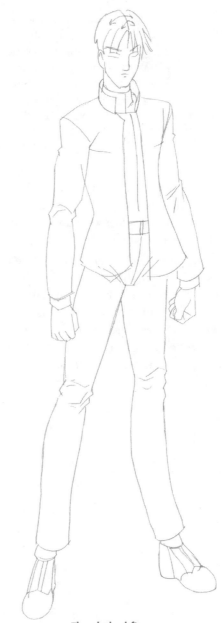

**Arrows indicate points of articulation.**

**The clothed figure.**

The previous figure is decked out in sporty, yet casual clothes. Of course, we don't see much in the way of upper-body definition, and some of that is due to the jacket, but this young buck isn't really ripped enough to see much anyway.

### Mangled Manga

Keep in mind, unless the plot specifically calls for you to do otherwise, your characters should not dress against their body type. Someone with gargantuan muscles should not wear baggy clothes—because then you don't get to see the gargantuan muscles! Our teenage male figure does not wear form-fitting clothes because as a slender and nonmuscular character, there is no reason to emphasize the body.

In the finished figure, we see that Dave chose the character's jacket to have a pronounced cut in the mid-section, which emphasizes that this is a slender character.

Another nice touch is the fact that the character is wearing "high-waters," pants that appear just a tad too short, and the cuffs of his jacket are just a bit short for his arms. It's a subtle but effective touch, implying this character is probably growing faster than his parents can keep him in new clothes.

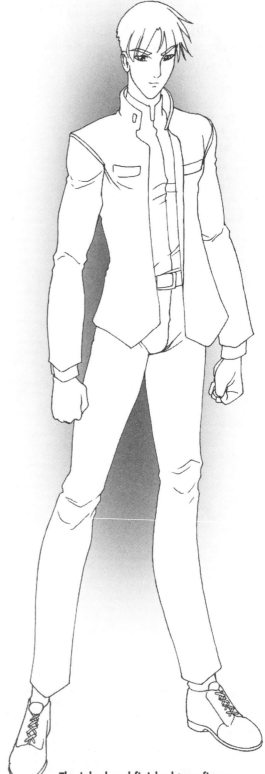

**The inked and finished teen figure.**

# The Muscular Male

shoulders. Of course, here the shoulders are simply represented as a longer line from arm to arm. The difference will become much more pronounced in the next drawing.

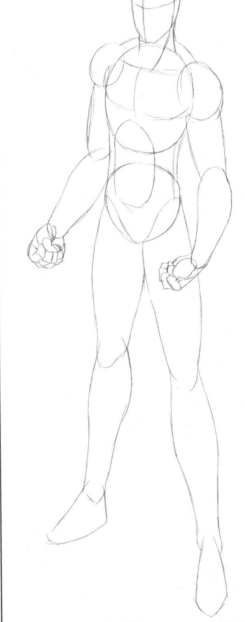

**Stick figure for muscular male body type.**

Immediately we see one crucial difference between this figure and the outline of the previous two: This character has broader

**Circular shapes define a more muscular figure.**

The biggest difference here is the upper arms, where we see what are clearly going to be bulging muscles. The shoulders are larger and beefier, too, as is the area above the chest and around the neck.

Note that there are fewer steps to this body type than the first two. It's not that drawing a figure such as this entails any less effort, I just figured by now we could skip a few steps, as a lot of the explanation in the early stages becomes redundant.

Not only do we have more defined musculature on the abs, chest, and neck, but we see more outlines of muscles all over the body: forearms, upper arms, thighs, and calves. Unlike the athletic figure, this is not a figure that hits the gym just enough to stay in shape. This is a character that attends the gym religiously, and the results show. In particular, the upper arms are much more rounded and sculpted than in previous figures.

This is a well-defined, well-sculpted figure with chiseled features. Other than the shoulders, he doesn't look particularly *bigger* than the athletic character, but as a result of paying attention and *calling* attention to the muscles, this will ultimately look like a much tougher and more formidable character.

For the finished figure, David adds even more small details in the muscles. We see more small lines to denote muscles, and nowhere is this more apparent than the very visible and well-defined pecs and abs.

David has chosen this particular strongman to be a boxer, and he enhances the image of him as a rough-and-tumble tough guy with some thick, dense lines to represent bruises or scuffs, as well as some bandages on the face. This is a character who can take punishment, as well as give it right back.

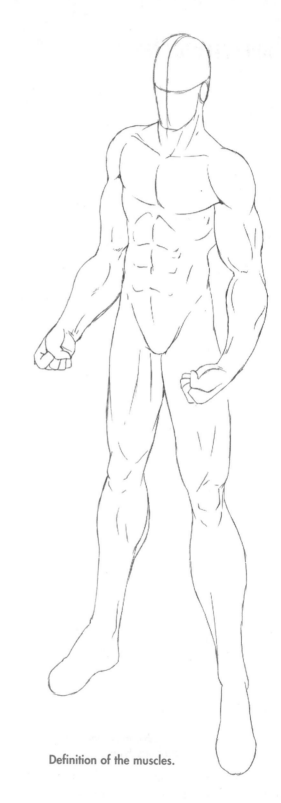

Definition of the muscles.

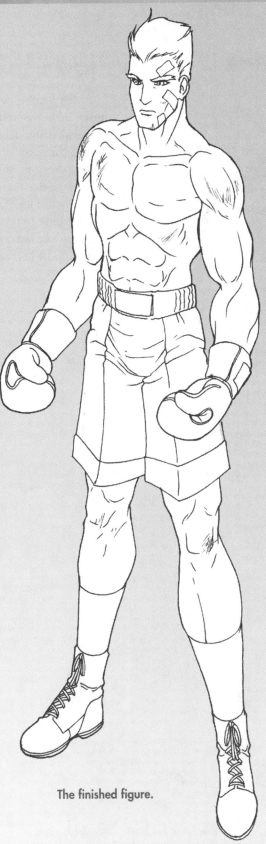

The finished figure.

### Sketchbook Savvy

Although a book on anatomy is fundamental to every artist, a more real-world or practical visual reference is a must for most artists. Magazines are a great source. Men's fashion magazines are great references to dress and accessorize your character, and even to find the right hairstyle. Fitness and muscle magazines are a good place to see muscular figures in action and in various poses, both natural and unnatural.

# The Husky Male

Now for a radically different figure. For this husky man, we start out with an outline with very wide shoulders and hips. We're going to draw a character of tremendous girth, and one thing to keep in mind when designing a character such as this is the stance. Note that David has the arms and legs far apart. This is because this fella is going to be wide enough that his legs and arms can't be vertical, as they could not realistically support his weight or his center of gravity.

Stick figure for husky male body type.

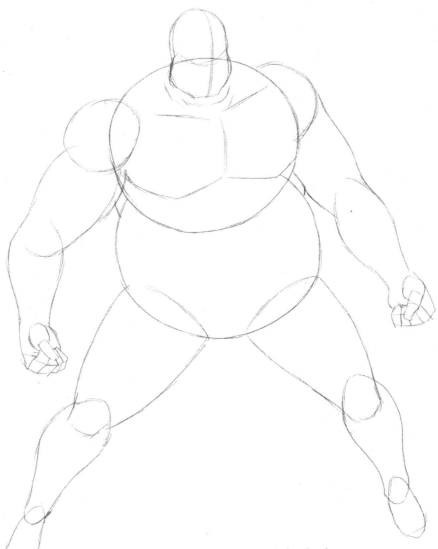

Big and round are the operative words for this figure type!

In the case of this figure, the chest and mid-section are both round and much larger than the head, two and a half to three times the height of the head and roughly three and a half times the width. Where the chest and mid-section in previous figures were laid out as smaller circles separated by a small cylinder, there is no room for the cylinder here. There are just two big circles on top of one another. The circle representing the upper body is large enough that it extends above the shoulder area of the previous figures. In fact, you'll note that this character's head is halfway inside the circle, rather than above it, separated by a small cylinder to represent the neck.

The upper arms are much wider than the forearms, and the character's thighs grow progressively beefier as they approach the mid-section. We see some outlines of a chest—but no six-pack abs to be found here!

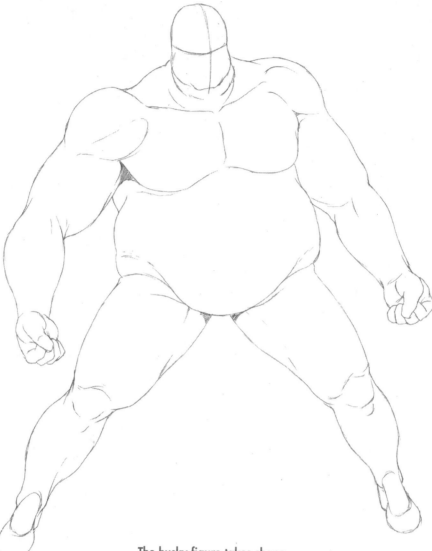

The husky figure takes shape.

There is still a lot of roundness to this character, but perhaps the most noticeable thing here is the sag to the character's belly. The fact that the stomach hangs down in a frontal shot suggests this is a character of enormous mass. As a general rule of thumb, your character's tubbiness can be determined by the size of the lower circle representing the mid-section. This circle is usually smaller than the circle representing the chest with a character that is in shape, but as it gets larger, so does the need for your character to lay off the double cheeseburgers and chocolate shakes.

This character, like the muscular character, has more rounded limbs, especially in the thighs and upper arms. But unlike the muscular character, the limbs are less defined, suggesting there is mass, but not a lot of *muscle*.

The chest sags a bit; this is not the tight, rock-hard chest of our muscular male, or athletic male, or even our teen. This is a chest with a lot of meat on it. You'll also notice that this character has no neck (or a gigantic neck, depending on how you look at it). We see some lines to represent chins and double chins, and the head is resting inside the character's upper body.

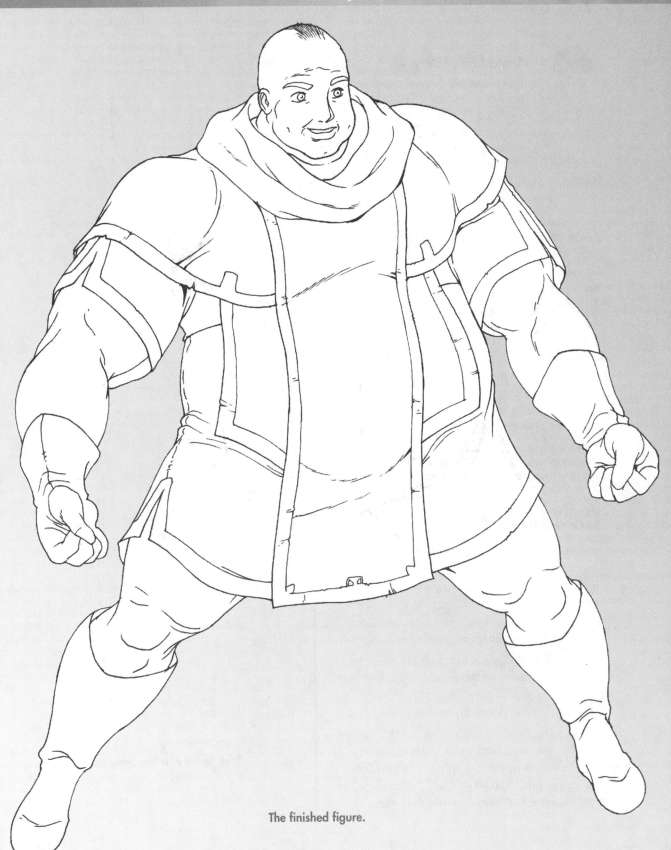

The finished figure.

## Sketchbook Savvy

Want to make a fat character appear even fatter? Sink the head lower into the body and increase the circumference and quantity of the double chins. It's a fact that the larger you are, the less of a neck you appear to have, and by increasing the thickness of the neck, you add pound upon pound to your character.

We present our finished character, garbed in some vestments to make him look like a monk, or some sect of religious martial artists. Remember when we talked about having your character dress to what is appropriate and what accents the body type? In *this* case, our porky friend is wearing clothes that are a little tight in the chest and belly, so we have no doubt that this is a character who packs on the pounds. Moreover, he is wearing clothes that look like they would normally *be* large on somebody. When a character puts on what appears to be flowing robes, and they end up *still* a little too skintight, you know it's time to take away chubby's trough of hot fudge.

# The Young Male

Now we move to the opposite spectrum, from large to small. There are plenty of kids in manga: bratty young brothers, runaways who happen into trouble, orphans who stumble into adventure or some hidden land. And there are some fundamental differences to drawing children.

The most obvious is that kids are shorter. Not only do they not have the height, but their heads are larger, to emphasize that the rest of the body is comparatively smaller.

Naturally, when you are drawing the outline of your character, limbs will be short, as will the line representing the spine. They would still be proportional to that of adult bodies, just a miniaturized version of adults.

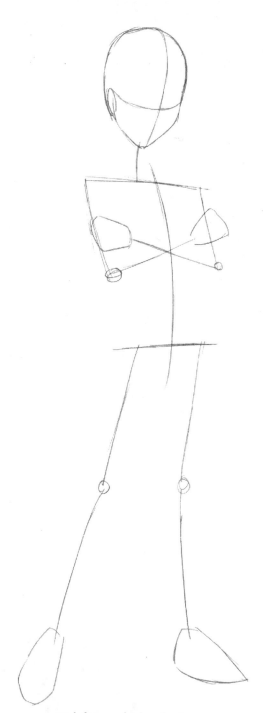

**Stick figure of a boy body type.**

In the previous drawing, we can see that his features are slender, and his neck in particular is slight, to emphasize that big ol' noggin sitting atop the neck. The chest and mid-section are oval-shaped rather than circular, giving the figure a thin aspect.

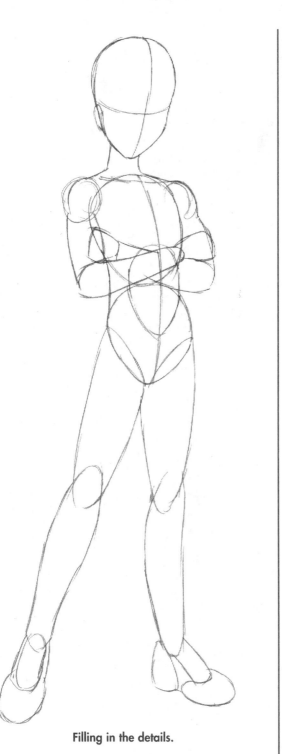

**Filling in the details.**

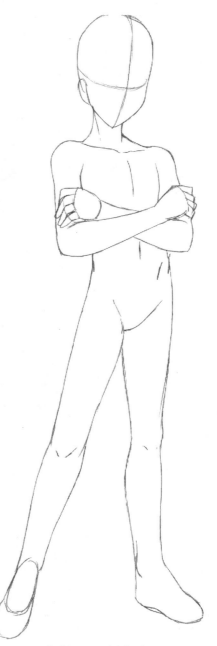

**Fleshing out the body.**

The finished figure.

As this figure is fleshed out, we see that limbs remain thin like the torso. There are no defined muscles, and the arms and legs are mostly straight. (In this figure, you can't see the upper arms, but you're just gonna have to take my word for it!)

Even decked out in a futurist outfit, we can tell that this youngster's head is proportionally bigger to his body than previous figures. The clothing this kid is wearing gives him just a bit more bulk, but he's largely got the build of a skinny stick figure. As with the teen, this character has no muscles or muscular definition, so there is no reason to design him in an outfit that accentuates those features.

One nice touch David gave to this outfit is the enlarged neckpiece, which spotlights how thin this young man's neck appears to be.

## The Least You Need to Know

◆ As you initially draw the outlines for characters, they appear similar, unless they have radically different body types like that of an obese person and a child. It's not until you flesh out the characters that differences appear.

◆ Some of the most important parts of the body are the chest and the abdomen. The size and scale of these features will help determine your character's size, age, and fitness level.

◆ A working knowledge of anatomy—or at least reference books on anatomy—can be extremely helpful in defining your character's musculature.

◆ Dress your character to accentuate his body type. A muscular character will show off his muscles. A fat character will not be able to conceal his girth. And there is no reason to emphasize muscles on nonmuscular characters.

## In This Chapter

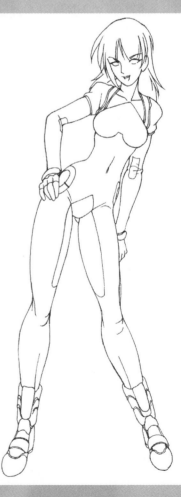

# Sugar and Spice and Everything Nice: Some Basic Female Body Shapes

Having fully explored the XX chromosome, it's time to cover the fairer sex. As with the males in manga, perhaps even more so, female characters tend to be attractive, whether they are protagonists, girlfriends, supporting characters, or damsels in distress. Sure, you might still find a pudgy house matron or wise grandmother, but manga is mostly populated with teen and young adult hotties, even in the Shojo books that are geared toward female readership.

Naturally, females have a different body shape from males, even as different females have varying body shapes from one another. We'll explore these differences in this chapter, even as we discuss which sort of female character is best suited to a particular body type.

# Battle of the Sexes

Before we get into specific character types, let's look at some differences between the male and female figure. In this cutaway torso of the female figure, we can see the profile of the back is kind of an s-shape from the back of the neck to the posterior, curving outward at the shoulder blade, inward toward the stomach and waist, and outward again as it approaches the rump.

The front of the torso has round breasts that slope over the curve of the chest. Below the breast is a stomach, slightly concave at the same level where the back curves the farthest inward. This is because females generally have much smaller waists than males.

It's probably no surprise that the breasts of many comic book characters tend to be on the large size, although they are not quite the same as the impossibly large and improbably gravity-defying fantasy figures that you find in most American superhero comics.

**Sketchbook Savvy**

Breast size in females can often be a good indicator of the character's age. In general, the more developed the figure, the older the female.

# The Athletic Female

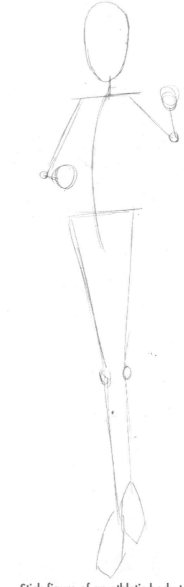

Stick figure of an athletic body type.

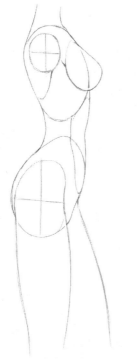

A side view of the female torso.

We open with the standard stick figure, which shows the character's body language more than its body *type*. As with our outline figures in the previous chapter, we don't know any of the particulars with this character, other than she (or he!) is not a child, nor is this person particularly overweight or large.

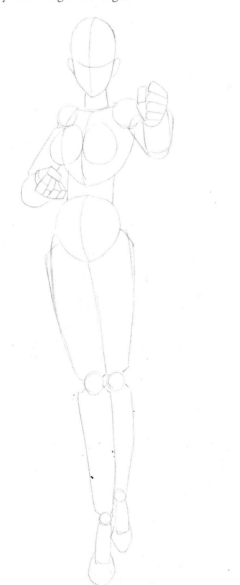

**The figure takes on a female shape.**

Our circles-and-cylinders mannequin settles the question regarding the sex of this character once and for all. This typical manga female has much more of an hourglass figure than its male counterparts, a small waist, larger hips, and more pronounced breasts. They also have a slightly longer and thinner neck, as well as thinner ankles and smaller feet.

### Sketchbook Savvy

Females have the following:

◆ Smaller waists

◆ Breasts

◆ Curvier hips and limbs

Males have the following:

◆ Wider necks

◆ Wider torsos

◆ More muscular definition to limbs and abdomen

As this figure is smoothed out, we see that the female figure is much curvier than the male, in every aspect of the body: legs, arms, and torso. Really, the only area not more curvy than the male is the head and the hands.

Note in this picture we see an oval representing the stomach. However, unlike the male figure, there are no defined "washboard abs."

Here is the figure fleshed out further, where we see lines to represent the musculature. Where we showed in the last chapter an athletic male *and* a muscular male body type, for females, the muscular and athletic types are generally one and the same. Except in the case of female bodybuilders, which are fairly rare, females do not have the definition to their muscles that males do. Or even if they do, the muscles are smaller, so there is less emphasis on them.

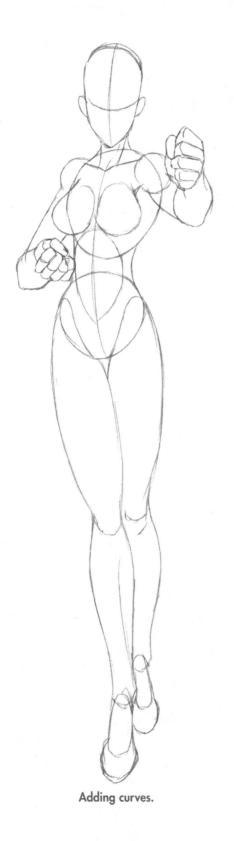

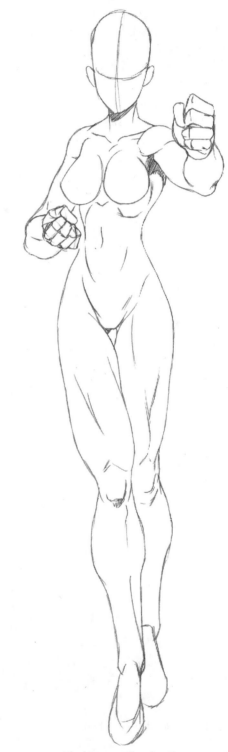

Adding curves.

Fleshing out the details.

We can't stress enough how valuable a knowledge and reference on anatomy is for an artist, especially as it applies to proportions and musculature. As with males, there are plenty of magazines to serve as reference for hairstyles, clothing, accessories, and body types. Women's fashion magazines are an excellent way to keep up on the latest hair and clothing fashions, and a Victoria's Secret catalog or the swimsuit issue of your favorite sports magazine are good for more candid pictures.

Ahem … you wouldn't be the first artist to have a few magazines featuring even *more* candid pictures, which you can reasonably *claim* you use for reference.

In this figure, David uses arrows to indicate where the folds of clothing will be, based on the character's anchor points. As we will see, this female martial artist figure wears a smaller outfit that does not cover most of the character's points of articulation. Instead, based on the outfit that exists solely in David's head, he maps out the curves and folds of the outfit, including marks to denote leg wraps, shoes, and gloves. Also, since this is a character with longer hair than the typical male character, David anticipates how the hair is going to fall and flow.

In the finished and inked figure, our athletic female appears to be some sort of martial artist or fighter character. As in every other part of Japanese and American culture, there is more emphasis on female flesh than male, so costumes tend to be a bit more revealing. In the case of this martial arts robe, the arms are left bare, and the legs are visible all the way up to the hips. Obviously, this is to give our fight girl more room to kick. Yeah … sure, that's right!

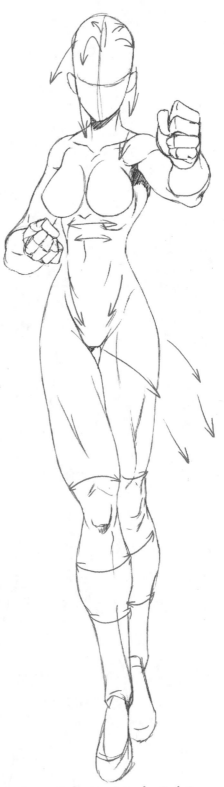

**Arrows indicate points of articulation.**

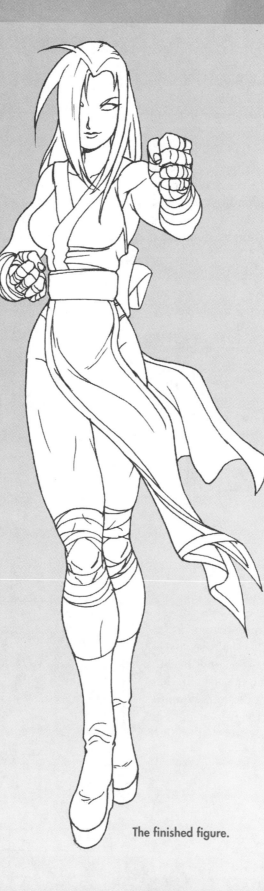

The finished figure.

Unwrapped and wrapped fabric.

# The Teen Female

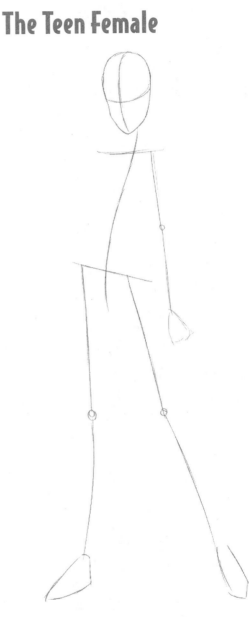

Stick figure of teen body type.

Although we can't see the fighter woman's arm and knee wraps in detail in the figure, David generously provided us with close-ups of the fabric as it appears unwrapped and wrapped over the limb. The fabric shows periodic tears, both to indicate wear and to show flexibility.

Why the wrap, anyway? It's the same principle as boxers wrapping their hands in practice. Our fighting martial artist lady doesn't want to scrape her knees or knuckles while she is punching you in the nose.

Here is the stick outline of our teen figure. In this case, we can see that the body language is more reserved than in our previous female. Already, we can tell that we are probably dealing with a much less aggressive type of character. Of course, it still remains to be seen whether this is a female or male and what age this character will be.

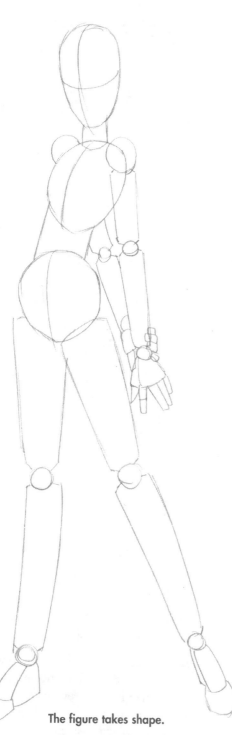

**The figure takes shape.**

waist and mid-section is thin, suggesting this figure will have the curves of the female hourglass. Limbs are thin, as is the neck. And, if nothing else, the body language of this character seems to suggest a female; this character is in a much more feminine stance.

From this cylinder and circle figure, we can now determine the gender of the character—it's a girl! There are no breasts, the chest is slim and oval, and the cylinder between the

**Smoothing out the shape.**

As David rounds out the character from shapes into limbs, it comes into better view as a female, with curved features in the torso and limbs. We also see outlines of breasts, although they are considerably smaller than the round globes of the adult figure we saw previously. That should tip us off that we are dealing with a character who is not fully developed (that is, a teen) and likely someone in her early-to-mid teens.

Fleshing out the character, we can see there is no evidence of muscles on this character. There are some slight lines to represent the curve of the stomach, the knees, and elbows, but little else. The limbs and neck are long and thin, and the limbs are mostly straight, without a tremendous amount of curvature.

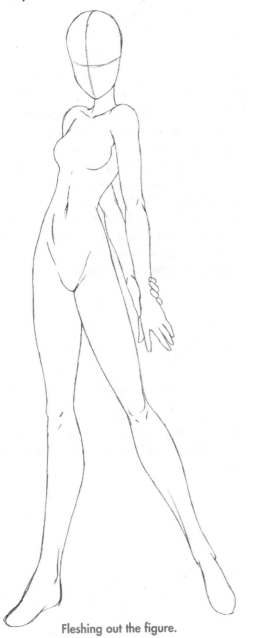

**Fleshing out the figure.**

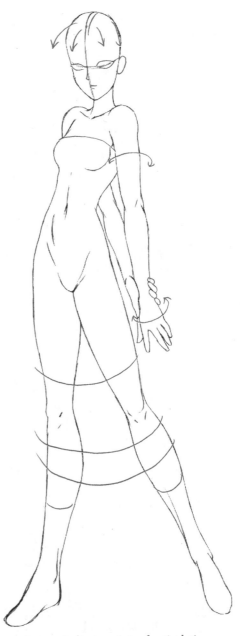

**Arrows indicate points of articulation.**

In the previous figure, David not only lays out the face, but anticipates the hair and the clothing of the character. It seems safe to assume that this character will be wearing a dress, based on the guides David has put on the legs of the figure.

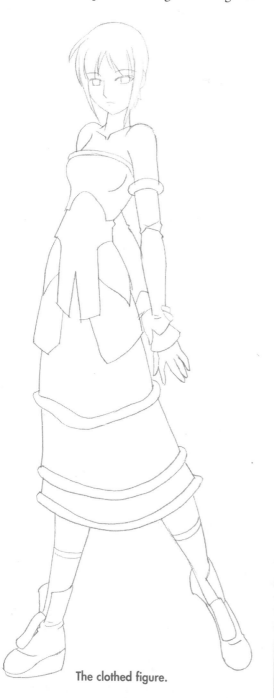

The clothed figure.

The final figure is indeed wearing a dress, and we can see that the guides David drew not only accounted for the skirt, but accessories to the arms and hands as well.

### Sketchbook Savvy

In this nearly finished figure, the character has breasts, but no visible cleavage. Again, David is suggesting that this is a character who is developing, but not fully developed.

David commits the character to ink, adding details as he does, such as some lacy frills to the dress, as well as the matching arm bands.

This is a character who is clearly dressed for an elegant occasion, perhaps for a formal dance or some sort of debutante ball, but her body language suggests she is not entirely comfortable, either with her formal dress or her surroundings. Boots with the frilly dress also suggest a hint of rebellion, a fashion statement that this girl has her own style. Even though she's in a dress, she's not *that* sweet.

Close-up of lace pattern.

Here David goes into detail on how he designs the lacy pattern on the dress, a valuable bit of reference to have when using the character in close-up shots.

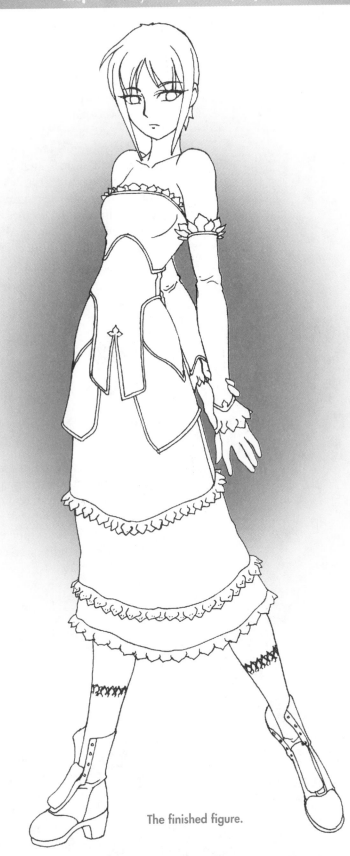

The finished figure.

# The Adult Female

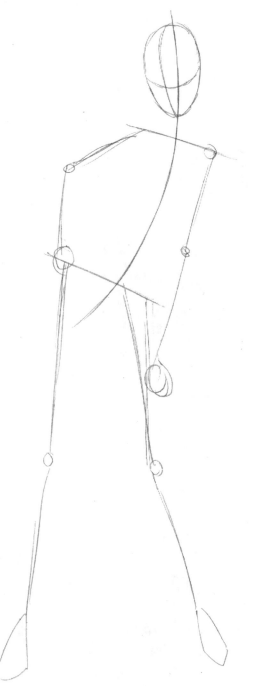

Stick figure of adult female body type.

This figure is for an adult female, and, arguably, a "sexy adult female." Not that we can tell that in this drawing, but the body language of this character is certainly more suggestive and confident than the outline of the teen figure. The way a person stands can show whether the character is shy, confident, fearful, angry, or determined. As you can see, you often can tell a lot about the character just from a stick figure outline—so just think how effective the correct body language can be on a fully rendered figure. We'll explore body language in a little more detail in the next chapter.

As with the latter half of the previous chapter, I am cutting out some of the steps to prevent redundancy.

### Sketchbook Savvy

Never underestimate the power of body language. Body language can effectively tell what your character is thinking, his or her emotions, feelings, and personality.

The next figure has a confident, suggestive aspect to her body language, leaning to accentuate an already curvy body shape, as if the character is trying to be sexy and seductive.

The hourglass is much more pronounced in this figure than in the teen female, and the breasts are much larger and rounder, suggesting this is an adult female—or at the very least a more *worldly* female.

Fleshed out, we can again see there is little to no emphasis on the muscles, beyond some minor definition to the stomach and the joints of the limbs. The legs are much curvier in this female figure than the scrawnier teen figure. Again, this multitude of curves on this figure suggests full physical development of the character.

### Say What?

What is better than wisdom? Woman. And what is better than a good woman? Nothing.
—Geoffrey Chaucer (1340?–1400), English poet

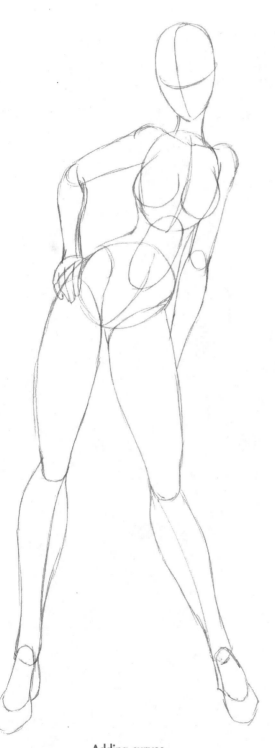

Adding curves.

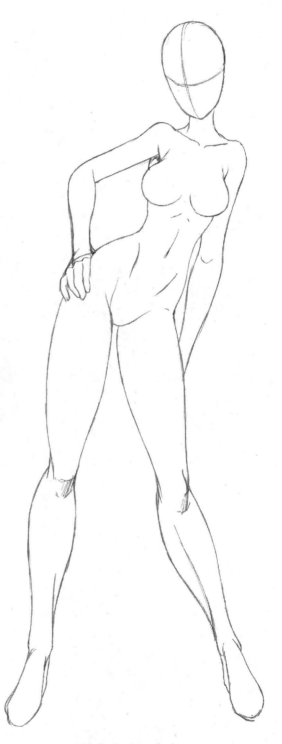

The fleshed-out figure.

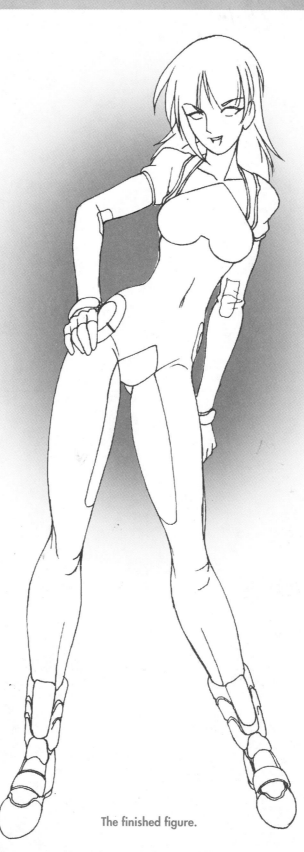

The finished figure.

The finished character, inked and fully rendered. Finally, David has put her in a futurist outfit. It is also a skintight outfit, which accentuates the character's curves and body type. This finished figure exudes not just confidence and sexiness, but also a certain cockiness. This is a character who likely has a chip on her shoulder, who is determined to prove herself as good as her fellow soldiers, pilots, students, or whatever, but who is not above using her feminine wiles to get what she wants.

In short … look out, guys. This one is *trouble!*

# The Female Child

**Stick figure of a girl body type.**

Now we present the female child, which as far as body types is not much different than the male child body type. Again, we start with a larger head and limbs and a torso that is smaller and shorter than the adult or even teen body type.

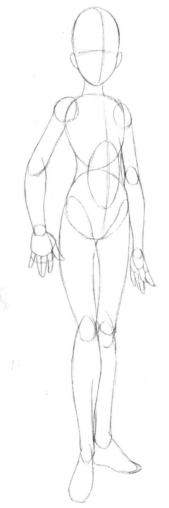

**Sketching the details.**

There is less attention to curves here. The girl child is naturally not going to be developed as an adult or a teen. There are no breasts, and the hourglass aspect to the female figure—curving outward at the chest and the hips and inward at the waist—is not pronounced like it is in older females.

And, probably needless to say, there is no evidence of muscle development, either.

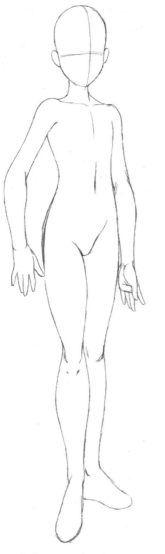

**Fleshing out the shape.**

Fleshed out, there is still very little difference between the male and female child. There is slightly more curvature to the legs, particularly the thighs, but in general the gender of the child is indeterminable based on the body type.

Of course, in the final figure, it's obvious that this is a female child, as this figure has long hair and a frilly dress. This character's outfit does not accentuate any curves, because at this stage in her development there are no curves to accentuate.

## The Least You Need to Know

◆ Female figures have more curves than males, with wider hips, a smaller waist, less-defined muscles, and breasts.

◆ Female arms and legs tend to be curvier as well.

◆ Female characters do not have the definition to muscles that males have. This is most apparent in the abdomen, biceps, and thighs.

◆ Breast size is a good indicator of the age of a character. Teens generally have smaller breasts than adult characters, and children have none at all.

◆ There is very little difference between the body types of male and female children. The differences become apparent as the character's features are rendered.

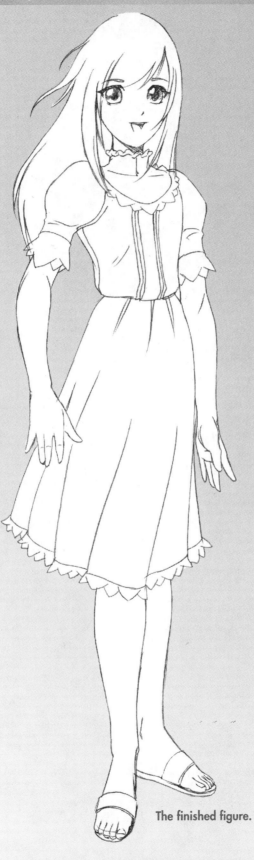

The finished figure.

## In This Chapter

◆ Go with the flow

◆ Exaggerated poses

◆ Awesome action

◆ Reflex and reaction

# Bodies in Motion

We discussed movement in Chapter 2, but we want to return to it in this chapter, as action is such an important and prevalent part of manga.

Unless your manga book consists of characters standing around talking the entire time (and really, who wants to read that?), you're going find many opportunities during the course of your story to spotlight your character in action. Your character may have to run from someone, or chase someone, fight, or perform some astonishing act of physical prowess—and sometimes do all of the above in the span of just a couple of pages. You may be able to draw great characters, but it's just as important to be able to capture them *doing* something.

## Manga to Move You

Face. it, your characters don't actually move in your drawings. They are static black and white lines on a page. These lines work together to form an overall picture of a character in action, but even so, it's still a picture without movement. Your picture is a split-second freeze frame of your character in motion, frozen forever on a page. Your job is to give the illusion of movement, and to do that successfully you need to infuse your drawing with as much energy as possible. Action should be exaggerated, and the characters' poses as extreme as possible (I really hate to use the word "extreme," since it has been co-opted by the advertising industry for a million lamebrain soda and fast food ads, but in this case the term "extreme" is both accurate and appropriate.)

# Sucker Punch

**Spine line.**

As always, it's good to start with a line to represent the center of a character, the way the character is moving ... the character's *flow*. This line corresponds to the character's spine, but it's an oversimplification to say you are *just* drawing the spine. This flow might extend down the legs, up to the arms, or both, depending on the character's pose. Laying down the main line provides the guide for what the overall motion of the character is going to be.

**Lines indicating the shoulders and pelvis.**

The next step is to add lines to indicate the directional flow of the shoulders and pelvis, which, respectively, guide the direction of the arms and legs. Depending on the motion, there will be a difference in the length and angle of this line. This will often be longer if the corresponding limb is extended.

### Say What?

For every action there is an equal and opposite reaction.
—Sir Isaac Newton (1642–1727), 3rd Law of Motion

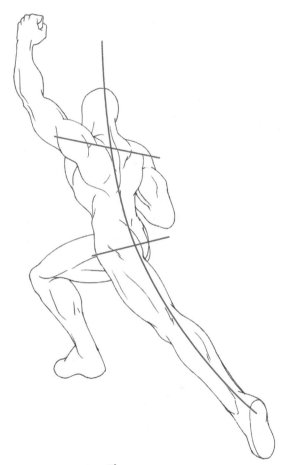

**The uppercut.**

Newton's Law of Motion about everything having an equal and opposite reaction is something to consider in your character's action pose. In the case of this figure throwing an uppercut, we see that while the one leg is extended, the other is bent forward. This is a reaction to the extended leg, helping to balance the character. Similarly, the upper body is turning into the punch, so naturally the arm that is not punching is being pulled back. Action ... reaction.

**Finished figure.**

Each side of the body counterbalances the other and tends to do the opposite of the other. If you had both legs backward, or forward, your character would fall over. If both arms were forward, your character would be punching with much less force.

Here is the figure without the motion guides.

Another aspect of action and reaction to consider is the character on the receiving end of the punch. Likely that character would be wildly off balance, and the rules of one limb counterbalancing the other would not apply.

# Run for Your Life

**This line will show extreme curved motion.**

David provides the motion lines of another figure, and from the extreme curve, we can tell that this is going to be a very exaggerated action pose.

**Lines indicating the shoulders and pelvis.**

The torso takes shape in this picture, as we see the lines denoting the shoulders and pelvis.

This is another exaggerated pose—a character running, extreme speed suggested by how far forward the character's torso is from his extended leg. Note the counterbalance of the limbs. One leg is bent while the other is extended. One arm is forward while the other is back.

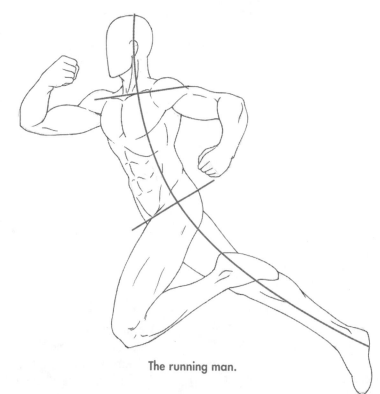

The running man.

Finished figure.

You should also note in this finished figure that not only does one arm counterbalance the other, and the legs too, but one arm will counterbalance its opposite leg. Don't believe me? Put this book down for a second and walk around the room. Notice how your arms will swing naturally, one arm swinging backward as its opposite leg moves forward. This becomes even more pronounced with a character who is moving quickly, something that is captured in this drawing.

### Sketchbook Savvy

The pause button on your DVD, TIVO, or VCR can be very handy when it comes to referencing poses of action shots. Rent some over-the-top action-packed martial arts movie; freeze-frame it during the kicks, leaps, and punches; and try to capture the same pose on paper. Martial arts magazines are another great reference, particularly for fight sequences.

# Leap into Action

Curved motion line.

The long, curved motion line in this figure is curved in the opposite direction of our previous figures. The shoulders and pelvis lines are close together here, suggesting the bend of the back is pronounced. (We're cutting some steps here, as describing a single motion line and a finished figure without a motion line will begin to get redundant.)

In the next figure, you see that this character is taking a leaping punch, one leg extended, the other tucked back. While one arm is extended for the punch, the second arm is back. However, it is balled into a fist, suggesting this figure is about to deliver a second rapid-fire punch with the other arm as soon as the first blow is delivered.

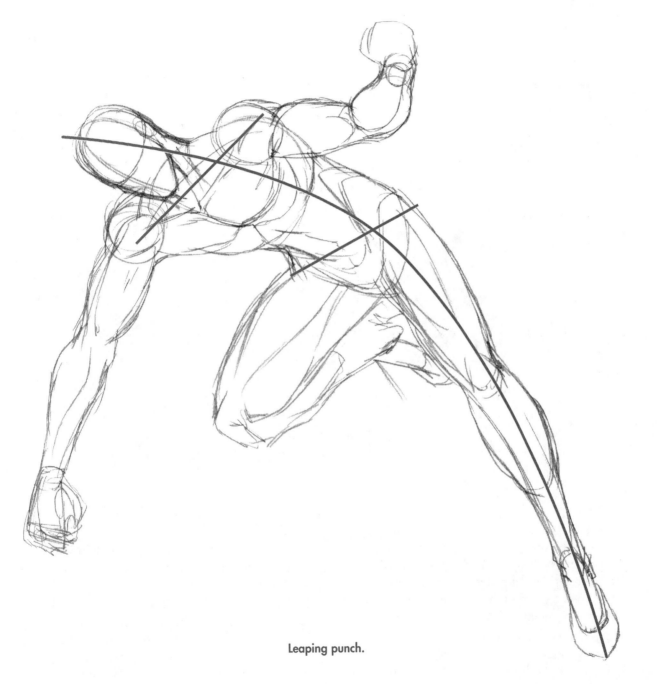

Leaping punch.

# High Kick

Dual motion line.

Here's a different sort of motion line. Actually, it's a dual motion line, as we see a small line to represent the body of the character, a small line to represent the shoulders, and a very long curved line showing the motion flow. Could it be we will be seeing a character with very long legs?

Now that we see the figure, we can tell it is not so much a figure with very long legs as a figure with both legs extended, in a very powerful kick. In the case of this figure, the primary motion line follows the legs, because that is where the flow of movement is coming from.

The arm opposite the kicking leg shows that the character is reacting to, and compensating for, the strength of the kick. Drawing in the arm helps the character keep his balance.

Now it's time to break out your preferred reference source and try to capture various characters in action. Make them run, make them jump, make them punch, make them kick. And, when you have a handle on that, we'll move to the next portion of our book. We can draw bodies now, different figures and body types in action and inaction. But now it's time to give them human faces!

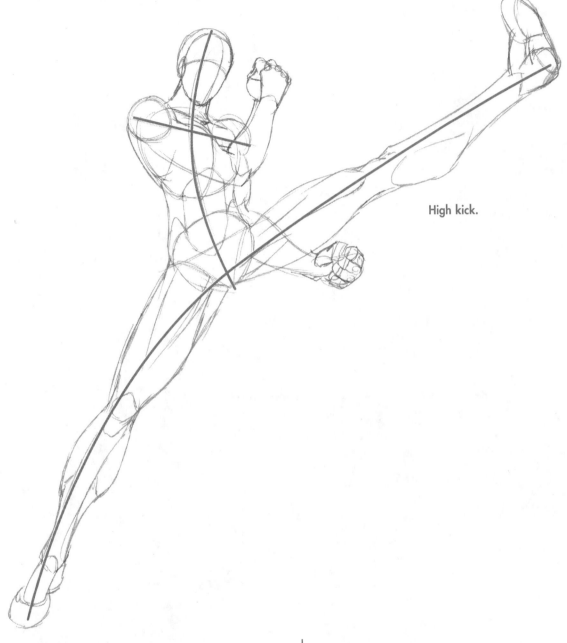

High kick.

## The Least You Need to Know

◆ For action shots, more is better. It's prefer-
able to exaggerate the poses than down-
play them for a more "realistic" effect.

◆ Limbs tend to counterbalance one
another. When one arm moves forward,
the other moves back. Ditto for the legs.

◆ Arms and legs also counterbalance their
opposite counterpart. When a right arm is
forward, a left leg is back.

◆ Newton's Law of Motion is always some-
thing to consider when drawing action: "For
every action there is an equal and opposite
reaction." It's not enough to show your
character hitting; make sure you also show
the effect of what (or who!) is being hit.

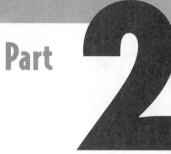

Part **2**

# Making Faces

Now that we've mastered making a figure, it's time to give it a human face. Literally, in this case, as in this part we focus on the part of the human that is the most expressive and emotional: the face. The face is also one of the crucial parts of your art if you want to make a comic in the style of manga. Faces in manga are easily recognizable for their large and expressive eyes; at the same time, other facial features are small or subdued. And manga characters aren't just emotional, but are often emotional to the extreme.

In the following pages we go into detail on every component of the face: eyes, ears, nose, hair, and mouth. We look at where to put them on a face and how this differs on various faces, as well as how to put the features on at different angles. In short, we show you everything you need to know to bring your character alive with emotion.

## In This Chapter

- ◆ The basics of manga faces
- ◆ Female facial proportions
- ◆ Male facial proportions
- ◆ Child facial proportions

**Chapter 6**

# Not Just Another Pretty Face

So, now that you know some fundamentals to building bodies, it's time to bring these characters to life, to give them individuality and personality. And there's no better place to start then getting a handle on that thing that makes you who you are and separates you from everyone else: the human face. You see one every morning in the mirror; now it's just a matter of getting it down on paper.

In, naturally, a manga style …

## Facial Proportions Made Easy

We'll explore differences between faces soon, but first let's discuss some similarities. And since this is *The Complete Idiot's Guide to Drawing Manga*, not *The Complete Idiot's Guide to Drawing Like Picasso*, let's assume we're all working with standard facial features of two eyes, two eyebrows, two ears, a nose, and a mouth, and we want them to correspond to the average human (nonmutant!) face.

For the purposes of manga, the portion of the face comprising the eyes down to the chin will take up only the lower half of the head. A good rule of thumb is to keep an *eye-width* distance between the eyes and a half-eye distance from the sides of the head.

As for a profile shot, the face is still roughly divided in half. The front of the face to the beginning of the ear makes one half, and the ear and back of the head are the other. The eye-width rule-of-thumb is reversed. There is a half-eye width between the eye and bridge of nose, and a full-eye length between the eye and the ear.

How cute or how old you want the character to be will help decide the placement of the nose. For young/cute characters, keep the nose lined up with the lower eyelashes. On the more adult designs, lower (and often lengthen) the nose. The size of the mouth also varies with the gender of the character, as the mouths for females are often much smaller—but more round and full—than the males.

### Manga Meanings

**Eye-width,** as the name implies, is the horizontal length of the eye. It's an informal unit of measure but a good gauge when positioning the eyes in relation to one another, and the face.

# The Female Face

We'll begin with the quintessential manga face: small features except for the eyes, which clearly dominate the face. The face is roughly divided in two, with the forehead and skull area above the eyes comprising the upper half of the face, and the tops of the eyes down to the chin comprising the lower half.

The nose is understated, suggested with a line or shadow, and the features of the mouth are smaller for females than they are for males. The lower lip tends to be more rounded as well, suggesting fuller lips.

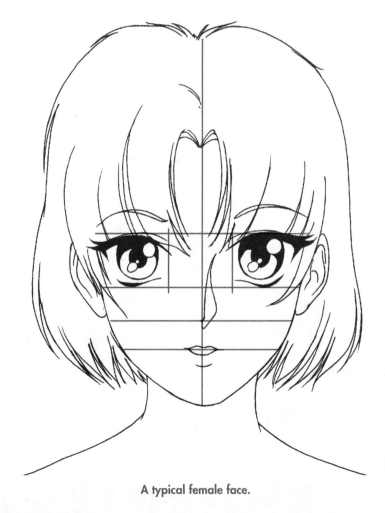

A typical female face.

Also, we should note, these portions and features are not exclusive to female characters. In manga many male characters, often teens, students, or "innocent" characters, are portrayed somewhat androgynously, with more pronounced "female" facial features. How you choose to approach your male might depend on the subject matter of your story, the personality of your character, how you view him, as well as how others characters view him.

In this picture, we get a better sense for the placement of the nose and ears. The top of the ear is roughly aligned with the top of the eyes, and the bottom of the ear is aligned with the tip of the nose. And, of course, where the nose was hardly visible in the straight-on shot, here the slope and shape of the nose is quite distinct.

### Sketchbook Savvy

In a nutshell, men's faces have:

◆ Bigger chins
◆ Thicker necks
◆ Longer noses

Women's faces have:

◆ Bigger eyes
◆ Thicker eyelashes
◆ Smaller, rounder mouths

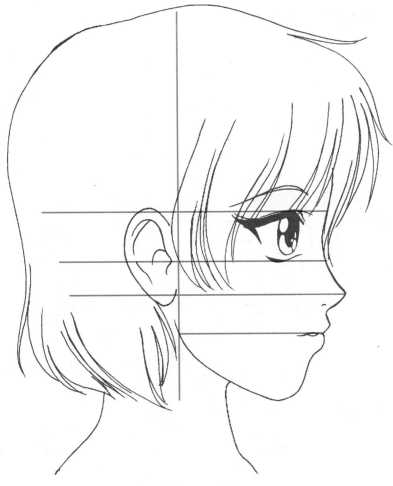

**The female face in profile.**

# The Male Face

We'll discuss eyes in greater detail in the next chapter, but what should be immediately apparent in the drawing of this male character is that his eyes are much smaller than his female counterpart's. This is more of a heroic or mature type of male character, perhaps a prince or a nobleman, a hotshot pilot, an intense young cop, or some gangster rising up through the criminal underworld. The eyes are almost half the height of the previous female face, and the majority of the lower half of the face is taken up by the nose, which is more clearly defined than the nose in our last face.

The ears of this face are higher than the female face; the top of the ears are aligned with the eyebrows; and the bottom of the ears end about mid-way down the length of the nose.

Note, too, certain features emphasize a more masculine face. The neck is thicker, and the chin is wider and flatter. The lips are longer, too, and hence appear to be flatter.

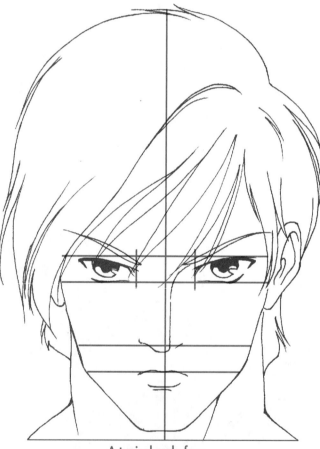

A typical male face.

Here we have the side view of our male character. As in our straight-on face, this profile shows a more serious, worldly character, by just making the eyes smaller and less round, the nose lengthier, and the chin fuller.

And, again, this character has a thicker neck, and where the female profile neck was concave, this neck has a slight outward bulge, suggesting the male Adam's apple.

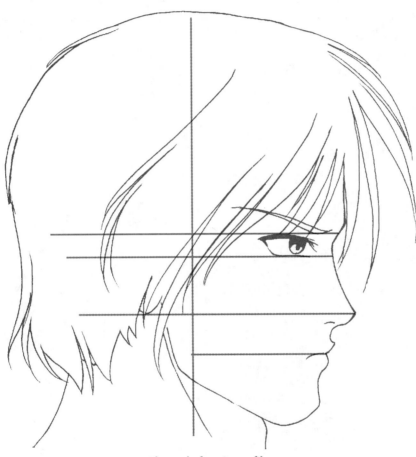

The male face in profile.

# The Child's Face

The straight-on shot of the child's face is almost heart-shaped, as opposed to the more oval shape of the adult face. The top of the skull is larger and wider than the female head. The chin is not only smaller, but there is considerably less length from the nose to the chin.

For younger characters, the tip of the nose is lined up with the lower eyelids. The eyes are significantly larger, too, taller and longer than the adult female's eyes. And the ears, although not significantly larger, are placed lower and angled to stick out.

In this profile view, we get a better sense of the placement of the ears, which tend to be much lower on a child's face. This puts extra emphasis on the enlarged head, as does the nose, which tends to be even smaller and (shorter!) on a youth than it is on the female face.

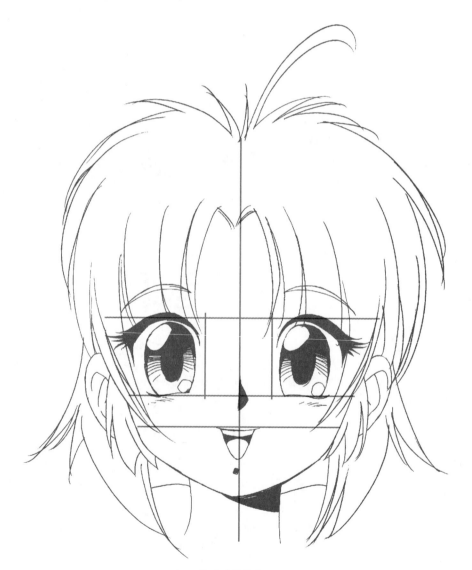

A typical child's face.

### Sketchbook Savvy

Looking for the fountain of youth? For your characters, it might be no more difficult than the placement and size of the ears. The younger your character, the lower the ears tend to be on the head, and the bigger they are, too. The height of the ears can make the exact same face appear to be a young child or an early teen depending on where the ears are placed.

As always, the best way to learn more is to take these lessons and experiment with variations of them. What happens when you put the small "male" eyes on the big-eared, enlarged head of a child? What effect do you get when eyes are placed too close together, or too far apart? Best-case scenario: You discover something really new and cool. Worst case? Well,

then you've got something to line your birdcage with, and you know what *not* to do next time.

## The Least You Need to Know

◆ There are some simple tricks to learning facial proportions, such as bisecting a face into two halves and using eye-width and half-eye width distances to assist in placing the eyes.

◆ A character's gender can be determined based on accentuating different facial features and the placement of these features.

◆ On the other hand, youthful or innocent male characters often take on more stereotypically female facial features.

◆ You can radically alter a character's apparent age based on position or size of facial features.

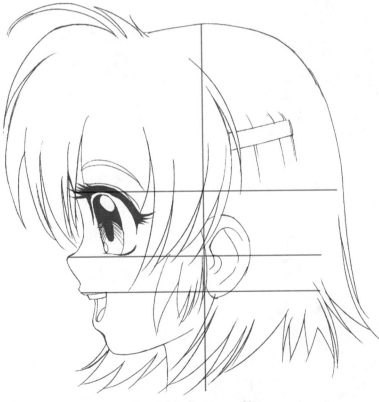

The child's face in profile.

# In This Chapter

- ◆ The importance of eyes in manga
- ◆ The basics of drawing an eye
- ◆ Drawing different types of eyes
- ◆ Putting eyes together at an angle

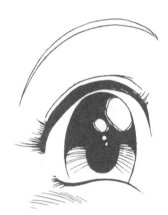

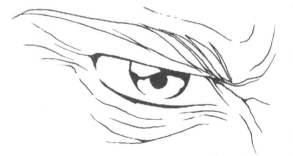

# The Eyes Have It

It's an oversimplification to say that manga is *just* characters with big eyes and feet, but there is no denying that manga characters *do* have big eyes and big feet.

American comic books are, in comparison, usually filled with more realistic-looking characters (although most are muscle-bound specimens of an impossible physical ideal). Manga, in contrast, is a style of wild exaggeration, and nowhere is this more prevalent than in the eyes of its characters.

## Windows to the Soul

Many other features of the manga face are understated. Noses are usually small and often nonexistent. Mouths, too, are small, although to a lesser extent than noses. In manga, the eyes truly are the windows to the soul, a tool to get a better grasp of what your character is thinking or feeling. Body language also speaks volumes, especially when it comes to action, but there is no better door into your character's head than the eyes.

### Say What?

An eye can threaten like a loaded and leveled gun, or it can insult like hissing and kicking; or, in its altered mood, by beams of kindness, it can make the heart dance for joy.

—Ralph Waldo Emerson, *The Conduct of Life*, 1860

# Them Big Baby Blues

By the end of this chapter, you'll see there is no one way to draw eyes, and that learning different types of eyes is one of the best ways to express your characters' personalities and their feelings. Here, though, let's start with a basic primer in what you should stick in your eye. Er … let me rephrase that: Here's a basic primer of what goes into *drawing* a good eye.

**Begin with the basic eye shape.**

The beginning step is probably the most crucial, as you are building the "skeleton" for your character's eye. As we'll show in the next section, getting the eye right is crucial to showing the reader what's going on in the character's head—or heart. For this basic eye, we start with a roughly oval shape, pinched on both ends, the higher end toward the outside of the face, where the eyelashes are longest. On the inside of the face, placed lower, is the character's tear duct.

**Add the lash line.**

Give your eye some instant definition by building up the lashes. Later, we can add individual lashes to help achieve a certain effect, but here we are simply giving the eye some weight and shape. The lash line thickens toward the outside of the face. The largest point of the lash line is where the oval of the eye is pinched on the outside of the face.

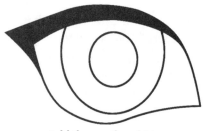

**Add the pupil and iris.**

The next step is to add a circular *iris* and *pupil*. In this basic eye, these are both perfectly round, although often these figures can take a more oval shape to show different emotions. Also, try a larger pupil (the inner circle) to show the character excited or enthralled with whatever he or she is seeing.

### Manga Meanings

The **iris** is the colored portion of the eye, which controls the amount of light that passes through the pupil. The **pupil** is the black circle within the iris, which expands in size when a character gets excited.

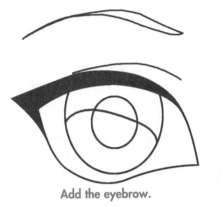

**Add the eyebrow.**

Here we add an eyebrow, comfortably above the eye, growing thicker as it curves toward the center of the face. A thin line above the eye denotes the eyelid, and a shadow from the brow falls across the upper pupil and iris.

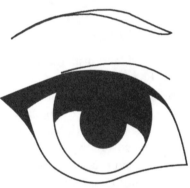

**Fill in iris and shadow.**

When you fill in this shadow, it adds a whole new sense of realism to the eye. Your eyeball is coming to life!

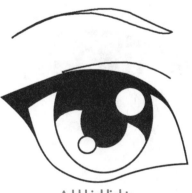

**Add highlights.**

A circle or two to denote highlights—reflections of what the eye is taking in—makes for additional realism. The upper highlight is usually the larger, representing a light source, and additional (smaller and lower) highlights are generally just reflections in the eye, to lend more realism.

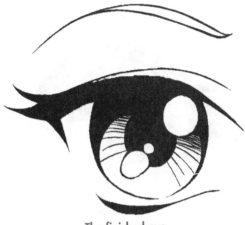

**The finished eye.**

Here is the inked and completed eye, with added flourishes such as eyelashes, secondary highlights, and some detail to the iris. In manga, the eyelashes often are exaggerated, in both the female *and* the male. Sometimes the eyelashes are impossibly long, just like manga eyes and feet.

The vast majority of manga is black and white, but if you do a close-up of your character, you can often differentiate eye color. Blue-eyed characters would have fewer radial lines in the iris, indicating a lighter color, whereas brown-eyed characters have more.

# Exemplary Eyeballs

After you've got the hang of constructing an eye, you can add an amazing variety of expressions to your character with just a few simple modifications. This will make all the difference in the world when it comes to bringing your character to life. Remember, the object is to give

your reader an emotional attachment to the character, and there is no better way of doing that than to give your characters emotions. Make them someone we feel for, someone we can root for, or, in some cases, root against!

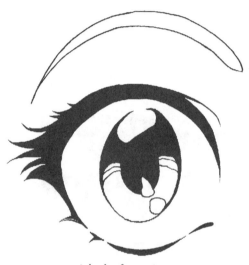

**A look of surprise.**

You can indicate surprise, shock, or wonder by elongating the eye. Stretch out the shape of the eye vertically, while making the pupil and iris more egg-shaped to achieve this effect. Note that the eyebrow is also raised, and the lashes have been extended.

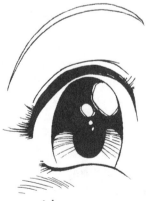

**A happy eye.**

This eye has a happier aspect than the previous eye. The eyebrow is lifted, and the iris and pupil are elongated into an egg-shape, but the lower eyelid curves above the lower eye. This eye shape suggests emotion, unlike the extended face showing gaping shock; the cheeks have been forced up as the result of a smile. On the outside of the face, on the lower outside of the eye, is some shading, indicating that these cheeks are flushed and are blushing with joy.

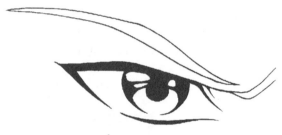

**An angry eye.**

Anger, disgust, and distain can be seen in this image. The angles of this eye, as well as the eyebrow, veer downward sharply toward the middle of the face, to the point where the brow hangs slightly over the eye. Eyelashes, which give the eye a more sympathetic aspect, are minimized, and the area above the nose has some lines to indicate a furrowed brow, adding a severe expression.

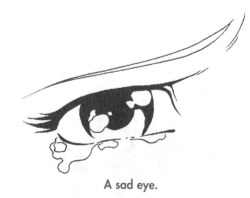

**A sad eye.**

In many ways the polar opposite of the angry eye, the sad eye belongs on the face of the heartbroken or the pathetic. Where the angry eye angles downward, this eye angles upward, the eyebrow following the same trajectory as the eye. Where the angry eye's angles are sharp and severe, this eye is mushy, more organic. Similarly, the highlights are also mushy and loose, suggesting a layer of tears clouding the eye. Here, the eyelashes return, giving the eye a more humanizing, empathetic aspect. Also, the top and bottom of the pupil are obscured by the upper and lower eyelids, suggesting the eyes are fighting to stay opened and struggling against tears.

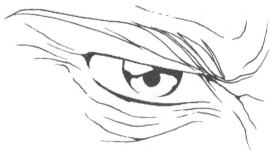

An older character's eye.

Modeled after the angry eye, this eye is given extra dimension with added detail. Bags under the eyes, crow's-feet, and bushy eyebrows can all add character and realism to a face. Often this is done to denote an older character, although bags under the eyes can suggest sleepiness, fatigue, even defeat.

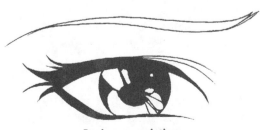

Basic eye variation.

A variation on the basic eye we practiced earlier, this eye is thinner, less oval, and more masculine. Although the basic eye could be used for a female or male, the male with the basic eye is most likely to be a young hero, a schoolboy, or somebody who still has something to learn (you've heard the expression "wide-eyed innocence," right?). This eye, less exaggerated, might be used on a male (or even female) to denote a more mature, worldly frame of mind.

There are, of course, more eye shapes and possibilities, as many as there are in the vast human range of emotions. When you get the hang of these, try experimenting on the variations; make thin eyes thinner, wide eyes wider; try making eyes more exaggerated and then less exaggerated. You'll be surprised what you come up with, and, ultimately, you'll add to your creative arsenal and the emotional range of your characters.

## Advanced Placement

So far, we've just looked at putting faces together from either a front or profile view, and if you just stick to those angles, you're going to be end up creating a pretty boring manga illustration.

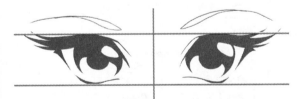

Ideal eye placement for a straight-on shot.

As we discussed in the previous chapter, the ideal placement for eyes for a straight-on shot is an eye-width distance between the eyes and a half-eye distance from the sides of the head. And for the profile shot, reverse it, so there is a half-eye width between the eye and bridge of nose, and a full-eye length between the eye and the ear.

Of course, not every shot is going to be one of these two angles. At least, let's hope not, because part of keeping a reader interested is to keep your story visually interesting, and there is no better way to do that than to mix up your shots and the angles you choose.

So what are some tricks to getting your eyes aligned correctly at an angle? You've certainly noticed that when putting faces together, David has kindly shown us some guides (highlighted in color) to better get a sense of facial proportions and proper placement. Although these guides were helpful in the previous chapter, here they are *crucial*.

### Mangled Manga

Don't draw both eyes on a face exactly the same. Eyes are symmetrical, so draw them as a mirror image of one another, as if the "mirror" runs vertically down the center of the face.

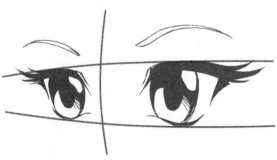

**The angled eye.**

If you need to draw the head at a ¼ *angle*, here is what you should do to distort the eye correctly (or at least give the *illusion* of distortion). The primary difference between this figure and the previous, straight-on shot is the obvious curve to the lines. There are no longer the straight lines on a flat surface that we've seen in our front and profile shots. The human face is round, and placement of eyes on an angled face should reflect that, as should the "eye guides."

The guides curve outward in a standard ¼ angle shot; the horizontal lines denoting the tops and bottoms of the eyes are farther apart the closer they are to us, narrowing as they reach the far side of the face. The vertical line bisecting the face no longer does so in the middle. Instead, it splits them, leaving the horizontal lines longer on the side of the closer eye and shorter on the farther line. The math gets a little trickier here, but there is a ½ to ¼ eye-width from the closest eye to the line signifying the center of the face, and there is little or no distance between the far eye and the center of the face.

So, following these guides, the closer eye will naturally seem larger. The pupil and iris of the farther-away eye are not smaller, but they sure look that way. That's because the eyeball itself is thinner. There is less visible *sclera*. That is, the eye narrows, and we see less of the whites of the eyes. This is a nifty trick to help capture the distortion of the faraway eye on a round face.

### Manga Meanings

The **¼ angle** is a shot in which the person or object is captured at a 45-degree angle (either to the left or right). The **sclera**, quite simply, is the whites of the eyes.

The same principle applies to a downward shot at a ¼ angle, with the eye guide getting narrower as it gets farther away. However, you'll notice that both eye guides curve upward (like a smile!). We're following the curvature of the face. In this case, the upper line is following the curve of the brow.

There is a half-eye width between the closest eye and the center of the face and no distance at all from the farthest eye and center, reinforcing the illusion of distance and the curvature of the face.

view. And, again, you'll notice the farther eye looks smaller, but only because there is less visible sclera. The pupil and iris are still the same size. Now *that's* what I call an optical illusion.

### Sketchbook Savvy

Want a quick-and-easy reference tool to place and position your eyes when drawing a face from an angle? Look no further than your refrigerator. Try drawing eyes—as well as the guides to position eyes—on an egg. Yeah, that's right: an *egg*. That way, you can look at the egg from whatever angle you would like, and that will help you get the hang of how you can capture eyes on a round face from a multitude of angles.

We could end nearly every chapter saying the same thing: practice! It may be redundant, but it's also true. Practice is the best way to improve. Learn from your mistakes, and don't be afraid to experiment. Sometimes it's more work than other times. Practicing eyes, though, should actually be fun, since this really is one of the most critical aspects to bringing your character to life.

## The Least You Need to Know

◆ Eyes are big in manga, literally and figuratively, and play a critical part in effective manga storytelling and characterization.

◆ Being able to draw a basic eye is the foundation of showing a wealth of character emotions and expressions.

◆ A few simple variances in the shape of eyes can radically alter a character's presentation and mood.

◆ Positioning eyes on a face from an angle is more difficult, but some handy tricks using guides can help you get the right perspective.

◆ You've *got* to practice. Don't skimp; I've got my *eye* on you!

**Eyes looking downward.**

**Eyes looking upward.**

In many ways this figure is the opposite of the previous figure, although the same rules apply. In this shot the guide lines curve downward. As we look up, the lower line follows the curves of the cheeks. As before, we still have the lines converging slightly as they recede from

## In This Chapter

- ◆ Mastering other facial components
- ◆ The key to understanding how to draw ears
- ◆ Nose-y shapes and sizes
- ◆ Drawing expressive mouths

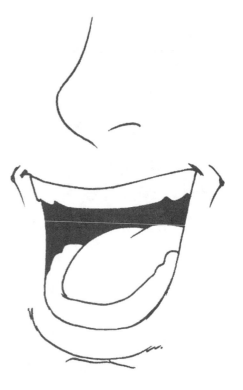

# Chapter 8

# Face Off

We've figured out a face and explored manga's most important—and expressive—part of a face: the eyes. Now it's time to look at the other components of the human face: the ears, the nose, and the mouth.

Of these, noses and ears are the least expressive. That is, beyond ears that flare or flush and noses that crinkle, there's not a lot that these features can *do*. So you really just need to get the nose and ears right once per character (and right from all the angles, naturally). The mouth, of course, is trickier, so we'll tackle that last.

## Now Ear This

This figure is the key to understanding ears. This figure is the ear's skeleton, so to speak. The reversed "C" follows the slope of the cartilage, and the lower object represents the hanging lobe of the ear. Everything inside the "C" is the inner ear.

Of course, there's more to ears than this. But keep this image in your head as you draw your ear, as a helpful starting point to fleshing out the ear. (Of course, this is the ear for the left side of a person's face. For the right ear, you would reverse the image.)

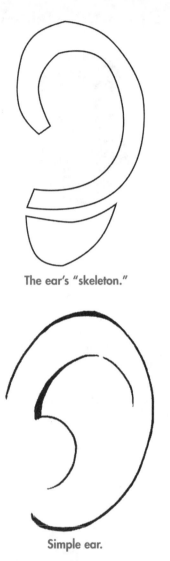

The ear's "skeleton."

Simple ear.

### Manga Meanings

The **pinna,** or auricle, is the visible portion of the ear, and the **tragus** is that little projection of cartilage in front of the inner ear. Hey! Who woulda thought *The Complete Idiot's Guide to Drawing Manga* would double as an anatomy book?!

More realistic ear.

This is the most basic ear, without a lot of detail or extra flourishes. The lines follow the outline of the previous figure, but we see nothing other than the *pinna* and the *tragus*. The simplicity of this figure gives it a more cartoony feel, as does its roundness. Depending on the style of art, we might see this simple ear on a more "cartoony" or simple character, a goofy kid or a comical sidekick, someone the reader is not to completely take seriously.

Here is an ear with a little more detail and, hence, it's a more realistic ear. It is longer and more realistically shaped than the basic ear. There is a second line behind the tragus, and the lobe and lines denoting the inner ear are less perfectly rounded. Although the basic ear had two lines to indicate the inner ear following a clean and simple arc, the lines of the inner ear in this figure do not follow one arc. The lower line veers toward the upper line, giving the ear a sense of depth that does not exist in the simple ear.

Complex ear.

The complex ear takes things even further. The ear is more realistically shaped and less like the perfect circle we saw in the simple ear. The tragus is more realistically shaped, and there are more lines in the inner ear. The ear is quite complex to accurately draw, so the more effort put into capturing its detail, the closer to authentic it appears.

Of course, this isn't anywhere close to appearing like a real ear, but it certainly is in comparison to our simple ear.

### Sketchbook Savvy

Ears giving you trouble? The good news here is you're not going to have to draw them *too* often. Many characters have hair that obscures the ears, and most have hair that obscures the upper half of the ear. Still, you never know when your character might get attacked by a hoard of bald barbarians, so learning how to draw ears, tricky as they might be, can be valuable. Even though ears are considerably less fun to draw than parts of the face such as eyes and mouth, you'll still need to practice.

As we've said, it gets awfully boring to see the same character from the same angle again and again. And you can only draw a profile shot so many times before it starts getting really old.

Front view of ear.

So here is the front view of an ear. It's much more of an oval than the circular side view, and you'll notice it's tilted a bit, as most ears tend to stick out from the head to varying degrees (for the ear on the opposite side of the head, it tilts in the opposite direction).

Lines to denote the inner ear follow roughly the same paths, although you'll notice how the lower inner ear protrudes out just a bit from the line of the outer back ear.

Back view of ear.

Easier than the front view, the back outer ear is basically a tall, wide cone with an inner and outer circle facing outward. With characters' hair, this is not something you will have to capture too often.

The large-nosed lead character is extremely rare, to the point of being practically nonexistent. Instead, you may find a large nose (or even normal-sized nose, which by manga standards *is* large) on certain types of characters, such as villains, lanky sidekicks, wizards, or insensitive ethnic types. Sadly, ethnic stereotypes often exist in manga, particularly older stories. (Or are they just much more obvious to us big-nosed Americans?)

Character ear.

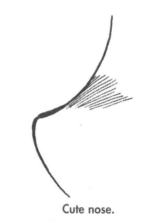

Cute nose.

Just for fun, here's a different sort of ear: a pointing ear you might find on an elf, or Vulcan, or some other sort of sci-fi or fantasy-based humanoid. The lines of the inner ear still follow roughly the same path and intersect the same way, but they follow a much more dynamic angle. The lower line of the inner ear intersects much earlier to the upper line, and the upper line extends farther, which helps make the ear appear longer, bigger, and deeper.

This nose is best for a kid, or a cutesy girl. Slight in size, slightly upturned at the tip, with a few lines above the tip to give the nose some added dimensionality. A small nose like this allows more facial real estate for the eyes and would probably work best on a larger, childlike head (large in proportion to the rest of the body, that is).

Viewed from the front, the actual nose outline would likely disappear altogether, although the lines above the tip of the nose would remain visible.

# Nosing Around

To nose, or not to nose? That is the question, at least when drawing manga characters. Manga characters are often drawn without a nose at all. Other times, the nose is small or implied with a shadow. This isn't to say you don't meet a character with a huge (or even normal-sized) nose here and there, but often these are characters that are intended to be unique or memorable or leave some lasting impression.

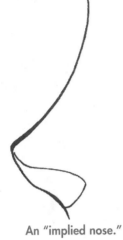

**An "implied nose."**

This is a different type of nose. Elongate the cute nose, and it is not just larger and longer, but its angles give the nose a regal bearing. Put this on a serious businessman, a snooty noblewoman, or some other figure of intelligence, stature, or authority.

Note that the bottom of the nose is implied with a shadow, just a simple line starting at the tip of the nose and curving around to the lower nose, which gives the nose a sense of top and bottom. This shadow could be left white, giving the nose a more artsy, abstract look. Or, you could make it more realistic by filling in the shadow with black ink or a gray tone.

**Basic nose.**

This is a more standard nose. This is probably a male nose, too, since pretty much all girls in manga fall under the "cute" category. In this case, rather than a lower shadow on the nose, David has drawn just a slight line to imply a nostril.

**More elongated nose.**

This is a variation on the standard nose, with the nose elongated. Again, this nose belongs on a more serious face, or a person of stature. This would be appropriate for a sexy teacher, perhaps, or a chief of police or noted scientist.

The shorter nose would be better on a more down-to-earth character, the neighborhood butcher, a sushi chef, a coach, a rumpled policeman, or a boxer-turned-gumshoe.

**Shadow nose.**

On its own, this might not even look like a nose. In many cases, this is the most typical of manga noses—a shadow that implies the nose rather than shows the nose. It's also a good indicator of which direction light is coming from.

This combo nose uses elements of the first two figures in this section. In this case, the light may be coming from above, and the nose is casting a slight shadow. The lines above the tip of the nose still give us the sense that the nose is upturned slightly. Aw … isn't it cute?

**Variation of the shadow nose.**

A variation on the previous figure, this nose appears even more abstract. Longer shadows indicate less light is hitting the right side of the face (the face's right, not *our* right!). Whatever the light source, it is coming from the character's left side.

This nose is longer than the previous nose, a more adult nose than the previous one. It would probably go on the more developed, longer face of an adult, as well.

Note, too, the slight highlight at the top of the nose. In this case, the shadow might be blacked in, while that slight highlight might be left white or darkened with some sort of gray tone.

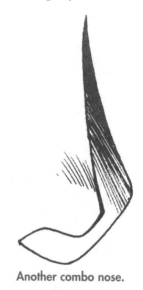

**Another combo nose.**

The super combo uses elements of the first two figures in this section, plus the shadow nose. Not only do we have the lines of the upturned nose, but we have implied shadow underneath and a darker shadow to one side. Since the side shadow is inked to make it progressively darker as it goes up, the lower shadow would probably be most effective with some sort of gray tone.

**Another combo nose with shadow cast over the face.**

Another combo nose, this one has a long shadow cast over the face. This is probably on a face in a dark room, or a room full of shadows, trying to achieve some moody *noir* effect.

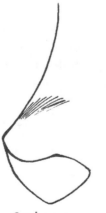

**Combo nose.**

In the case of this picture, our esteemed artist David recommends trying a *graduated* half tone on the shadow, starting from dark (at the nose) and changing slowly to a lighter tone (away from the nose).

### Manga Meanings

A **graduated** tone is when a color starts as one color and slowly transforms into another color (light to dark, black to white, and all gray shades in between—at least in the case of black and white manga). **Noir** is a genre of crime literature and film featuring tough-talking and cynical characters, bleak settings, and generous use of shadows. Please note: Most film terms can also be applied to comics.

**The non-nose.**

This nose, or absence of nose, generally belongs on an elderly person. It is typically above a mouth that sits low on the face, and the long nostrils are indicative of a face that has sagged somewhat due to gravity and age. The lines above the nose are spread out a little more, implying wrinkles as much as the shape of a nose.

# Mouthing Off

We've saved the most interesting component of the face for last. The mouth, like the eyes, can express a multitude of emotions and can change with just the slightest or most subtle line adjustment. In tandem with the eyes, the emotional range of your characters can be almost limitless.

But we're getting ahead of ourselves. For now, we'll just concentrate on making manga mouths that emote!

### Mangled Manga

Don't worry about matching word balloons to the speaker's mouth. A character can be "speaking" even if he or she has a closed mouth, gritted teeth, or a big smile. There is an understood suspension of disbelief here on the reader's behalf, and it is more important to convey your character's expression than it is to portray a character's mouth completely realistically.

**Frontal view of a pair of lips.**

These are female lips, as the less-full male lips are usually not drawn in any detail. The top upper lip and bottom upper lip are basically wide M-shapes, and the lower lip is a large half-oval. The upper lip is roughly one third the entire lip, and the lower lip takes up the remaining two thirds.

**Angled lips.**

Less clearly delineated than the previous shot, these lips belong on a three-quarter view face. The upper lip is a more curvy M-shape, and the bottom of the lip is a single smooth curve. This lower bottom lip is more of an elongated V-shape. Note the slight curve to the far side of the upper lip, giving the upper lip some extra definition. The sides of the mouth are a bit thicker, too, as the lips come together.

**Slight smile.**

This figure of a slight smile shows you how easy it is to convey an emotion with little more than a single line. It is simply an upward arc, with a small tilted line to each side of the "mouth" and a little dimpled circle to show the bottom of the lower lip. Still, it gets the point across, doesn't it?

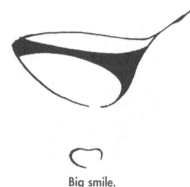

**Big smile.**

Try smiling in a mirror, and you'll see that it's not exactly natural to smile and have just your upper row of teeth and tongue visible. Still, nobody said manga was 100-percent accurate, and in many smiles, at least smiles where the teeth aren't clenched together, the lower row of teeth is not visible—but the tongue is.

Please note: This is a three-quarter view of a smile, which is the reason the line of the upper mouth trails off to the right.

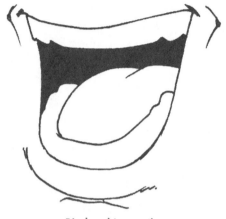

**Big laughing smile.**

For the big laugh we get both upper and lower teeth, as well as a much better look at the tongue. There is some definition to the shape of the teeth, some bumps to indicate canines up top, and molars in the lower back of the mouth. We also see dimples in the upper corners of the mouth and a line to emphasize the lower lip and chin, being forced together as a result of the wide-open mouth.

**Downward facing smile.**

The sad face is a downward facing smile. Some lines to each side of the face serve to emphasize the downward arc of the mouth, and a shadow falls below the unseen lower lip, the result of the lip's pronounced pout.

**Angry expression.**

An angry expression such as this generally appears on one side of the mouth. The mouth curves upward from a point in the front of the mouth, and the teeth are gritted together in an expression of rage. Not only that, but the teeth are realistically shaped, to the point where we even see part of the gum line. The lower back lip is also emphasized, and the mouth is open and straining with such rage it appears to be pushing the lip back.

**Exclamation of joy.**

An exclamation of joy, wonder, or surprise is largely different from the big smile in that the mouth is open wider, and there are no visible teeth. An absence of teeth makes a character appear younger, and joy and wonder are emotions often most associated with childhood.

Of course it's not a big leap from an exclamation of joy to a smile, which is why these expressions are so similar.

# Put Your Best Face Forward

We've now got almost all the pieces we need to make faces. As you practice them, as usual, play around with what you've seen and try to come up with things that are new and different. How big can ears be before they are *too* big? What's the effect of a big nose on a child's face? How many different ways can you make a smile—or a grimace?

We've got one last stop before putting it all together. Our next chapter promises to be head and shoulders above the others!

## The Least You Need to Know

◆ The nose and ears are the least expressive components of the face. Unlike the mouth and eyes, they do not change based on a character's mood.

◆ Noses are often minimized in manga, or completely ignored, to make more room for manga's large and expressive eyes.

◆ Ears can be tricky to draw but, fortunately, are often obscured by a character's hairstyle.

◆ Like the eyes, a well-drawn mouth is an effective tool to convey what your character is thinking or feeling.

## In This Chapter

- ◆ Hairdos for your characters
- ◆ Male cuts
- ◆ Female styles
- ◆ Making hair colors and highlights

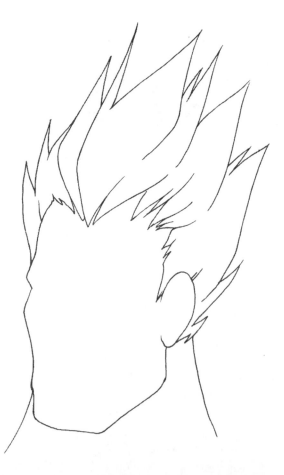

# Chapter 9

# Hair Today

We've looked at the individual parts of a face and how certain parts of the face are used to show a character's emotions. Hair is a different sort of feature. It doesn't actively express emotion (unless you count hair of a frightened character standing up on end). But just as in real life, the hairstyle choice of a character can tell you a lot about that person, their circumstances, and their personalities.

Particularly in younger manga characters, the youthful protagonists who comprise most of manga's starring roles, hairstyle can suggest an attitude. Sometimes that attitude is rebellious; sometimes it's sexy; sometimes it's nerdy; and sometimes it's shy. An out-of-style haircut might suggest your character is old-fashioned or behind the times.

## Some Male Styles

As in real life, there is less variety in male haircuts. Male hair styles tend to be shorter, except in period pieces, where there is more attention paid to male locks and tresses. Of course, there are always exceptions, just as there are on any given street of any given city. But, in general, male hair tends to be shorter, and female hair is, if not longer, portrayed in a wider variety of styles.

**Manga Meanings**

Androgynous characters are those whose mannerisms and appearance deliberately blur the line between male and female. Is that is a guy or a girl? Good question!

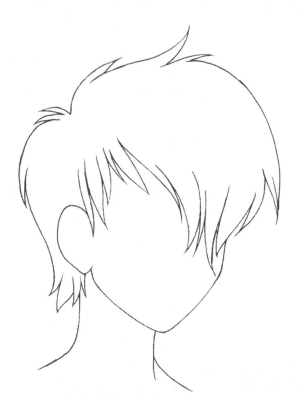

Typical hairstyle of a young male.

This hairstyle is like that of a young male, possibly a shy student or a reluctant hero. The hair hanging over the eyes suggests this might be a character who is naïve, who might not see the world as completely as he should, or who still has much to learn about something.

The hair comes to various curved points, and the amount of individual locks gives the hair a scruffy, unkempt appearance—that of a young boy who either doesn't know better, or care enough, to attend to his appearance.

On the other hand, this could just as easily pass as a girl's haircut. *Androgynous* characters are popular story devices in manga. Often girl characters are mistaken for boys or try passing themselves off as boys. This haircut could work perfectly for a tomboy girl trying to secretly get by in a man's world.

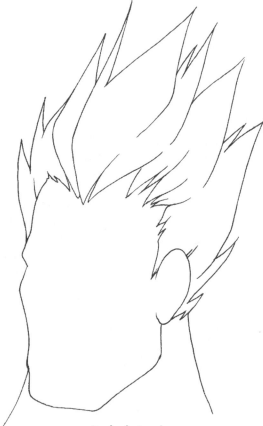

Punky hairstyle.

This haircut, curving upward in sharper angles and standing in tall, spiky points, suggests a more rebellious personality. This is the haircut of the apocalyptic antihero, the streetwise tough, or the too-hip jerk. Unlike the previous haircut, this character is very attuned to fashion, or at least to presenting himself as cooler-than-thou.

We'll talk about hair color in a few pages, but this is a hairstyle that would not be out of place with some multicolored streaks in it.

# Some Female Styles

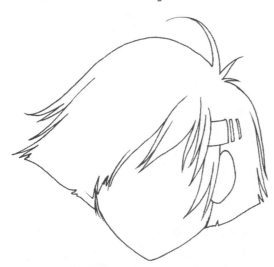

**Spunky hairstyle that suggests a young character.**

Short and angled in the back, hair in the face but not obscuring it, parted to flop over on one side and only reveal a single ear, this is the haircut of a spunky character. The spunky protagonist, a spirited best friend in school, maybe the cute girl with the crush on the hero whom the hero continually takes for granted or overlooks.

### Say What?

Hair style is the final tip-off whether or not a woman really knows herself.

—Hubert de Givenchy, *Vogue* magazine, July 1985

The hair clip contributes to the "cute factor," and the out-of-place hairs on the side and top of the head suggest this is a "real girl," not some unattainable feminine ideal.

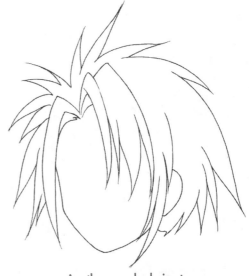

**Another spunky haircut.**

Here's another spunky haircut, but this one has more of a punky feel as well. Although the hair still meets in curved points, the angles are generally sharper, which gives the character a sense of a more edgy personality. This haircut belongs to the detached older sister, the goth gal, or the leather-jacket multipierced girl-friend of some street or *Yakuza* hooligan.

However, you could put this style on the face of a male child's head, and the style stays punky, but has a more feral aspect. For a young male, this is the haircut of some out-of-control wild child.

And, again, keeping with this haircut's punk sensibilities, this would be a hairstyle perfectly suited to multicolored (or multi-shaded) streaks and stripes.

### Manga Meanings

The **Yakuza** is the Japanese criminal underworld, Japan's mafia or Cosa Nostra.

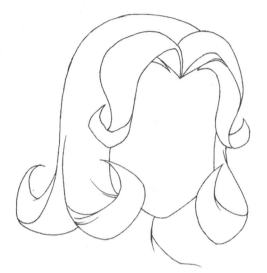

Feminine, "good girl" hairstyle.

This is the haircut of a good girl, rich girl, pampered girlfriend, spoiled rich girl, unattainable cheerleader, or some other variation on the campus hot chick. The gentle curving and curved hair implies a softness and femininity to this character.

In the next drawing, the hair is pulled back tightly and its long tresses are interlocked and overlapping in a braid.

Although this probably initially leaps to mind as the hairstyle of some uptight or serious schoolgirl, librarian, or female scientist, it could very well double as not just a female martial artist, but a *male* one as well. It could easily be the haircut of some young monk. Remove the hair hanging in the face, and it becomes the disciplined haircut of an older and more mature monk or male martial artist.

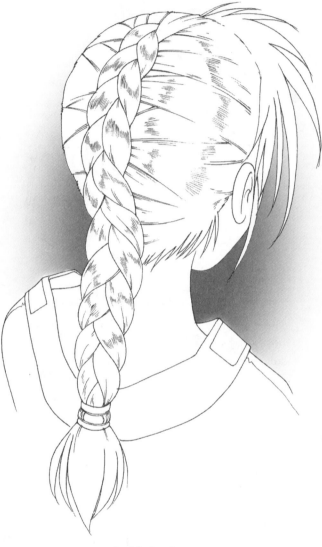

Braided style.

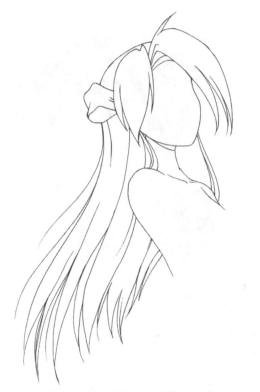

**Quintessential "cute girl" hairstyle.**

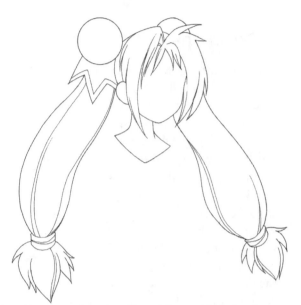

**Fantasy-oriented version of "cute girl" hairstyle.**

Long flowing hair, a bow, and hair parted in the front and hanging slightly over the eyes are fundamental aspects to this very popular girls' manga hairstyle. This is almost the quintessential "cute girl" cut, and since many if not most of the girls in manga fit in the cute category, you are likely to see it again and again. This cut is particularly well suited to stories with schoolgirl protagonists, or Shojo manga ("girl's comics") stories.

The next style is a more fantasy-oriented version of the cute-girl cut, one that you might find in a futuristic, sci-fi, or fantasy setting like Final Fantasy or Sailor Moon. This particular hairstyle is gravity defying, and utterly unrealistic, but also unmistakable and unique and cool. Most comics involve some sort of suspension of disbelief, and many of the far-out and fantastic manga comics involve a *lot* of suspension of disbelief. You could do worse than design a character who is instantly and immediately recognizable and unique … even if that person's appearance is not 100-percent believable.

# Coloring Hair in a Black-and-White World

In the previous drawings David left the hair purposefully blank, so there would be no mistaking the line work. However, when you are creating a graphic novel full of a multitude of characters, you're going to have to figure out some tricks to make the characters quickly and easily recognizable from one another. Although it's true that the vast majority of Japanese people have black hair and brown eyes, in manga there is a wider variety of colors, particularly in the hair, which makes it easier to tell the difference between characters.

Of course, the manga we are talking about is in black and white, so when I say colors, I mean I am *implying* colors, by using different tones to represent different colors. Rather than drawing everybody with black hair, some characters have a gray tone instead of black; some are darker gray; and some are lighter gray. And some, like the drawings we saw of different hairstyles, are simply uncolored. Manga readers readily accept a radical simplification of certain images, and this includes changes to the color of the hair from what is "realistic."

# Setting the Tone

Tones are most easily achieved by scanning penciled and inked artwork into a computer and coloring it using Adobe Photoshop. Photoshop is a photo manipulation program, but it's also been embraced by comic book artists as the foremost means to color comics.

For those who don't have the money to invest in a scanner, a computer, and expensive software, there is the more old-fashioned way of applying the tone directly to the artwork, usually using sticky "tape" of gray dots and cutting it and placing it on the art to archive the desired affect. These tones are called "Zip-A-Tone" or Zip-Tone.

### Sketchbook Savvy

A scanner, a computer, and Photoshop are the tools you will need to add tones *digitally* to your art. If adding tones by hand, buy an adhesive mechanical tone from your local art supply store. There are many manufacturers of mechanical tones, but like Kleenex, Vaseline, or Xerox, mechanical tones are most commonly referred to as Zip-A-Tone or Zip-Tone, named after the company most associated with selling the tones.

Of course, another option is to *not* use tones. Many manga books are simply pencil and ink, black and white with no grays or anything else in between.

The next figure's hair has been rendered simply in ink, and so the figure is black and white with nothing in between. The advantage to this style is it is faster. The disadvantage is that you lose much of the detail of the hairstyle, as well as a sense of individual hair.

In the next figure, David has gone in with some White-Out or white ink, and added a few white lines to give the hair a bit more personality and definition.

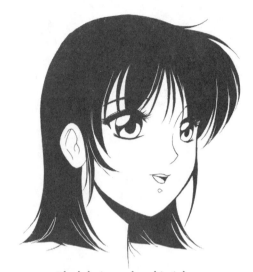

Black hair rendered in ink.

### Sketchbook Savvy

Yes, there is such a thing as white ink. And it's available in the same art supply store that carries black ink and in the same section, too. Make sure that you pick some up along with your other art supplies: it's invaluable for adding highlights.

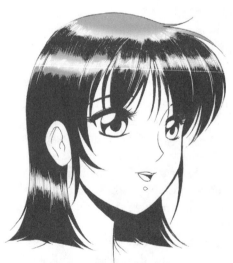

Highlights added to black hair.

This is the same figure as previously, but with highlights added. Obviously, it's more work than just flat gray, but it gives your character a vibrancy you don't see with just flat black. Ultimately, whether to add these kinds of highlights is a stylistic decision, and it's up to you to decide the look you want your book to have.

Keep in mind that full-color books are much more costly to produce than black and white. However, there is no difference in production costs between a book that is just black and white and a book that is black and white with all manner of gray tones as well. Colored books are filmed on four plates per page, each one representing either black, red, yellow, or cyan, which raises production costs. Black and white books are just filmed on a single plate, and grays, being just lighter ink percentages of black, are also captured on the black plate. So if it doesn't cost anything more to make your book, but adds pizzazz, why *not* add some gray tones?

Anyway, in the case of this drawing, David added a graduated tone in Photoshop. You'll notice the gray at the top of the girl's hair gets progressively lighter. After that, David made white lines over the gray (also in Photoshop) to achieve an even more pronounced highlight effect.

However, it would not be difficult to achieve the same effect by hand, rather than by computer. When inking the figure, leave the area black to which you are choosing to add a tone. You could then lay down gray Zip-A-Tone (or even gray watercolor, or pen, if you prefer). Then, over the gray you've just added, go over it with White-Out or white ink. *Voilà!*

"Haloing" highlights.

There's a different sort of highlight on this head. A graduated gray tone is added first, followed by some thin lines of white outlining, or haloing, the hairs between the gray and black of the hair. This has the result of separating the hair a little more, and perhaps this is the result of an overhead light or hair that is lighter on the top and darker at the bottom. A bad dye job, maybe?

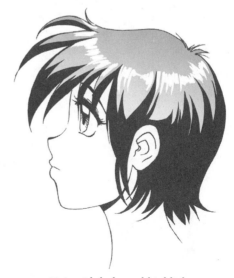

Hair with halo and highlights.

The second figure uses the same highlight effect from the first highlighted figure but the white highlight lines are wider, giving the impression that this hair is thicker and coarser than the hair in the first figure.

**Graduated shades of gray.**

**A single tone, no highlights.**

Like the earlier figure, this is an example of a single tone being used to color hair. Only, instead of that color being black, it's a gray tone. This allows us to see more detail in the character's hairstyle.

Does this mean that this character's hair is brown instead of black? Not necessarily. Again, there is an inherent suspension of disbelief among Japanese manga readers, who realize all characters likely have the same color hair, but also recognize a need to differentiate between characters.

For those of you who don't quite get the meaning of a graduated tone, here is the same picture. Only this time the tone is graduated, going from one shade of gray to one much lighter. Like highlights, this is a stylistic choice. But you might think, as I do, that the variance in tone makes the picture subtly more lively and interesting.

In the next figure, we've added white highlights. If you don't have a computer or the time or capability to make graduated tones, some highlights with white ink is a great way to add some dimension and make your character's hair a bit more dynamic.

The final version has a graduated tone *and* white highlights. Compare it to the others and decide what you like best. No one way is better than the other, just approaches that are different. Experiment to find which style best fits you.

You might also experiment with the hairstyles featured in the first half of this chapter, trying them with different colors, filling them in totally black, or adding highlights, tones, graduated tones, or combinations of all three.

## The Least You Need to Know

◆ Hairstyles can convey your character's personality and personality type.

◆ Many hairstyles are not for any one specific gender; what works on one female personality type might work just as well on a male, and say something completely different about his personality.

◆ Tones and highlights can be added to differentiate characters and make characters more visually interesting.

◆ Lighter-toned hair does not necessarily mean the character has light-colored hair. Manga readers are used to a certain suspension of disbelief when it comes to hair "color."

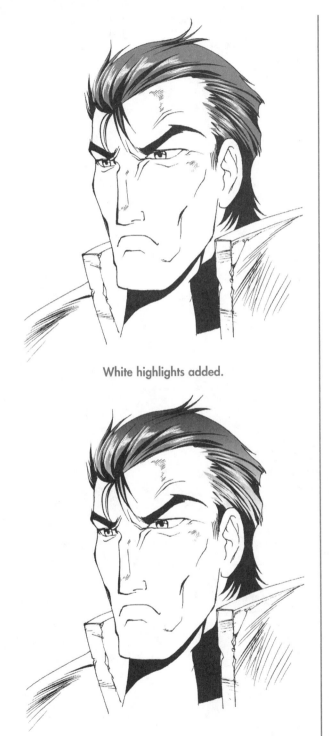

White highlights added.

Graduated shades of gray and white highlights.

## In This Chapter

◆ Conveying emotions through facial expressions

◆ Happy faces …

◆ Sad faces …

◆ Mad faces …

◆ … and more!

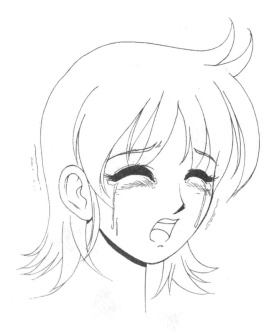

# Chapter 10

# Express Yourself

In previous chapters we've looked at individual components of a face, where to put them on the face, and their proper proportions. We've explored ways to make an emotional expression with just a mouth, or a single eye. But now it's time to be Dr. Frankenstein—playing with a Mister Potatohead—cobbling all these different elements together into a single coherent face. Not only that, we're going to explore various ways to bring your faces to life, to make the people into emotional—and *emoting*—beings.

A picture really is worth a thousand words, and nowhere is this more true than comics. Comics may be a marriage of words and pictures, but it is infinitely more important to *show* than to tell. Your character can talk about how happy he or she is, but if you want to make the reader feel it, make your character show their happiness. You'll go a long way toward getting your reader emotionally involved in your story. And remember, that's ultimately the bottom line in any comic, in any manga, and in any story. Keep the readers wanting more, and keep them turning the page to find out what's going to happen next.

# Making Faces

The comic book artist has it tough, tougher than anyone ever gives him or her credit for. In movie terms, not only is the comic artist the director and the cinematographer, but it's also up to the artist to make the characters in their stories "act." Your comic book characters need to persuasively and believably convey their emotions and feelings.

Always keep in mind that manga specializes in exaggeration. In our actors, we're not looking for a Meryl Streep-like performance of subtlety and nuance. Manga characters almost always wear their hearts on their sleeves. If anything, as actors, they are the scenery chewers, the consummate hams.

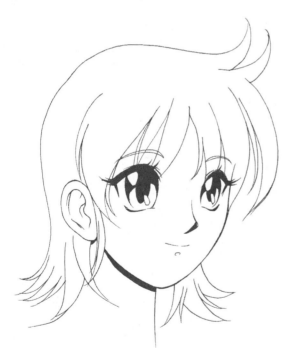

An expressionless face.

We'll begin, though, with a "control face." *Tabula rasa*. The blank canvas of a face doesn't convey any particular emotion, so we can compare against it as we crank up the dramatic tension.

In this case, we have the face of a quintessential sort of manga girl—large eyes and small nose. Her chin is thin, and ears are low on the face, indicating that this is a young adult. Her eyes are wide open; her mouth is slight and slightly upturned.

This is a perfectly adequate manga face. And yet, we have no idea what's going on in this character's head.

Let's see what happens when she finds a twenty-dollar bill on the ground.

### Say What?

When dealing with people remember you are not dealing with creatures of logic, but with creatures of emotion, creatures bristling with prejudice, and motivated by pride and vanity.

—Dale Carnegie, *How to Win Friends and Influence People*

# Get Happy

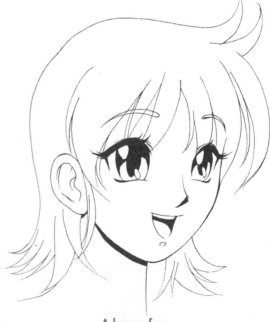

A happy face.

As discussed earlier, most emotion in the human face, but especially in manga, can be conveyed in the eyes and mouth of the character (perhaps this is the reason noses play such a small role in manga). This should be amply evident in this face, and the others that follow, as its eyes, mouth, and eyebrows vary with each given emotion.

Most of the changes between the normal face and this happy face can be seen in the mouth and eyebrows. The mouth is the more obvious of the two. Although there is no discernable difference in the chin, the mouth is open, and thereby occupies more of the lower face. The upper lip curves upward, and the lower lip has the same curve but is far more pronounced.

Between this face and the expressionless face, the eyebrows are different, but subtly so. They maintain the same shape and curvature but are slightly higher on the face, farther up the forehead and away from the eye.

Okay, so what does this girl look like when she finds a briefcase full of hundred-dollar bills on the ground?

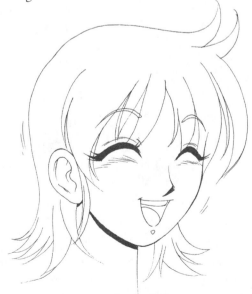

A very happy face.

Note the differences between this *very* happy face and the previous happy face. The primary difference this time is the eyes, which are squeezed shut (with joy!) and follow the same curve as the eyebrows. A few lines were added to suggest the upper eyelid, while some lines below the eyes follow the slight arc of raised cheeks, suggesting flushed cheeks.

A small but key difference can be found in the mouth. It's probably no secret that the bigger the smile, the happier the character. However, in this case, the mouth is not significantly larger than the mouth in the previous panel. But David's decision not to ink the interior of the mouth reduces the amount of negative space and is a cool optical illusion to make the mouth seem wider open than it is.

And finally, note the slight lines on both sides of the head. These suggest movement. This is a person who can't contain herself, who is too happy to stay still, who is convulsing with laughter, or about to burst with joy.

But the joy will be short-lived, as our heroine discovers the battery in her car is dead.

### Mangled Manga

Don't sell your eyebrows short! Although the eyes and mouth get most of the credit for doing the emotional heavy lifting, the tilt and curve of an eyebrow can speak volumes. In general, with a positive emotion such as happiness or surprise, the eyebrow is raised on the face and retains its natural curve. For negative emotions, worry, anger, or sadness, the eyebrow is positioned closer to the eye, and goes against the curve of the upper eye. Don't believe me? Go practice thinking happy thoughts and then sad thoughts in front of a mirror and see how your eyebrows react.

# Tears and Tragedy

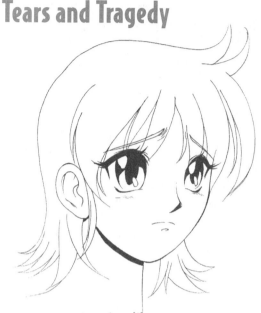

A sad face.

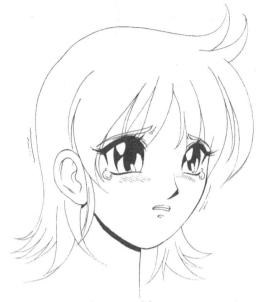

A very sad face.

Turn that smile upside down, as the saying goes, to capture a sad face. The curved mouth of this face has literally been turned over from the control face. And note this mouth is not one continuous line, but two small ones, following the same arc. This suggests a bit of a pout.

In this drawing the eyes have not significantly changed shape or size from the control face. The eyebrows, however, are straight, heading upward toward the middle of the face, where we see some slight lines to indicate a furrowed brow. We also see some lines below the face. As in the very happy face, the cheeks are slightly pinched up, although in this case, this suggests the eyes are struggling to stay open, and that tears may be on the horizon.

Those tears are pretty close on the horizon, too, as soon as our emotional guinea pig discovers somebody ran over her dog!

Everything is taken just a bit further in this drawing than it was in the last. The mouth retains its same shape, but is open, and with just a simple line through the horizontal center of the mouth we can see the mouth might be open, but the jaw is shut.

The eyes are smaller in this drawing, as the lower eyelid raises. The eyes are being forced smaller by the cheeks, which are pinched up even further, and the lines of the upper cheeks are more pronounced to convey the increased emotional intensity.

Note that the eyebrows are even closer to the upper eyes, although they keep the same angle and shape as they did in our previous sad face. The capper, of course, are the tears welling to each outer side of her eyes—some mushy circles with slight highlights indicating gathering and inevitable tears.

And as with the very happy face, some motion lines are added. In this case, it suggests unsteadiness.

Boy, our poor girl here sure loved that dog. How's she gonna take it when she learns she's been fired from her job and has just got an eviction notice?

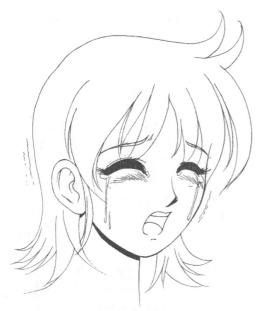

A miserable face.

Cue the miserable face, which shares many similarities to the very happy face, but some key differences as well. As with the very happy face, the eyebrows suddenly seem higher, but only because the eyes are now closed and, therefore, take up less room on the face. But these closed eyes are looser than the very happy face, their inner ends splitting into a couple of messy points rather than one smooth point, and the shape of the closed eye is less smooth and precise (crying is a messy business, after all!).

Those tears we saw welling in the eyes last picture are now streaming down the cheeks in unsteady lines. The flushed upper cheeks from the last picture have moved even higher, and are now puffy, inflamed lower eyelids.

The mouth is more of an elongated, open-mouthed frown, although we can see a curve on the upper lip (to indicate a quavering upper lip). Again, David has declined to fill in the blacks of this mouth. More open space equals bigger mouth, which equals louder crying!

The motion lines are even more unsteady and raggedy, echoing this poor girl's emotional turmoil.

### Sketchbook Savvy

Say it with symbols. You don't have to be completely realistic in manga. You can complement, and thus enhance, a character's mood with just a couple of small—and not completely realistic—artistic flourishes.

Sweat beads are good with the following:

◆ Nervousness
◆ Anger
◆ Agitation

Motion lines are good with the following:

◆ Laughter
◆ Rage
◆ Despair

# Mad Manga

We continue to put our girl through the emotional wringer. All cried out, she remembers her landlord is paid up on the rent and can't evict her. Thinking about that jerk really gets her angry. And so, we present the mad face.

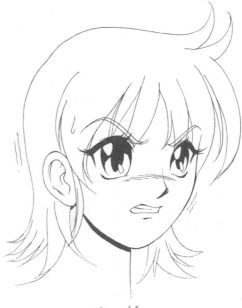

A mad face.

The eyes are wide open again, and roughly the same size and shape as the normal expression, the happy expression, even the sad. However, her eyebrows are descending furiously (no pun intended) toward the brow, arcing downward and converging upon it.

The upper lip of the mouth is almost an elongated "M" shape; the middle upper lip curves downward as the mid points curve upward like a snarl. The lower lip is flat, and the teeth within are more pronounced with slight bumps representing the teeth. Where a single line in the sad face showed as teeth that were together, these teeth are gritting, possibly even gnashing.

Above the mouth, curving over the nose, is a different sort of flushed face. These lines indicate a face flushed with rage, and this is subtly reinforced by the overall arc of the lines, which curve downward like a frown.

We don't just get motion lines in this picture, but also a bead of sweat. This girl is steaming mad!

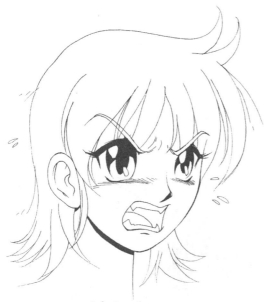

A furious face.

And thinking about what a jerk her boss is gets her madder and gives us the face of pure fury. This is a stay-out-of-my-way-or-get-socked-in-the-nose face.

In this drawing the eyebrows even more dramatically descend upon the brow slightly, even hanging over the inner eyes. The lines indicating the curve of the furrow are more pronounced and dramatic as well.

The lines of the cheeks have moved above the eyes again and are tighter together, making them darker, which is a nifty way of implying the face is even more red with fury. The lines are close to the bottom of the eye, as the wide-open mouth is pushing up the cheeks.

The mouth is open, and there's a trick with the teeth that is unique to manga. The mouth is drawn long and wide, wide enough that we can see the teeth curving back into the mouth, but this has the added effect of appearing as fangs, which is certainly appropriate for a character who is this livid. In fact, it's arguable that many artists are not doing this to show the horseshoe-shaped curve of teeth inside the mouth, but deliberately trying to achieve this fanglike effect; exaggerate the canine teeth to achieve a more angry, wild-animal effect.

Here we see multiple beads of sweat flying off her face. Again, this is another exaggeration, but it definitely helps achieve the effect of fury and contributes to setting the mood.

## Mixed Emotions

Here's a few more random faces to add to our repertoire. We'll begin with shock, as our friend remembers that stack of hundred-dollar bills and realizes she doesn't need a job, she can get a better apartment, and buy a new dog.

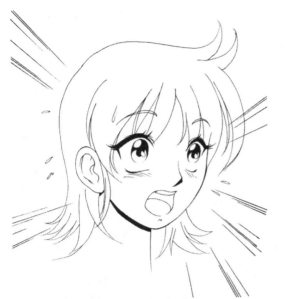

**A surprised or shocked face.**

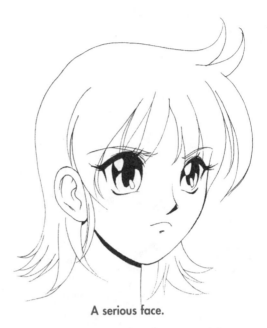

**A serious face.**

Her eyebrows are raised in the shocked fig-ure and follow the curve of the upper eye. In this case, however, her eyes are even lower, showing her eyes to be bugging out with sur-prise. Below them are slightly flushed cheeks. (Have you figured out yet that putting some "color" to a character's cheeks is a great way to enhance the emotion they are expressing?)

The mouth is open wide, in this case wider than the very sad mouth, but longer than the furious mouth. It has a mostly oval shape, which, in tandem with the exceedingly wide eyes, contributes to the mood of wide-eyed surprise.

Not only do we have some beads of sweat flying off this character, but we see some speed lines as well, giving the image added intensity and immediacy. We'll be discussing the mean-ings and uses of speed lines in Chapter 19.

The serious face, made when our girl pon-ders where her newfound briefcase stuffed with hundred-dollar bills might have come from, is actually the face that is least different from our initial control face. This makes sense when you think about it. In the control face we can't really tell *what* the character is thinking, while in this face we can only tell *that* the face is thinking. The emotion is more internal than previous faces and, therefore, the least demon-strative.

The difference between this face and the control face is in slight adjustments to the eye-brows and mouth. The mouth curves more dramatically in this face, and the line of the mouth follows a single arc. The eyebrows are close to the upper eyes and furrow ever so slightly, which is what gives it an intensity—and sense of seriousness.

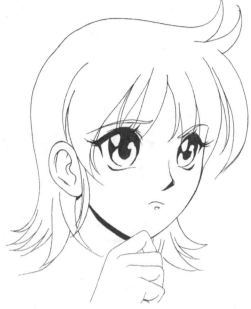

A thoughtful face.

Here, our heroine ponders the possibilities of what to do with her newfound fortune. In this face, echoing the uncertainty in the character's head, for the first time the eyebrows are not basically symmetrical reflections of one other, but are actually in conflict. The eyebrows sit not too far above the eye, one following the curve of the eye and ending slightly upward, the other in opposition, its inner corner descending toward the brow.

The mouth is curved downward, but like the eyebrows, it is not symmetric either. That is, the highest curve of the mouth is to one side. Again, this is a face in conflict, wrestling with various thoughts and possibilities, and the asymmetry of facial features helps convey inner turmoil. Want to exaggerate the features to turn thoughtful into *very* thoughtful? Elongate the curve of the mouth while keeping the curve distinctly to one side. At the same time, slightly close the eye with the descending brow and increase the furrow. Add a couple beads of sweat and motion lines, and you end up with a gal troubled by deep, deep thoughts.

Note that in this picture David has added a hand to the chin. For the art lover this may evoke Rodin's *The Thinker*, which is exactly as it should. Otherwise, it's just a chick rubbing her chin to help her figure out "Whuss up?"

### Sketchbook Savvy

Do some slight variations on the previous figure and see what emotional effect you achieve. Raise the eyebrows a little, open the mouth and/or make it a bit bigger (but keep the same downward slope), get rid of the hand to the chin, and add some beads of sweat and motion lines. You'll see, with just a few slight differences, the thoughtful face is just a couple small steps away from the *worried* face.

Now you know just about everything there is to know about putting emotions and expression on a face. Well, *one* face, anyway. But these tips and tricks apply to all faces. In the chapters to come, we're going to look at different popular character types in manga and how to draw them. After you have the hang of the basics of drawing these types, try putting the various faces we explore in this chapter on those characters.

And, as always, keep in mind that mastering art can only be done with trial and error. Don't be afraid to try variations on your faces. You never know what you're going to come up with!

## The Least You Need to Know

- The same face can express a multitude of different emotions, which can be achieved mostly through variances in eyes, mouth, and eyebrows.

- You can add to and reinforce the intensity of a character's emotions by adding flushed cheeks, sweat beads, and motion lines.

- Manga characters are not known for subtlety. The characters are often exaggerated in their features, emotions, and reactions. Embrace it; don't resist it.

- The best way to discover new expressions is through trial and error, taking the eyes from one expression and putting them together with the mouth of a different expression. You'll end up with a face that's completely new and different.

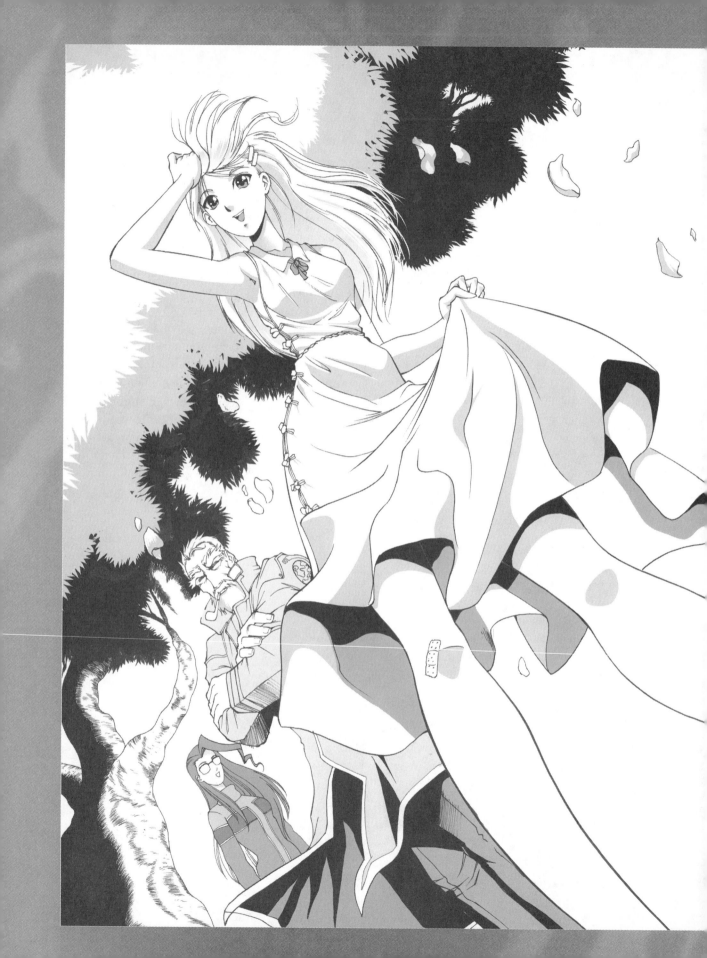

Part **3**

# Character Types

In this part we introduce you to some of the various popular archetypes in manga. These are character types that show up again and again in different stories. We discuss these characters' relationships to one another, and the role that they often play in a story.

In the following pages we introduce you to popular manga heroes and villains, sidekicks, sport figures, bruisers, and best friends. We even explore manga's animal kingdom, dream up fantasy creatures, and take a peek at creatures that go bump in the night.

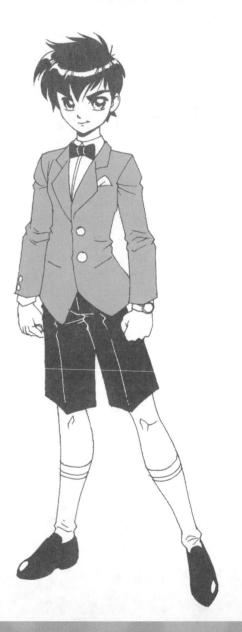

# In This Chapter

- ◆ Hip schoolboys and schoolgirls
- ◆ The flyboy with an attitude
- ◆ The antihero or street punk
- ◆ The intrepid kid detective
- ◆ Accessories make the character

# Chapter **11**

# Stars of the Show

Now that we have explored how to make different manga bodies and faces, it's time to put that knowledge to good use, as we move to the next section of this book. Here's where we meet various popular manga archetypes, the different sorts of characters that populate manga. This is by no means comprehensive, as manga has a vast (and always expanding) variety of genres and characters.

In this chapter we'll start with the good guys, the characters that get top billing, and the ones most likely to lead us on an adventure. Oh, and just so you know, not all "good guys" are male. The cocky pilot, the cynical post-apocalyptic punker, and the nosy kid detective might just as well be females. In general, to swap the gender, you just need to change the body type, the hairstyles, and some of the facial attributes.

In this chapter we'll also look at some of their accessories and accoutrements, the things that complement and help round out your character.

# The Schoolboy and Schoolgirl

stories are tales featuring school-aged males. These stories take place in a school setting, at least until the character is swept up into some crazy adventure.

Keep in mind, also, that when we say school, we are not necessarily talking about a conventional school. The schoolboy archetype might be training in a spy school, some martial arts academy, or even a futuristic outer space outpost where he is training to be a fighter or a pilot and defend humanity.

In Chapter 3 we showed you how to draw the schoolboy body type. Remember, he does not have to be of heroic stature or have a muscular body to emerge as the story's hero. In fact, that is usually one of the points to these escapist stories, as the average boy reader finds the schoolboy archetype the easiest to relate to.

David has outfitted this particular schoolboy in an outfit of simple black, with a wide and open collar to accentuate the character's thin neck and a shirt that shows a slender body type. He added folds in the clothing and buttons using white ink or White-Out.

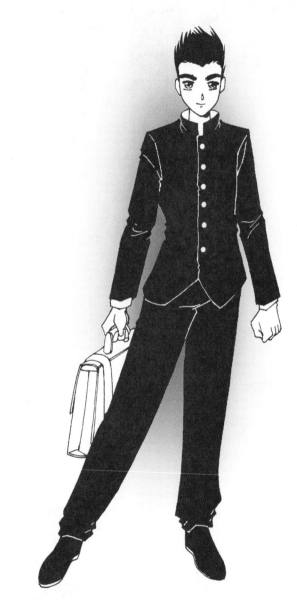

Schoolboy.

Bookbag/briefcase.

One of manga's most popular character types is the schoolboy. As we've stated, boys' Shonen manga is wildly popular and features stories of excitement, adventure, and daring-do. As it is geared primarily toward boys (although not necessarily enjoyed *just* by boys), many of the

Most characters have some sort of accessory or flourish to their clothing, which makes them either more interesting, more realistic, or both. In this case, our schoolboy carries a fashionable bookbag/briefcase. It is simply a thin rectangular object with various belts and buckles added for detail.

**Jacket and shirt details.**

Here David offers another view of the schoolboy's shirt, this time unbuttoned (as well as un-inked), to give a better view of the design. The undershirt would very likely remain white, to allow some visual contrast when this character unbuttons his jacket.

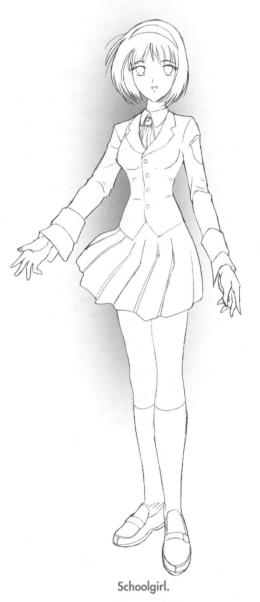

**Schoolgirl.**

One of the other most popular characters, naturally, is the school*girl*, who is both the love-interest in many schoolboy Shonen tales and the protagonist of girl-geared Shojo books. (Japan, with very different sexual mores than America, also shows an extreme fascination with schoolgirls in the explicit and adult-oriented Hentai manga, but I already *told* you we weren't gonna get into that!)

I should also mention that female leads are by no means exclusive to Shojo manga. There are plenty of heroic female leads who have the starring role in Shonen manga as well, butt-kicking babes who are every bit as formidable and tough as their male counterparts.

David has designed this figure with a teen female body type (see Chapter 4), with big eyes and a small nose and mouth, accentuating the cute aspect to the character. She is in a schoolgirl-type uniform of knee-high socks, a short-pleated skirt, and a button-up jacket with a frilly tie.

### Sketchbook Savvy

Give your character some easily identifiable clothing or accessory. Often characters in manga look similar, so something to make your character stand out as unique or identifiable is always helpful. What accessories the character chooses can also help define his or her personality, such as the nerd with the pocket protector or the "cool dude" never seen without a pair of shades—even indoors.

School crest detail.

Schoolgirl's shoe.

The devil is in the details, as the saying goes. Here David shows us the school crest that adorns the sleeve of our schoolgirl's uniform. It's a good idea to design certain aspects of your character's uniform, outfit, or costume before you draw the character in sequential panels. Many characters are identified by what they wear (what would Superman be without his cape and red "S"?), so it's a good idea to figure out these things beforehand. This is especially important if your character will be wearing the same thing for all or most of his or her adventure.

A figure of the schoolgirl's shoe is not the most exciting picture, and probably not a lot of fun to draw. But often it's objects like this that can be difficult and trip you up. Sometimes it's actually better to practice on the stuff you don't like to draw, or don't want to draw, because when you get the hang of that, you'll ultimately be a much better artist as a result.

The stocking in this figure is form fitting, with some little dots at the top to show the upper hem, and there are some slight folds at the ankle.

An alternative stocking, less form fitting, will give the character a more disheveled appearance. This belongs on a character who doesn't much care about being popular in school, or maybe the poor girl whose parents can't afford to buy her new stockings.

Close-up of the knee-high stocking.

Another kind of stocking.

# The Pilot

The pilot or soldier is a different type of archetype, usually more mature than the schoolboy, and hence we portray him more as an adult, based on the athletic male body type discussed in Chapter 3. These stories often feature a cocky young adult who learns humility, or a rookie who finds the courage to be a hero. While schoolboy tales let young readers escape into a similarly aged character they would like to be, the tales of young adults present roles models to which younger readers can aspire.

In this case, our hero has been outfitted in a high-tech armored uniform or mech, with lots of sleek lines and layers to accentuate the intricacy of the design. *Mech*, by the way, is short for mechanical, and we'll be exploring that in much greater detail in Chapter 22.

### Say What?

A hero is no braver than an ordinary man, but he is braver five minutes longer.

—Ralph Waldo Emerson (1803–1882), American essayist and poet

The next drawing shows our pilot, minus the helmet, looking suddenly much more human and vulnerable, despite the cocksure grin.

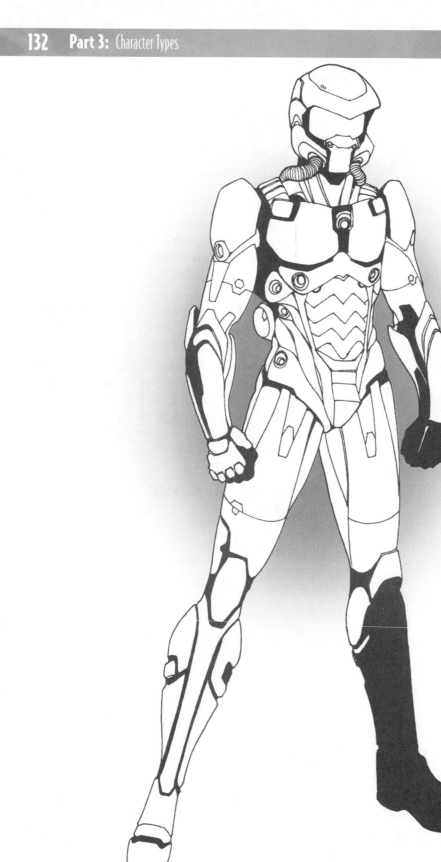

Pilot or soldier.

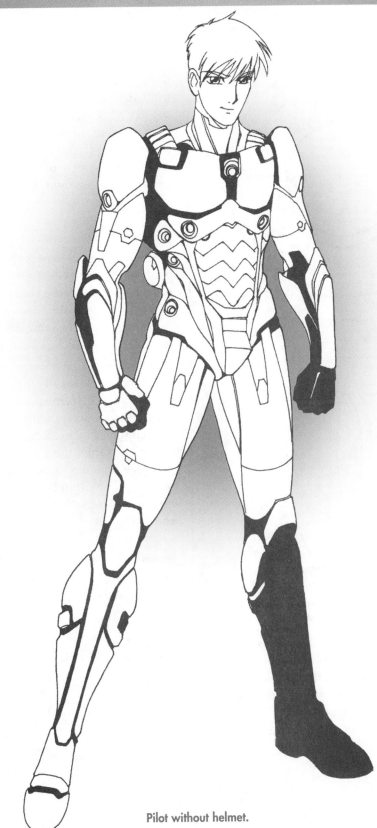

Pilot without helmet.

The front and side views of one of the
doodads on the pilot uniform.

When designing a figure, or some part of a
figure or its uniform, it's advisable to draw it
straight on. When you have the hang of that, it
becomes much easier to draw it at different,
angled views. The first figure is a frontal view.
Looking at it straight on, it appears as perfect
concentric circles, although we really have no
idea of the item's dimensionality.

When viewing the doodad from a side angle,
notice that the perfect circles we saw in the
front view are gone. Each layer is now oval
shaped. Also, you'll notice that the side view
shows dimension that the front view doesn't,
achieved by placing the oval-within-oval to the
far left of the outer one and then another
within to the far right. Cool effect, huh?

## The Punk

A different sort of hero is the antihero, the
punk with an attitude, or the post-apocalyptic
protagonist. Here, the character is accessorized
with a rag-tag mix of different objects, ban-
danas, chains, belts, bracelets, and whatever
bits of body armor he's been able to beg, bor-
row, or steal.

There are plenty of sci-fi manga stories set
in a post-apocalyptic or *dystopian future*, where
the heroes are scrappy survivors who have
learned to get by in an unfriendly and danger-
ous world. Often these are rebels fighting an
evil government to make the world a better
place. And often, in keeping with the bleak set-
ting, these stories have very unhappy or tragic
endings.

These antiheroes are the ones who are fight-
ing to make their dark world a better place,
even if they have to be ruthless and break a lot
of rules (and bones!) to do so.

**Manga Meanings**

A **dystopian future** is one in which
things have gone terribly wrong, and
some or most aspects of this future
have made things much worse for
humanity. By contrast, a utopian
future is where everything is better
than it is now, perhaps even perfect. Of course,
stories set in utopian futures lack the drama of
dystopias, so you won't find a lot of those.

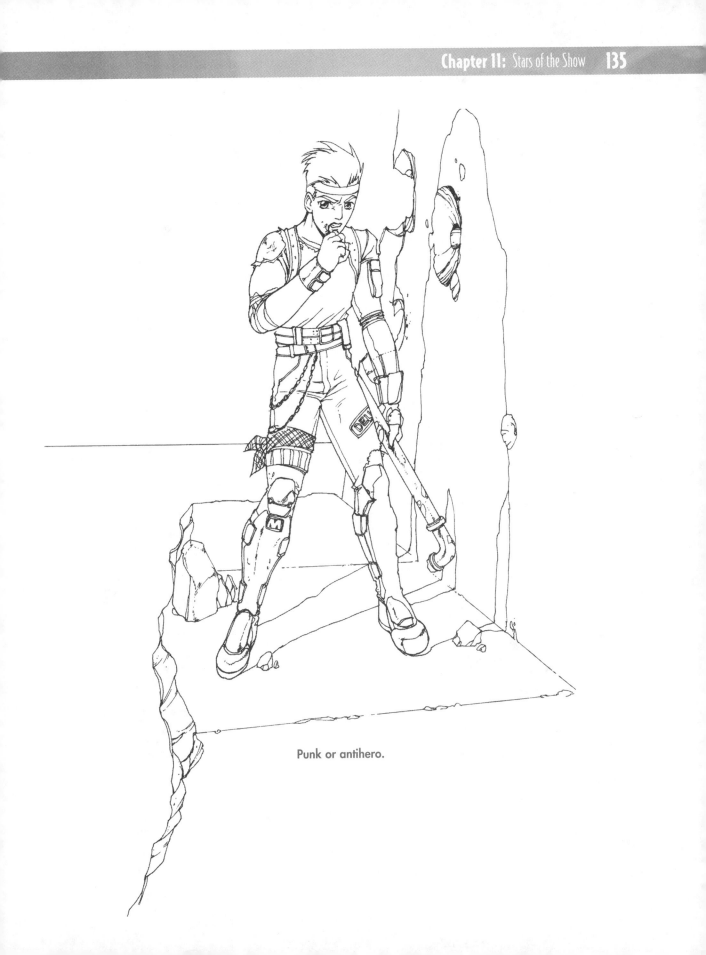

Punk or antihero.

**Close-up of pipe.**

**Body armor.**

Here's a picture of our punk antihero's weapon, an old lead pipe. Hey, when you're fighting for your life in a bombed-out world of radiation and mutants, you'll take anything you can get your hands on to help even the odds in a fight.

A piece of body armor outfits our antihero; in this case, it's a knee and shin guard. Military magazines and books are good for this sort of reference, particularly magazines on contemporary warfare.

And certainly no punker ensemble is complete without a pair of steel-toed, leather high-tops. In this case David has added an extra protective plate to the front of the boot to provide maximum butt-kicking damage!

**Boot.**

# The Kid Detective

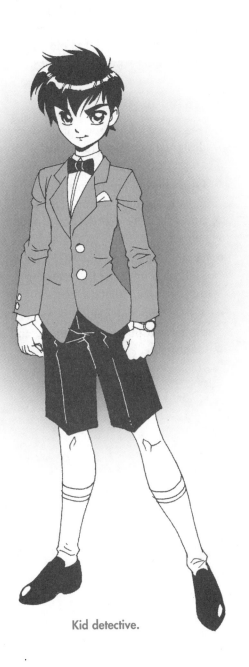

Kid detective.

We've established that there are manga books for *all* ages, and that includes young children. Manga has plenty of young readers, in their very early teens and often even younger. And many of these books feature kid heroes, grade-schoolers who are extraordinary or who find themselves in extraordinary circumstances. (And again, this is not to say these very same books aren't enjoyed by adults and young adults, too, because quite a few of them are.)

So we introduce one final protagonist arche-type, the precocious kid detective, or child spy, scientist-geek gadgeteer, tech savant, or gamer. These stories tend to be a little more fun, fan-ciful, and far-out, where an overlooked kid eventually proves himself (or herself!) equal or often even superior to the adults or older kids who have previously underestimated him or her.

If this type of kid seems familiar to American books and movies, it should, as should many of these archetypes, which tend to transcend the American/Japanese cultural boundaries.

In this figure David has given the intrepid youth short pants and striped socks, which give him a more youthful appearance, as well as a bow tie and handkerchief, which conversely have a more grown-up aspect to them, like this lil' guy is trying to appear more adult and sophisticated than he actually is.

There's nothing cooler for a kid than to be able to imagine themselves with some weird, expensive gadget that their parents would probably never allow their kid to get their hands on. Perhaps this is part of the appeal of the teen spy or geeky gadgeteer—to be able to use or build all sorts of expensive and impossibly high-tech weapons and devices.

This watch is just that sort of piece of equipment. What does it do? Darned if we know.

Watch.

Camera bow-tie.

Another cool device is the camera bow-tie, which has the effect of taking something seemingly nerdy and making it cool. It's not enough to have a pocket laser or a two-way communicator; it's much cooler if it is hidden in a pen or innocent-looking pair of sunglasses.

## The Least You Need to Know

◆ There are a multitude of hero archetypes, designed to appeal to a wide and diverse range of readers.

◆ Often heroes are people you can relate to in extraordinary circumstances. Other times they are extraordinary people you can aspire to be.

◆ When designing your character, consider each item of his or her clothing or costume from a variety of angles.

◆ Accessorize and fashion your hero with things that make them unique and easily identifiable.

# In This Chapter

- ◆ The best pal
- ◆ The goofball sidekick
- ◆ The scientist
- ◆ The battle-scarred veteran
- ◆ The trainer

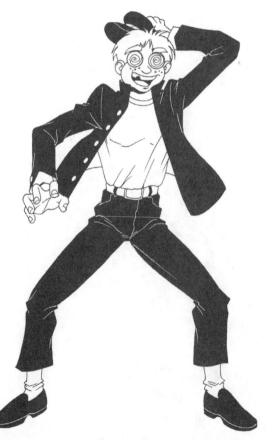

# Support Staff

A supporting cast is by no means unique to manga. In fact, supporting characters are universal to drama, Japanese or English, whether the medium is comics, books, television, or film. Everybody has a friend. And no matter how antisocial a lone-wolf antihero is, he or she usually has that *one* character to whom they have some attachment or allegiance.

Sometimes the supporting character is a friend or a relative; sometimes it's some wizened elder. Sometimes these characters need help; sometimes they provide help; often it's a little of both. Supporting characters are also a valuable way to provide exposition, as a sounding board for the ideas or emotions of the main character.

## The Best Bud

Nearly everybody has a best pal. And these best pals usually end up playing the role of sidekick, going along with the main character on an adventure, and assisting along the way. Usually the supporting characters are sidekicks who look up to the main character and are not *quite* as cool as the main character. Maybe they have some quirk, knowledge, or special skill, and almost always this skill will come in handy by story's end.

### Say What?

If a man does not make new acquaintances as he advances through life, he will soon find himself left alone; one should keep his friendships in constant repair.

—Samuel Johnson (1709–1784), English writer and critic

There are two primary types of sidekicks: the serious sidekick and the comic relief. The serious sidekick is more capable, at least superficially. The serious sidekick is less of a bumbler and may have some cool and crucial specialty. The comic sidekick may have the exact same specialty, but it may be less evident because of the character's tendency toward goofiness.

This drawing is a sidekick who obviously is some sort of techie. Perhaps this is the hero's hacker/programmer pal, able to glean necessary information and exposition from government or enemy computers. Perhaps he is a gadgeteer, able to concoct all manner of weapons or helpful devices. In the case of this drawing, the character looks like he is outfitted in some sort of virtual reality gear.

David has equipped this high-tech buddy in a headgear and stylish glasses, with spiky hair, to give him a bit of a nerdy look, albeit one of a "cool nerd." Stripes on the shirt and one on a pant leg, as well as futuristic boots, round out the ensemble, which is accessorized with a shoulder belt, some miscellaneous round doo-dads, some strange mech attached to the belt, and a mechanical glove on one hand.

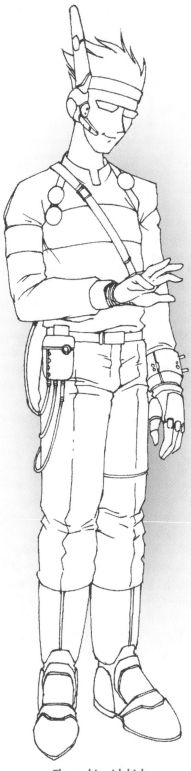

The techie sidekick.

**Close-up of headgear.**

Here's a closer look at the headgear, a head-band attached to some strange piece of mech—what looks to be an antenna, earpiece, and microphone. We'll be talking about mech in greater detail in Chapter 22, but this is a good example of how just a small mech accessory enhances a character, making him look cooler or more futuristic.

### Sketchbook Savvy

Not all supporting characters are human. Plenty of sidekicks in manga, particularly manga for kids, are animals or purely fictitious and fantastic forms of critters. (We'll show you a selection of interesting critters in Chapter 15.)

# The Goofy Pal

**The comic sidekick.**

The comic sidekick, on the other hand, is not just goofy in behavior, but also appearance, to reinforce the character's comic aspect. Because manga is a visual medium, much of the character's foolishness is seen in the panels, with broad physical comedy and exaggerated features and reactions.

David accentuates the wacky in this oddball sidekick in almost every way. The character is lanky, tall, and thin, with high-water pants and saggy socks to emphasize the body type. Most sidekicks are either tall and skinny or short and fat (the same applies to comic duos). Again, this is because an odd-looking body type reinforces the notion of an odd character.

The character also has large hands, which makes the arms seem longer and skinnier. His face is freckled; he seems to be missing a tooth; and his eyebrows sit comically above pinwheel eyes. As we said, these comic characters tend to react—and overreact—even more than normal manga characters, which lends to their comedic personality. Likely this fellow is doing an excited double-take at a pretty girl he's just seen. (It also bears mentioning that his eyes will not always be the overly large, circular pinwheels we see here; this is just a picture of the character as he is very excited and is exaggerated to achieve the desired effect.)

# The Science Mentor

The brainy scientist.

Although some sidekicks are friends along for the adventure, others serve in the role of mentor. They have some experience or knowledge to share with the protagonist and might take the protagonist under their wing to tutor them.

In many cases this character is a teacher or a scatterbrained scientist. Their knowledge or field of specialty can be valuable to the manga lead, and perhaps their science can help the hero by supplying him with some gadget to get the upper hand on the bad guy.

Of course, just as often it is the scientist whose experiment is what caused the problem the hero is dealing with in the first place.

For this character Dave has designed a female in glasses and a long, multi-pocketed lab coat. The character is in a turtleneck, in clothes designed not to accentuate the female form. She wears glasses, and her hair is somewhat out of place, implying she is too busy with science and experiments to pay too much attention to style or trying to impress the other sex.

Oh, and for the record, scientists and other mentor supporting characters can be comic relief just as well as the protagonist's friends and contemporaries. Often the "absentminded professor" is played for laughs in Japanese manga, just as it is here.

Close-up of tablet and pen.

Dave equips this character with a high-tech tablet and a pen, perhaps intended to be a futuristic laptop. Remember, in the case of manga scientists, it's always good to equip them with something high-tech and cool. The more impossible the device, the better, as it implies the scientist has unparalleled skill in the lab.

# The War Horse

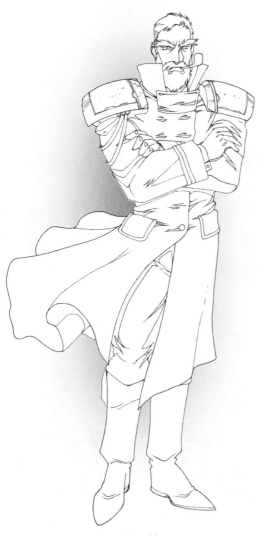

The old soldier.

The old soldier is a more serious supporting mentor character. This character has lived through the horrors of war and has some wisdom to impart when it comes to fighting, piloting, or defeating the enemy. This is an authoritative character, with some gravity to his (or her!) bearing. Often this character has a missing limb or significant disfiguring injury—incurred during an ancient battle, naturally.

For this figure David has outfitted him in a military-like outfit, with large shoulder pads, high collar, trench coat, and boots. However, unlike some of the more sleek uniforms we've seen in younger characters, this is bulky, suggesting this character does not have to move around quickly, run, jump, or do battle. He may be in the military, but he's way behind the front lines, *giving* the marching orders, not taking them.

David has also given this character a thick beard and bushy eyebrows, to add to the sense that this is a character who is older (and hence wiser). And, finally, this old fellow is given a pipe as a visual clue to enhance the idea that he is solemn and wise.

### Sketchbook Savvy

Young people in manga do not have beards, not even young adults, so a beard is a good visual clue that somebody has been around the block a few times.

# The Coach/Trainer

The martial arts mentor.

A similar figure to the old soldier, serious, but more active and action-oriented, is the coach/trainer. Although the old soldier may dispense Yoda-like advice about life, battle, and war, the coach/trainer is more like Morpheus in the *Matrix* movies—wise, but still able to kick major butt.

The coach/trainer archetype might be a monk, a martial arts expert, or somebody raised to fight dirty on the streets. He *might* even be a coach or trainer! This is a character who, for whatever reason, takes the protagonist under his (or her!) wing and shows that character the ropes … even if it means giving the hero a few

black eyes or bruises. Invariably, the hero not only learns from this figure but exceeds his training and expectations. And almost always in these sorts of dramas, toward the end the student becomes the master.

This character is younger than the old soldier but still older than the protagonist and muscular and in shape enough to still kick a little tail. He might bear scars from his many battles. Although the old soldier's scars tend to be bigger, like mangled or missing limbs, as well as psychological scars, the trainer/mentor archetype often has smaller scars, but more of them.

Oh, and it should be noted that this is the character that probably has the biggest target on his back. This is the character most likely to be killed off so that the student will have the motivation to get revenge on the murderous bad guys.

Drawing a scar.

Here David shows us how to draw a scar, to give our trainer mentor an appearance of having had a rough past but still coming out on top. David begins with two roughly parallel lines converging together at both ends. Next, David gives the scar a rougher appearance with some sharp, curved lines coming outward from each scar line. In the final figure, David has erased the original penciled base line, and the inked line jags outward erratically from each line. Voilà—instant scar tissue! The character becomes instantly more formidable, because he has clearly survived some tough battles, which his body will never allow him to forget.

## The Least You Need to Know

- ◆ Supporting characters are sometimes serious and sometimes serve as comic relief. But they almost always help the protagonist of the story when the chips are down.
- ◆ Comic sidekicks tend to have a goofy appearance and use lots of physical comedy and exaggeration.
- ◆ Supporting characters are sometimes friends, tagging along on an adventure and offering some manner of expertise.
- ◆ Other supporting characters are mentors, imparting their wisdom or experience to the lead character.

# In This Chapter

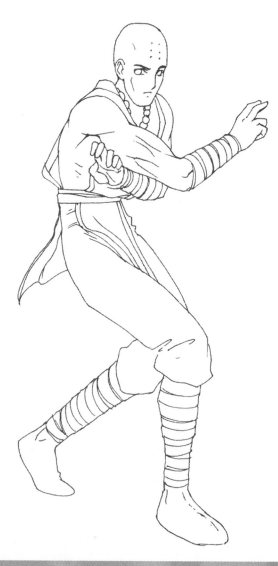

# Rough and Tumble

Many of the characters featured in this chapter might fit just as well in the protagonist chapter, or at least as one of the supporting cast. However, because much of manga is so action-oriented, we chose to give the bone-breaking, butt-kicking action archetypes of manga their own chapter. (Actually, they threatened to break our necks if we didn't!)

And so, since action plays such a huge role in manga, we thought we would take the time to look at the action archetype in the world of manga.

## Bruisin' and Brawlin'

Make no mistake about it: Manga is action-oriented, particularly in the very popular Shonen manga geared toward young males. Fight scenes are well choreographed, and a particularly nasty brawl might go on for a dozen pages or more of just fighting and punching, taking punches, and then getting up for more. The same goes for chases or gunfights. American comics have discovered *decompressed storytelling* in recent years, in which the action is strrrrrretched out to make what might normally take place over a short length of time seem much longer, and seem much more dramatic as a result. But this has been going on in manga for decades, and nowhere is this more evident than action sequences, which often take up a disproportionate amount of a book's total page count.

**Manga Meanings**

**Decompressed storytelling** takes what might be a short event and stretches it out into a longer scene for dramatic effect.

There is no single type of action in manga. Action comes in all shapes and sizes, although some is more appropriate to a particular genre. That is, you probably won't find a lot of gangsters using laser guns, or martial artists fighting giant robots. Of course, this isn't to say you *can't* do that, either. It just depends on the story you wish to tell.

The drawings that follow feature some of the more popular action-oriented characters. Whether these figures turn out to be heroes or villains is entirely up to you.

# The Tough Guy

There is no more basic archetype of tough guy than … the tough guy. This is the sort of hard-working lug who ends up getting into a scrape because he's trying to do the right thing. He's usually got more brawn than brains and is quick to solve a problem with his fists. The tough guy might come from all walks of life, but usually has a blue-collar job like a dock-worker or bouncer. He might be a hired goon from the Yakuza who sees the error of his ways or is trying to defend the honor of a girl, or he might be a cop or a detective who is known for getting answers with his fists and not for sub-tlety.

Of course, this same figure could just as well be a villain: a tough-guy enforcer for the Yakuza who hasn't seen the light and just wants to bust our hero's head. Or maybe he's just a random goon or muscle-head standing be-tween our hero and our hero's goal.

For this picture David used the muscular male body type, with a tight tank top to accen-tuate the pronounced musculature. A few well-placed bandages show that this fellow is no stranger to trouble, or to pain. This is rein-forced by the rip in his shirt. David has acces-sorized him with a broken pool cue. What better weapon to bust heads in some dingy dive bar while on a late-night quest for justice?

**Boot detail.**

We can't see the tough guy's feet in any detail, so here is a more detailed drawing of this char-acter's boot. If you have a character that is a cer-tain type, it's important to equip that character with accessories that match that type. Some characters do not wear a lot of clothes or acces-sories, so what you equip him or her with needs to be "in character."

A tough guy is not going to be wearing flip-flops or pink bunny slippers. He's going to be wearing steel-toed boots. Better for kicking enemies in the teeth, y'see.

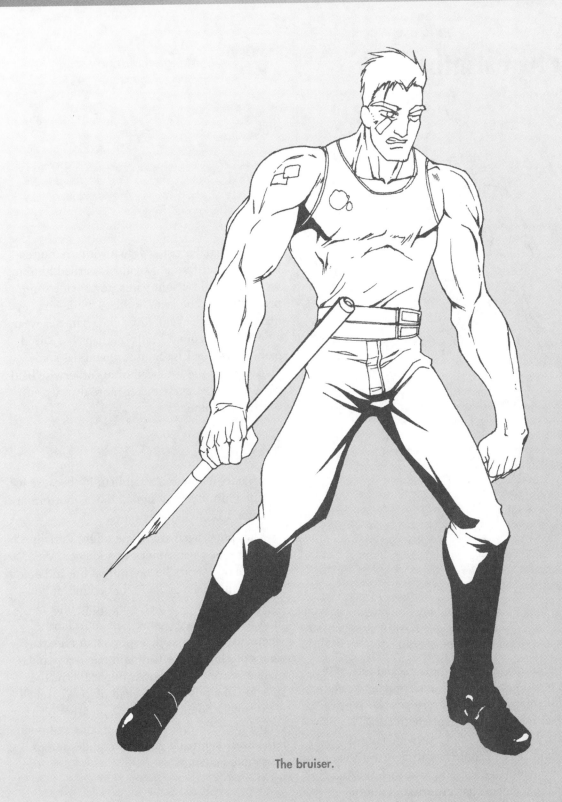

The bruiser.

# The Martial Artist

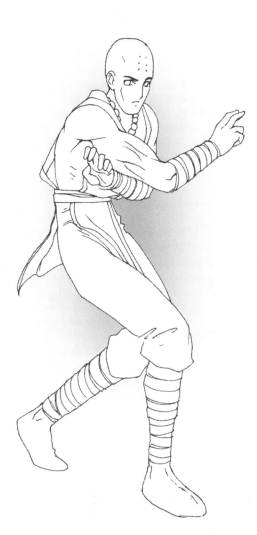

The monk/martial artist.

Like the tough guy, the monk/martial artist figure could just as well be a bad guy or a good guy. The martial artist is a very popular type of character in manga, particularly in books set in the past. Before technology provided guns, tasers, and lasers, people had to fight with hand weapons, hand-to-hand and foot-to-foot. And just as Asian cinema has exported numerous kung-fu, karate, Samurai, and chop-sockie action films, so has manga.

### Mangled Manga

Don't let the label "monk" fool you. While many people think of monks as men of peace, in manga (as well as in Asian cinema) they are usually competent if not extraordinary fighters, characters who are often devoted to quiet study and contemplation, but more than able to defend against villainy and threats against their society or the master they serve.

The martial artist is drawn with the muscular male adult frame. David has garbed him in wraps and lightweight pants, to provide some protection on the arms and legs while giving maximum maneuverability. The character wears a necklace of round beads (perhaps borrowed from Marge or Lisa Simpson) and has some markings on the forehead of his otherwise bald pate, to make the character more distinct, fearsome, and unique.

# The Sport Hero

If this next fellow looks familiar, it's because we watched him being designed top-to-bottom in Chapter 3 on male body types.

The sports hero archetype might initially seem strange to an American audience. We venerate our sports heroes in real life and enjoy a sports film such as *Rocky*, but comics following the exploits of athletes are quite uncommon in the United States. Not so in Japan, where, as we have said, a sportsman rags-to-riches or chump-to-champion tale is a popular manga genre. These books might follow the struggle of a boxer or baseball player (baseball is extremely popular in Japan), an Olympian, or even a martial artist as he gains skills and popularity and eventually goes from underdog to undisputed champ.

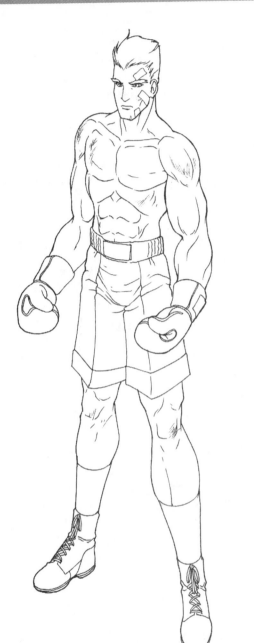

The athlete.

# The Beautiful Spy

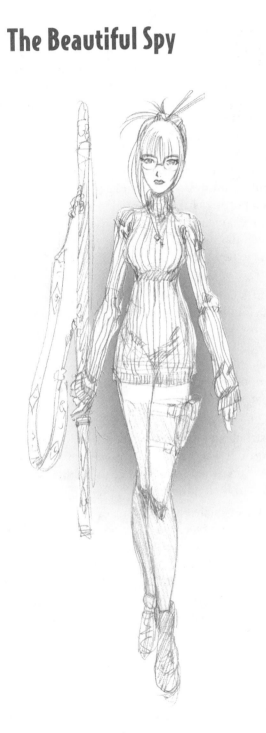

The sexy spy.

### Say What?

Champions aren't made in gyms. Champions are made from something they have deep inside them: a desire, a dream, a vision. They have to have last-minute stamina, they have to be a little faster, they have to have the skill and the will. But the will must be stronger than the skill.

—Muhammad Ali, boxer

The sexy-but-deadly female is a familiar archetype in both Japanese and English comics—as well as all other storytelling mediums. Manga is rife with tales of bewitching lady spies, double agents, femme fatales, and beautiful killers. They might be the main characters, some captivating eye-candy for the guys, and an empowering role model for the girls, a character that performs amazing feats of stealth, guile, and fighting prowess. This character might also be a supporting character, enticing some naïve main character along on an adventure, in which the two ultimately fall in love or the female betrays him—or both!

As we discussed in Chapter 4's discussion of female body types, ugly females are in a definite minority, as are overweight females. Of course, you can flip on the TV or thumb through just about any magazine and you could find the same applies to just about any form of entertainment, whether it comes from Japan or America.

These female action characters may not be as strong and muscular as their male counterparts, but whether they are portrayed as heroes or villains, they are not above using their good looks to their advantage.

This penciled figure is one of an athletic female body type, in a short body-sculpting striped outfit. The character is equipped with a firearm holstered on her upper thigh, as well as a long sword. Glasses on the character's face lend her an innocent aspect. Perhaps this character plays a demure librarian by day and doubles as a deadly assassin by night.

Let's go closer on our beautiful spy, for a penciled face shot. In this neck-up shot, out of context from our previous shot, this female could very well be a schoolteacher, a college student, or a librarian. The turtleneck sweater lends to the scholarly aspect of the character. It won't be until later in the story that we learn those hairpins are actually deadly sharp and can take out a man's eyeball at 100 feet!

## The Least You Need to Know

◆ Action is very popular in manga and populated by many action archetypes, both good and bad.

◆ A popular storytelling device in manga is decompression, in which a short event is stretched out into a longer scene for dramatic effect.

◆ The majority of action archetypes are built using the muscular or athletic body type.

◆ The female action archetype is less muscular than her male counterparts. Invariably, they are beautiful, and not above using sex appeal to achieve their goals.

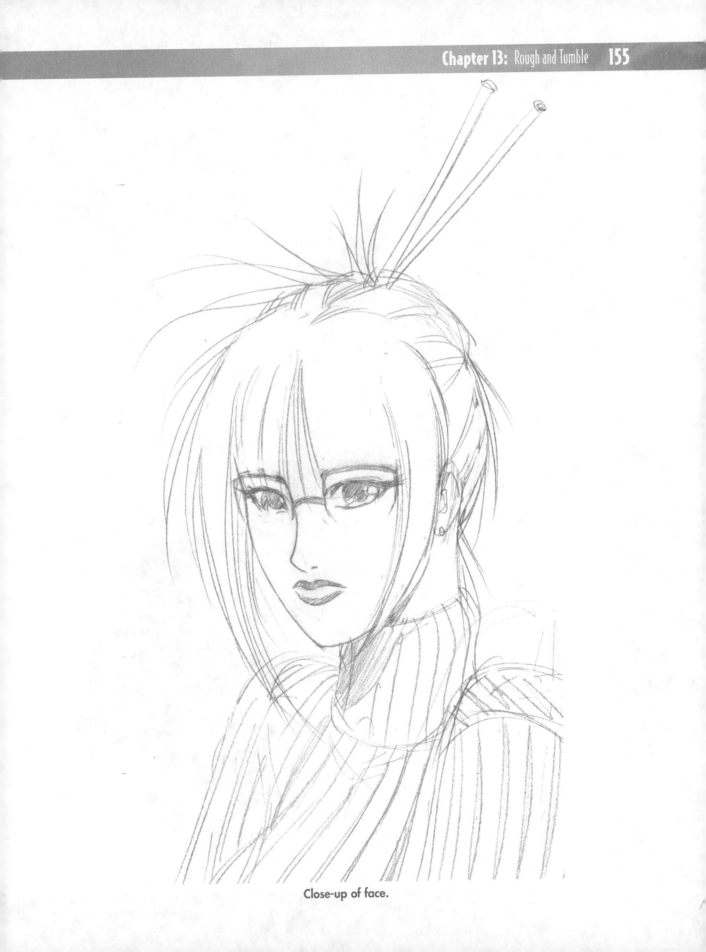

Close-up of face.

# In This Chapter

- ◆ The soldier archetype
- ◆ The evil mage
- ◆ The seductive sorceress
- ◆ The corrupt businessman

# Chapter 14

# Heavies

Villains play a crucial role in any drama, as they are usually the primary obstacle placed against any story's protagonist. Manga has a long history of villains to die for: colorful baddies, maniacal despots, evil wizards, megalomaniac businessmen, and ruthless gangsters.

Villains are almost always more interesting than their heroic counterparts. And they are usually more fun to write and draw, as well. Some are evil; some are flawed; some are sympathetic; and some are just plain bonkers. But these are the archetypes that give a story its flair and panache, and you should always strive to make your villains as unforgettable and cool as possible. Sometimes this is difficult and painful to do, because as a comic creator you will almost always have to kill your villainous creation at the story's end. Of course, this might be the reason that so many good villains refuse to stay dead!

# The Soldier

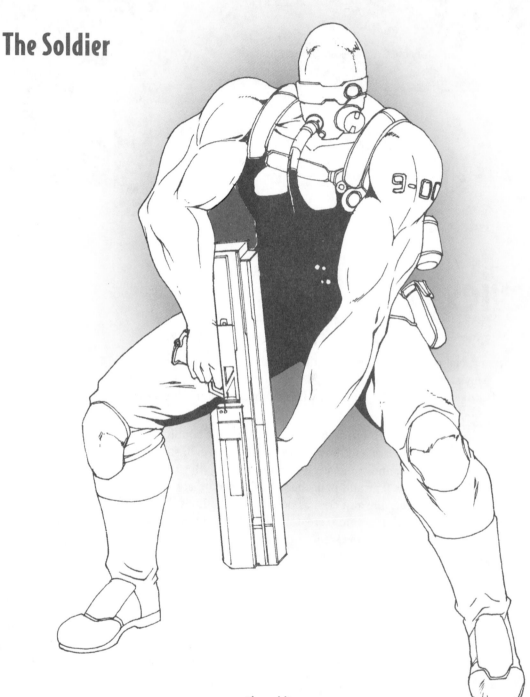

The soldier goon.

Whether your hero is going up against an evil race of alien marauders, Yakuza cutthroats, ninja assassins, or intergalactic shocktroopers, your character is almost certainly going to be pitted against this archetype and probably will go toe-to-toe with them multiple times, before the ultimate showdown with the story's primary villain.

When we say soldier archetype, we don't necessary mean *just* a soldier. Not in the military sense, anyway. We mean minions, henchmen, people employed by the bad guy or working in service of him. These are almost always nameless, faceless goons, expendable for story purposes, cannon fodder to put up against your hero. These are the stormtroopers in *Star Wars*, orcs in *Lord of the Rings*, Nazis in *Indiana Jones*, ninjas in *Kill Bill*, and zombies in, well, every zombie movie ever made.

### Say What?

The more successful the villain, the more successful the picture.
—Alfred Hitchcock (1899–1980), English film director

The key to a good soldier archetype is a good design. You need a memorable uniform, costume, or weapon and something that easily identifies them as a bad guy. This can be as simple as all the characters wearing sunglasses, and the same black suit, white shirt, and black tie, as in certain Yakuza gangster dramas.

In this case you don't want to vary the design too much. You don't want these characters to be thought of as individuals. Likely, through the course of an adventure or a story, your protagonist will have to face a multitude of these soldier characters, and will likely leave a long, bloody trail of their bodies. By keeping them from appearing as individuals, you keep the reader from having too much sympathy for them. If your character is killing villains who appear to *be* people, suddenly your protagonist becomes a whole lot less sympathetic, less easy to like and relate to. Of course, *sometimes* that is the point, but not usually.

For this picture David has designed a soldier with a mechanical headpiece (to preserve anonymity). We see the musculature, particularly in the well-defined arms, of the muscular male body type. David has given this character a

numbered tattoo on the arm, again, to take away from this character's sense of individuality. He wears boots, protective kneepads, has grenades and other items hanging from belts across his torso, and carries a gun that looks like it could blast just about anything to smithereens.

This soldier goon would likely be traveling with others who look and act exactly like him (the only difference being the identification number on his tattoo).

### Sketchbook Savvy

Villains should be as unique and unforgettable as possible. Their minions should be well designed but have no real identity beyond serving their master's designs and desires.

## The Mage

Fantasy—stories of characters who exist in or are transported to magical lands—is a popular genre in manga. Many of these tales feature some power-mad magical wizard, a mage (short for "magician" or "magic-user") who is determined to rule the land using tyranny and dark magic.

Our evil mage character featured on the next page is drawn in long, flowing robes. He has long hair and a beard, a sign that the wizard is old, if not ancient. His face is lined with wrinkles; his brow is dark and furrowed; and he has no pupils, which dehumanizes him, as pupils are such an expressive part of the face. David has designed the mage with some sort of mechanical device on one shoulder. (It's always fun to mix magic with high and low technology, as it adds a more unique and interesting element to your fictional fantasy world.)

The character has a claw-like, skeletal hand, with long nails, pronounced knuckles, and some veins on his hands. David has added a black-to-white graduated tone to the bottom of the character's robe, giving an otherworldly effect to the character, as if he is just materializing out of thin air or is perhaps only semi-tangible.

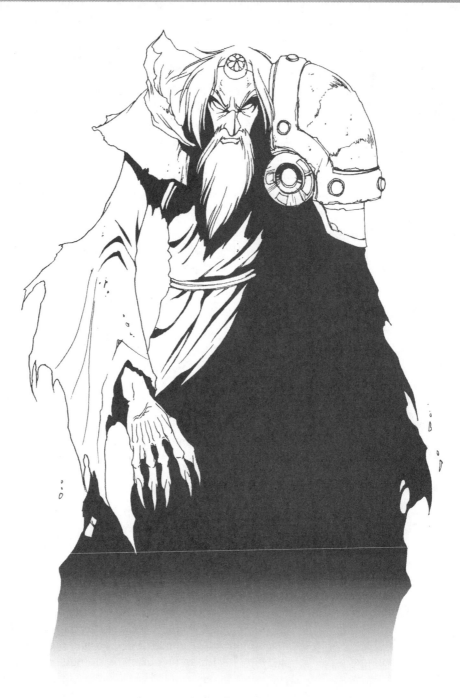

**The mad magic user.**

Usually, in these sort of tales, there is a good wizard to help the hero take on the bad. He is roughly analogous to the battle-scarred veteran archetype we discussed in Chapter 12 (but, y'know, garbed in wizard's robes and magic accoutrements rather than a military uniform, and with a more benevolent aspect).

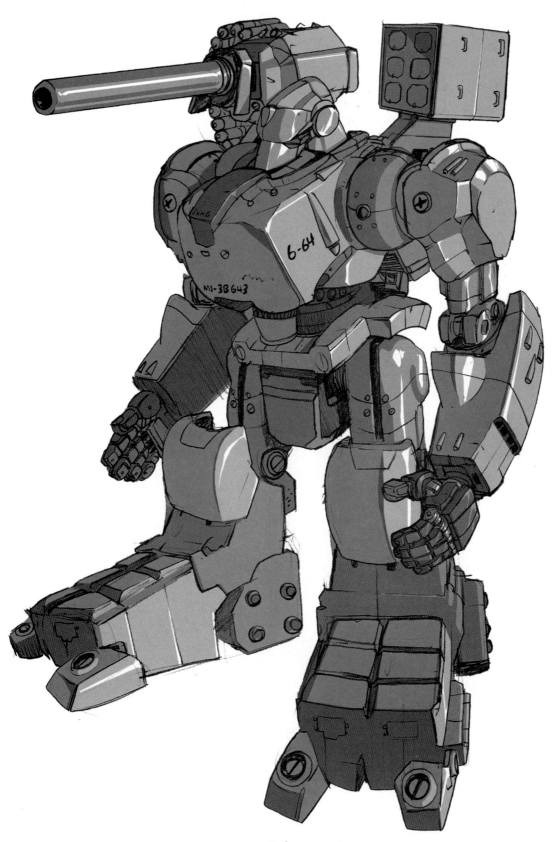

**Robot warrior**

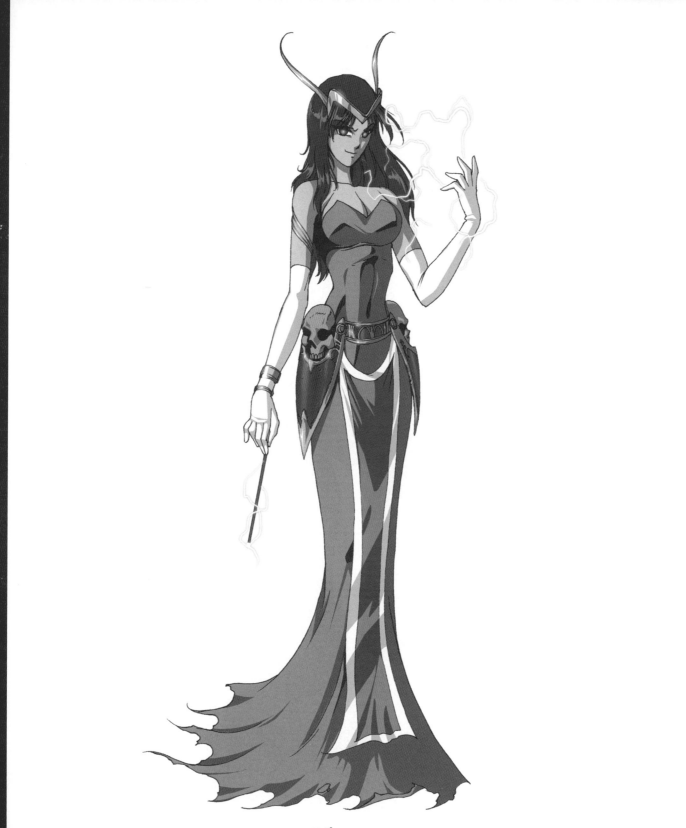

Evil sorceress

Pterodactyl critter

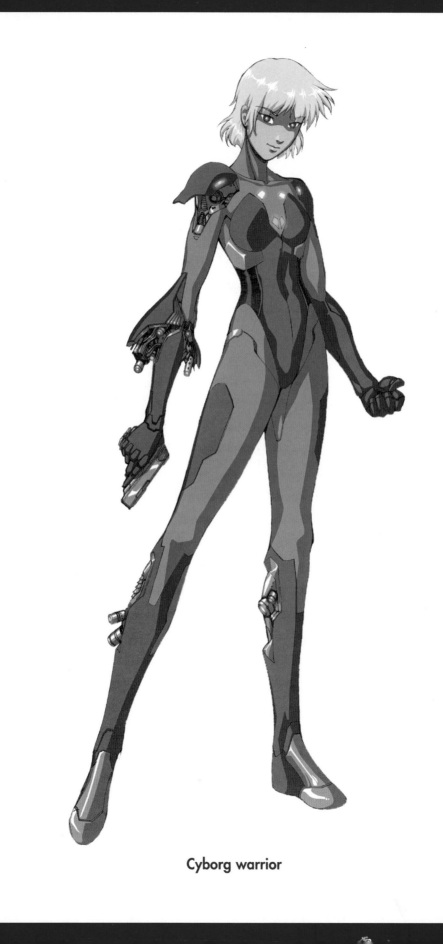

Cyborg warrior

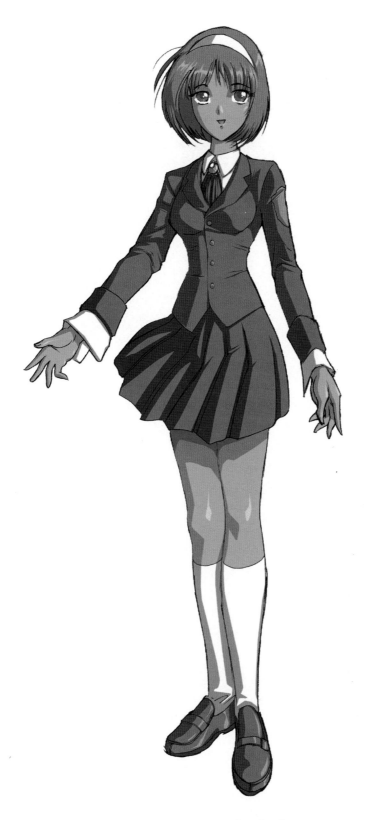

Teenage schoolgirl

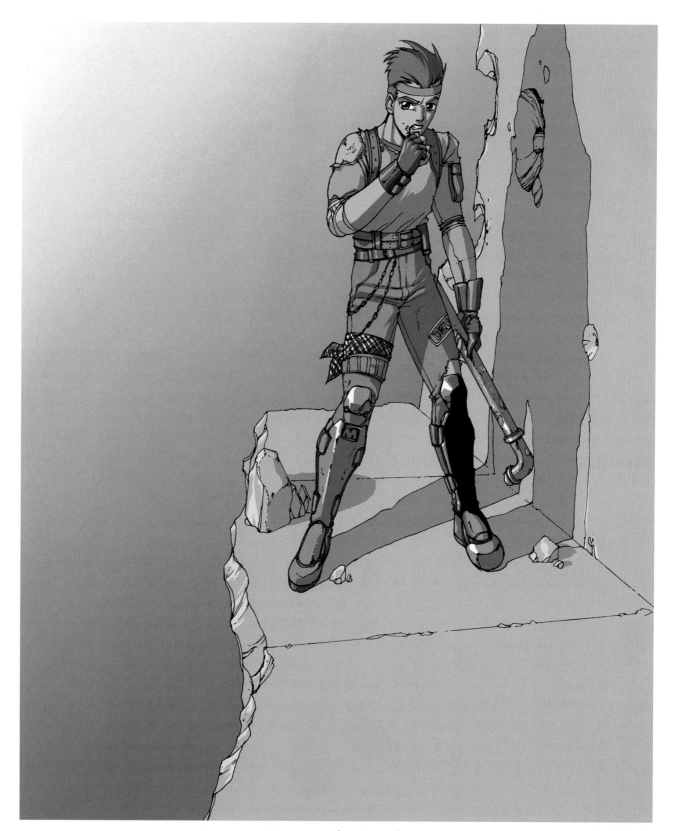

**Post-apocalyptic punk**

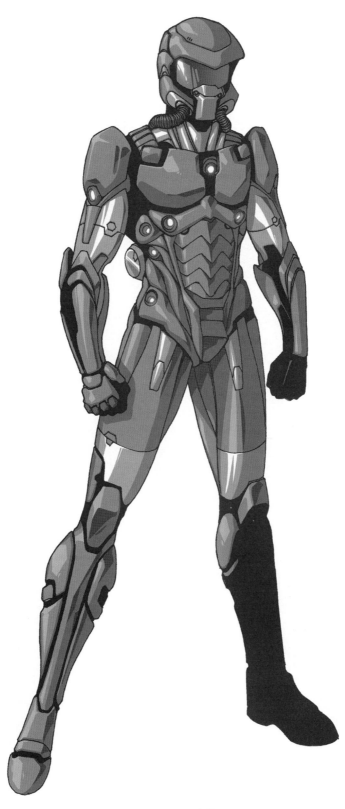

Futuristic soldier

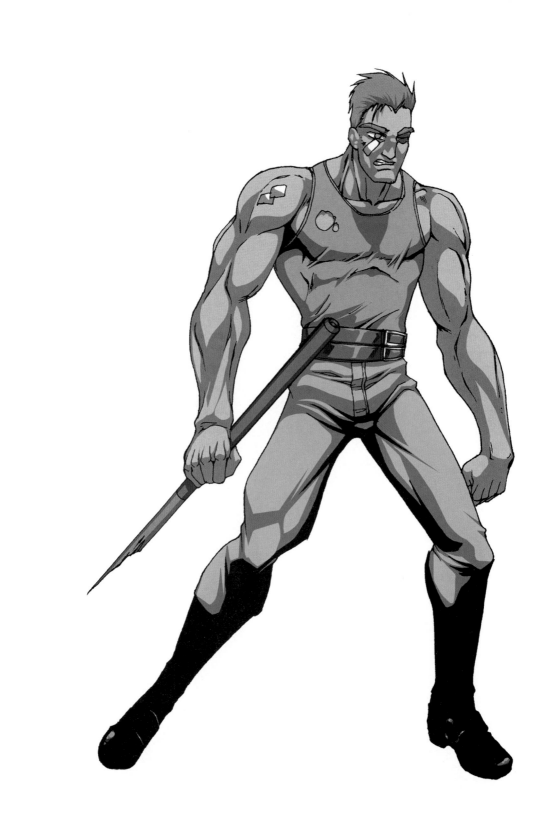

**Ready to rumble**

**Science nerd**

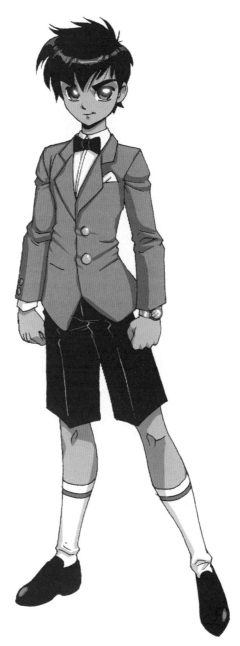

Youthful schoolboy

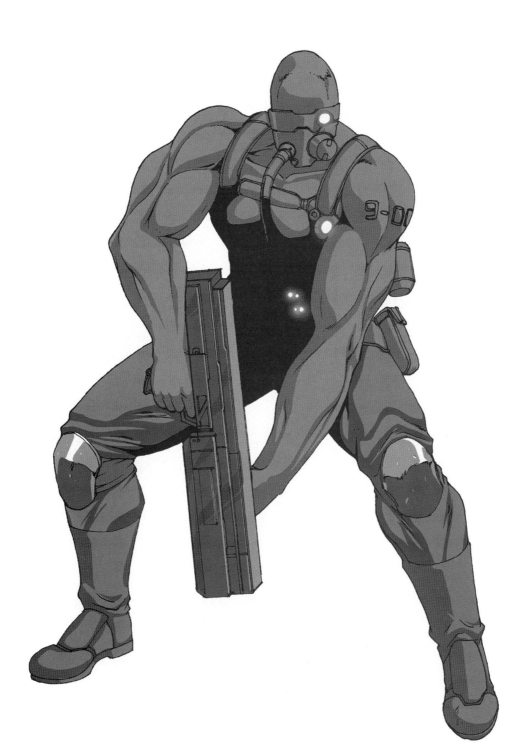

Well-armed warrior

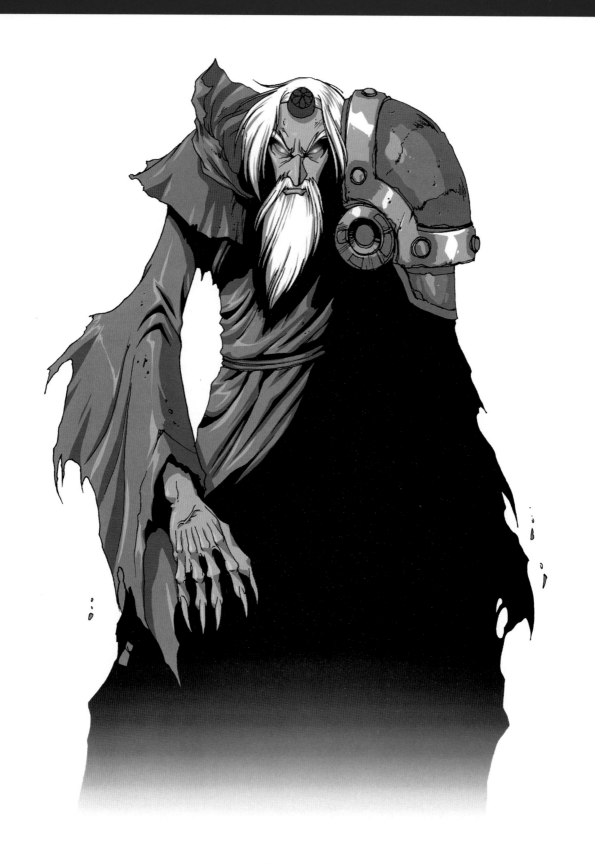

**Evil mage**

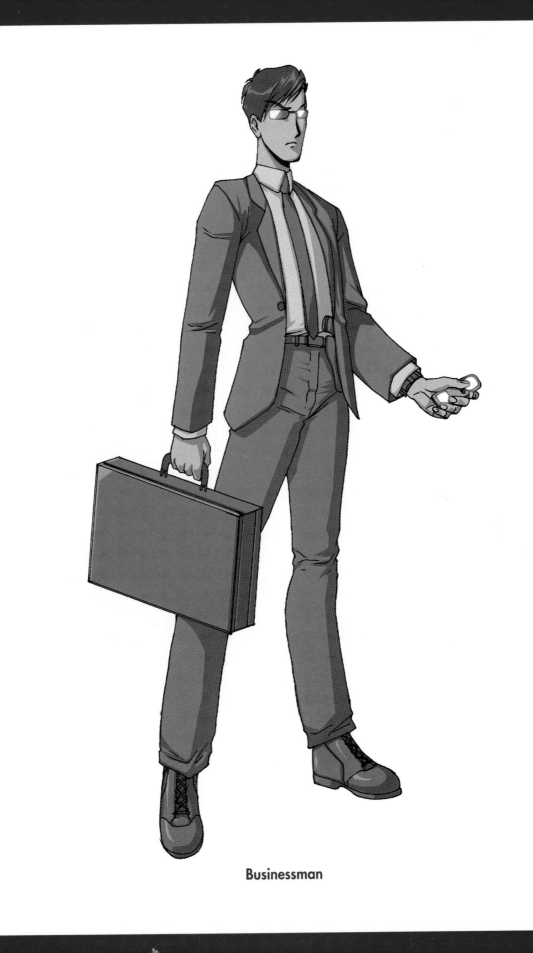

**Businessman**

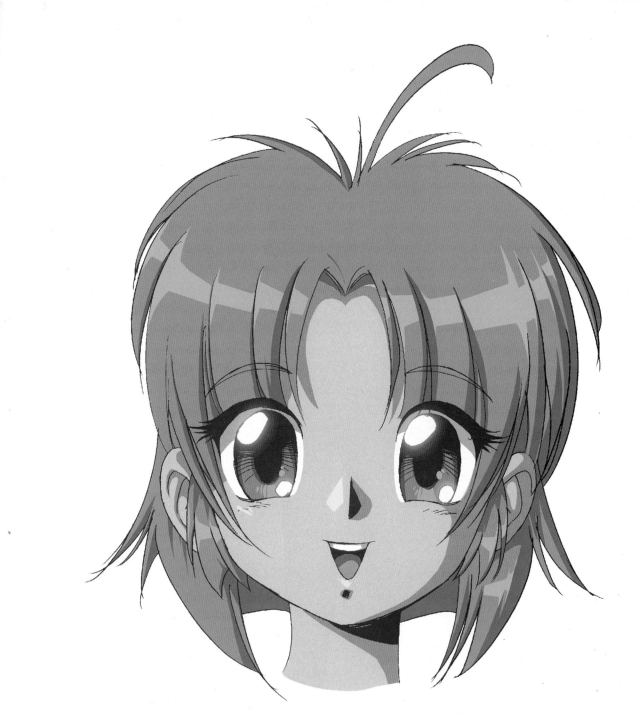

**Young girl close-up**

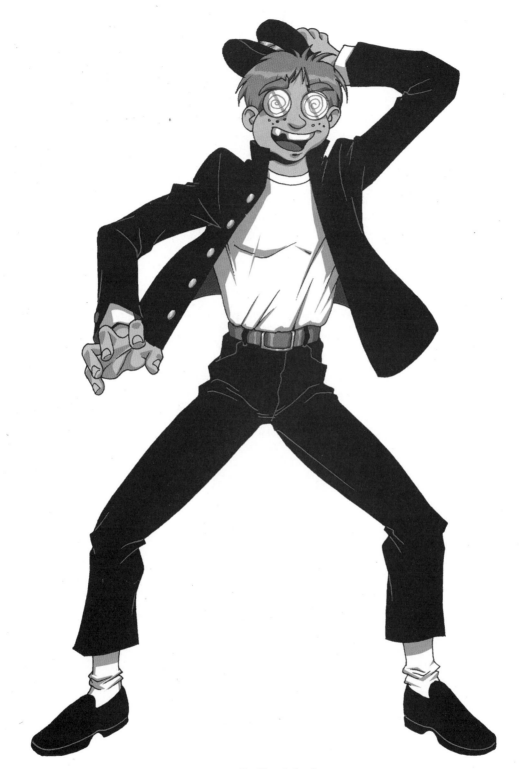

Goofball sidekick

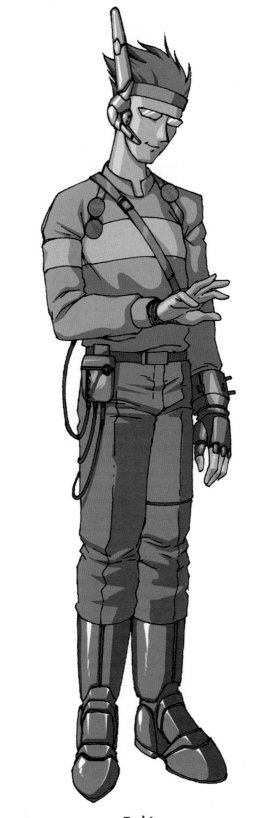

Techie

# The Sorceress

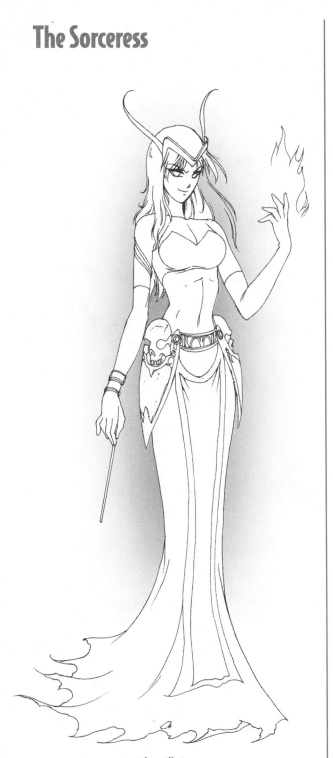

The villainess.

The sorceress is a twist on the evil mage, generally playing the same role, although the sorceress is younger and has (obviously) more sex appeal. These characters are usually more interesting to draw than their male counterparts, who tend to favor boring flowing robes.

This fetching figure is designed with a unique headpiece, as well as bracelets that adorn the wrists and upper arms. She wears a long skirt, enhanced by an ornate and decorative belt (skulls on a character's costume are usually a tip-off that you are dealing with one of the bad guys—or gals, in this case).

This character has an expression that is a mixture of scorn (in the brow and eyes) and amusement (seen in the slight upturn of the mouth). If you are going to have a character with sex appeal, it's a good idea to take advantage of that in your story. Perhaps this character is some sort of temptress to pit against our hero, able to bewitch him into doing her bidding, or otherwise compel him by using her magic—and her feminine wiles.

# The Corrupt Businessman/ Government Agent

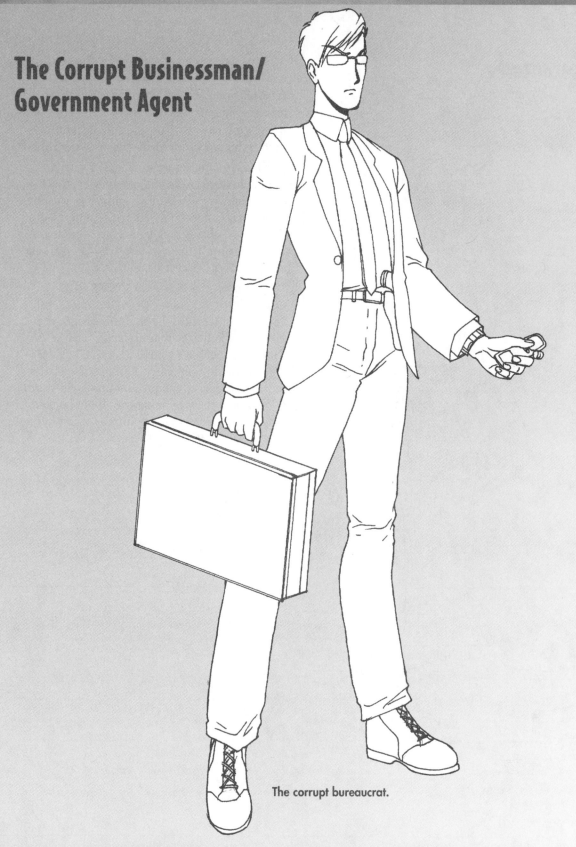

The corrupt bureaucrat.

This sort of character is popular in contemporary stories, since tackling an evil corporation or an unjust government seems to be very fashionable in modern society. The nefarious government or corporate villain is an old standby in these sorts of tales and usually not a particularly interesting one. All too often these characters are generic and forgettable, with no original personality, motivation, or design.

Here David tackles one of the bureaucratic baddies. A stylish suit covers a tall, thin, athletic male body type. The character is accessorized with a briefcase, expensive watch, and a cell phone.

The hair is short, and bangs hang to one side over the face. Dark glasses keep us from the eyes; the brow is in a perpetual severe furrow; and the lips are pursed disapprovingly.

Of course, this character could just as well be a stooge or lackey (or soldier!) of the evil business or corporate entity, which is all the more reason to try to differentiate your villain into somebody cool and unique.

### Mangled Manga

Just because corporations and governments tend to be nameless entities doesn't mean your corporate or government villain has to be. Make your villain interesting, in appearance and personality, and your story will be more memorable as a result.

Here's a close-up of the white-collar villain's weapon of choice: the cell phone, a piece of modern mech that has changed contemporary storytelling forever. No longer do characters have an excuse not to be in contact with each other, and one doesn't need a secret wristwatch communicator or walkie-talkie to maintain communications. But try to avoid hackneyed plot "twists" like cell phones dying at the most crucial time, just when they are needed. That is lazy scriptwriting—and just lame.

Cell phone.

## The Least You Need to Know

◆ The actions and decision of villains drive the action of most stories. The hero will generally have to thwart someone or something as a result of a villain's machinations.

◆ A villain's minions should be well designed but not have a lot of individuality.

◆ A hero will take on many faceless minions or soldiers before his ultimate confrontation with the primary villain.

◆ Interesting villains make for interesting stories. Generic villains make for forgettable stories.

## In This Chapter

◆ Animals in manga

◆ Fictitious zoology

◆ Four-legged friends and foes

◆ Birds, insects, and fish

◆ How to anthropomorphize animals—and why

# Weird and Wild

We've discussed how manga has a tremendous amount of diversity in genre and story content. There are stories set in alien worlds, in the past, and in the far-flung future, and there are just as many stories that exist in some contemporary reality populated by all manner of strange and fantastic creatures. If you have even the slightest knowledge of manga's popularity in America, you know that manga critters have a huge visibility, and likely have played a role in making manga—and anime—so popular here.

Some of the most popular anime exports are cartoons like *Pokemon* and *Yu-Gi-Oh*, featuring a multitude of ... well, we're not sure *what* they are. But you find these odd buggers not only on cartoon channels, but as plush animal likenesses on the toy store shelves, as well as adorning collectable trading card games based on the cartoons.

Simply put, we just *can't* talk about manga without exploring the weird and wild zoology found within its pages. These animal characters are often the protagonist's loyal friend, sidekick, steed, or creatures the hero has to catch or collect. And in many cases, despite the character's harmless appearance, these creatures can be very dangerous—even deadly!

# Crafting Critters

When drawing an animal, whether it is based on a real animal, or it is a purely fictitious invention of your imagination, the approach is basically the same one you would take to drawing a human. It's best to begin with a stick figure outline, just to make sure you have the basic shape you desire. Next give it more form, using shapes such as circles and cylinders, before fleshing it out, and then finally adding inks and tones and any small details you think will help complete your beastie.

However, the crucial difference is that the beastie shapes are different than human shapes, sometimes radically different. You can't draw this based on an upright chest and mid-section, head, neck, and four limbs. Your character may have all these features we just mentioned, but the shape is likely to be very different, as is the center of gravity. There are man-shaped creatures, of course, like monkeys or a bear standing on his haunches, but there are many more four-legged animals, animals with wings, or fins—or whatever!

And because animals are so different from one species to the next, there is no one approach to designing them. Each one might be different, and you will have to build them differently from the stick figure outline on up.

### Sketchbook Savvy

Even fictitious animals take *some* inspiration from real ones. A trip to the zoo is a great way to be inspired, as you will almost always discover some creature you didn't even know existed. Nature magazines and educational TV channels are also good ways to discover new and wondrous creatures.

So for this chapter, we'll explore a bunch of different critters and show how Dave went about designing them. Of course, this is by no means a thorough exploration, because there is an almost limitless number of creatures to inspire you—and an infinite amount that can be captured in your imagination.

# The Bront Beast of Burden

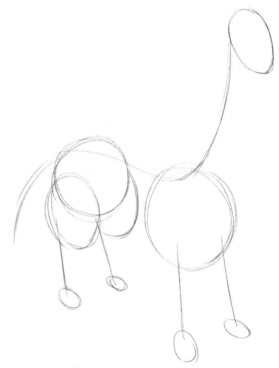

Rough sketch of a horselike creature.

Just as our human stick figures gave us a rough idea of the characters' size, or even their personalities based on their body language, this rough outline shows us we are clearly not dealing with a human. This is some sort of four-legged animal, and it looks almost horselike in this drawing, albeit a horse with a very long neck.

The central line of this character is literally its backbone, sort of a backward s-shape that runs the length of the animal's tail, up its back, and then curves upward into a long neck, where an oval head sits upon the neck. There are two circles representing the figure's body, a larger one, lower to the ground, representing this critter's chest, and another for the hindquarters. We have two more circles reinforcing the back legs, so immediately we can tell this is a largish critter, one that could possibly support a human rider. And the figure is complete with four lines representing legs, each with an oval to represent the foot.

### Sketchbook Savvy

Reference books are just as important for drawing animals as they are for humans, perhaps even more important, so it's a good idea to invest in an animal encyclopedia, and books that specialize in the anatomy of insects, fish, dinosaurs, and even mythological beasties. The *Eyewitness Books* series (DK Publishing) is my preferred source of reference.

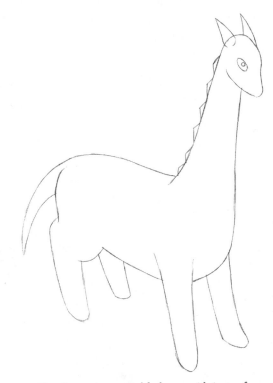

**The figure comes to life here, with just a few added details.**

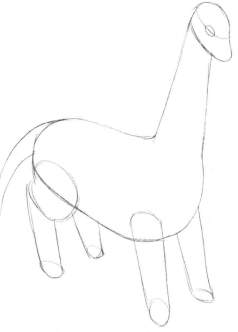

**The figure comes into better view.**

David connects the chest and hind section together and adds dimension to the neck, tail, head, and feet. The legs of this creature are basically round cylinders, and we see the shape of the head has changed from an oval into a more complex figure, so it has the appearance of having a nose and skull. Dave added the eye about halfway into the face, although that will likely change from animal to animal.

Isn't it amazing how a pupil in the center of an eyeball can go such a long way toward making your character seem alive? Other details are in the ears and some bumps along the neck, and we are left with … well, it's not exactly a brontosaurus, and it certainly has horselike aspects. So do we knock David for drawing a character that is not photo-realistic?

The answer is no. If there is a "cute" factor to drawing girls in manga, multiply that unreal factor by two or three for critters. Animals and beasties in manga tend to not be very realistic, whether they are based in reality, or purely fantasy creatures. So there is a lot of leeway in creating cool and fanciful creatures. Of course, things that are simplistically rendered tend to be cute, and hence more likable. If your intention is to scare, sometimes it's better to give a figure more detail and realism, but that's a discussion we'll get into more next chapter.

Here is the final figure of this brontosaurus-creature. David did not add a tremendous amount of detail between this and the previous figure, or even this and the *second* figure. A gray tone adds some dimension to the figure and suggests an overhead light source, and David has added some highlights to the creature's eyes. (The gray in the background is simply a design element.)

So in the end, is it a horse creature, or a brontosaurus creature? It doesn't really matter, as this *could* be both—the hero's steed in some time-traveling yarn, or perhaps the horse equivalent on some distant planet in some futuristic sci-fi manga tale.

**Finished figure.**

# Winged Wonder

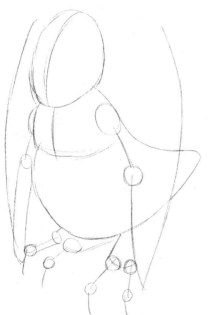

Rough sketch of a birdlike creature.

Dave tackles a very different sort of animal here. And it should be clear just from the outline that we are not dealing with a *quadruped* or a *biped*, but some *avian* creature.

The body shape is upright, unlike our four-legged brontosaurus critter, but it's not upright like a human. The body is squat, and largest in its cone-shaped lower body. In the case of this creature, its head is bigger than its chest, and we see lines to denote arms (wings) and feet, as well as joints to the arms and feet. The two curved lines rising outward from the lower "arms" suggest the creature's wingspan.

I'll say it again: When tackling figures with which you are unfamiliar, it's great to have a handy reference. I mean, how many people actually have pterodactyl anatomy committed to memory?

More details are filled in.

With the basic figure now captured satisfactorily, more details are added to this figure, such as big round eyes, a beak, and a long, cone-shaped back of the head. Also, the limbs have been fleshed out, and we see the shape of the creature's wings, which now appear to be folded back behind it while this little bird guy is at rest.

**The creature takes on a more birdlike appearance.**

David adds more details here, including a pupil to the eye and some markings to the chest. We also see a line behind the arm, which represents the fold of the creature's wing.

Here's the final figure, with the eye penciled in and a highlight added to the eye. Again, even in the animal kingdom, the eyes really are the windows to the soul. That is, a fully rendered and realized eye really helps your character or creature achieve a more lifelike aspect.

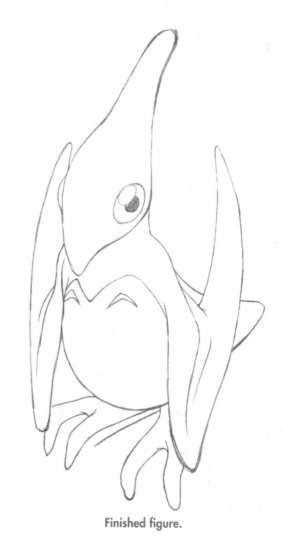

**Finished figure.**

# Claw Critter

We're moving into more fanciful territory here, for a creature of pure fiction and fantasy, the sort of goofy whatzit you might find on an afternoon *Pokemon* rerun. This character is roughly based on a badger, with the body type of a turtle—that is, a turtle that walks upright.

**Rough sketch of a more fanciful creature.**

**More definition added.**

In this figure we have a small, squat biped, with short feet and large forearms. It's also evident even in this rough outline that this character has dangerous-looking claws on its hands and feet. In all likelihood, the large forearms are partially to emphasize the large claws that will follow, as if the forearms have to compensate in size to carry those extraordinary clawed hands.

### Sketchbook Savvy

Want to invent a critter but stumped on what you want? Try mixing and matching aspects of one creature with another. Perhaps combine two very opposite creatures, such as an elephant with a parakeet. Or perhaps mix two creatures that share similar traits, and yet are visually very different, such as a shark with a scorpion. This is your chance to play Dr. Moreau!

More details are added to this figure, such as definition to fingers and toes, as well as a nose, mouth, and eyes. In this case, the simple triangle nose over the stretched out w-shaped mouth gives the lower face a bit of a feline aspect. The thick brow area gives the eyes a sunken and sinister aspect. Already, with just the rough of the face and the claws, we can tell that this critter is not exactly cute and cuddly.

And yet, once David adds large eyes and a line to indicate a slight smile; this fellow does seem cute. Although with the spiky fur added to the back of the head, down the character's back, and on the back of the arms, this is a creature who is probably best kept cute from a distance.

**More details define the creature.**

Please note, in this case, the character's eyes have changed considerably from the previous figure. Gone is the large brow area that gave the eyes the sunken aspect. The eyeballs are slightly bigger in this figure, too. This is a rare instance when David revised the figure from one step to the next. He didn't like how the eyes appeared based on where he was taking the design of the character, so he altered them. And hey!, as an artist, that is *your* right. You do whatever you want to do to get the picture that you want, and that *you* think works best.

Here's the finished figure, colored in grayscale, and given some cool stripes on its face and arms. David left the stomach area of this creature white, because contrast between black and whites, or other colors, often make characters' appearances more interesting. (It makes things "pop" as well, such as this character's small but easily visible white nose.) David completes the figure with a graduated tone to the eyes, as well as white highlights.

**Mangled Manga**

Don't go crazy and add too many tones to your figure just because you can. Often it's best to keep things simple with just white, black, and one or two shades of gray. Add too many shades, and the figure will get muddled and hard to make out. Also, if a creature is being featured in a lot of panels, you might ultimately want to keep things simple. You'll save yourself time in the long run.

Finished figure.

# Two Tails

Another crazy critter is up, and this time we have the character in an action shot. This is a figure jumping, and not only that, it's a figure with two tails. Now, if you haven't looked ahead to the more finished drawings, this is a figure that might be hard to discern, at least out of context. If somebody is looking over your shoulder while you are drawing it, they might not understand what you are drawing.

But who cares! Tell that nosy guy to move along! All that matters is that *you* know what you're drawing, and that the finished product makes sense.

Anyway, in the case of the next rough figure, we have a line representing the spine determining the flow and movement of the character. Circles represent the head and body, and we see lines to indicate limbs, feet, and the two tails of this strange creature-to-be.

Rough sketch of critter in action.

The critter is more clearly defined.

Stripes add more detail.

Our figure suddenly makes a lot more sense in the next picture. The limbs and tail are more clearly defined, and we see a rough outline of the almond-shaped eyes and the triangle-shaped ears. David has also seen fit to add what appears to be a horn on this crazy-lookin' varmint.

Some other things to look at are the way the ears are placed so they are pulling toward the back of the head, the hind legs are bent back, and the front arms are coming together, following the slope of the spine we saw in the previous figure. All of this lends to the illusion of movement, showing that this creature is leaping downward. It is leaping into the movement, rather than against it, which suggests the character is leaping of its own will rather than falling against its will.

More details are added to this figure, most noticeably stripes on its back, on its tails, and on its front legs. We also see the pads of the back feet of this critter, pupils, and a line that more clearly defines the shape of the ears. Except for the two tails and the horn, this creature now has a very feline aspect, and is kind of a manga-ized fantasy version of a cat. I'm going to dub it the elusive two-tailed Caticorn. (Get it? Cat + Unicorn?)

Here's the final version, with just a few added details. The horn of the Caticorn was embellished with some detail. There is a slight shadow between the chest and the lower right paw, and there is another curved line within the ear to give it more depth and dimension. And, of course, pupils have been darkened, and highlights added to the eyes as well.

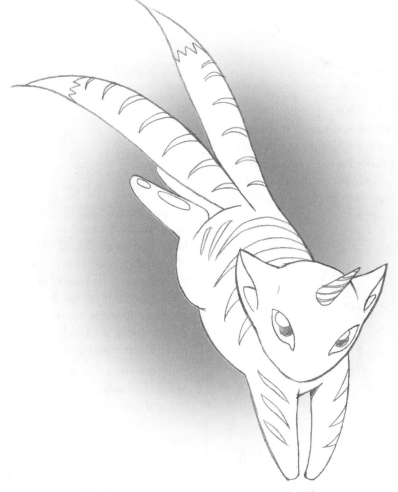

Finished figure.

# Snake-Eyed

Rough shape of snake.

Not everything can be outlined using shapes or circles. Or at least here's one object that can't: the snake. This highlighted figure seems to be little more than a random doodle or a scrawl, at least at this point. Of course, knowing this is a snake, we can say this is a pretty good stick figure of one, can't we?

Arrows help indicate position.

Here David adds a triangular head and extends the tail. The rough shape from the previous image is highlighted. With the arrows, we get a better sense of how this serpent will be sitting, or lying, or whatever it is that snakes do!

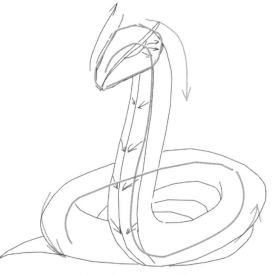

The snake comes to life.

And here we finally get a better sense of what we are looking at. The base of the snake looks like a rolled-up hose, with a curved triangular tail peeking out at one end. Up the neck we see some arrows to indicate the direction of the lower body scales. Eyes have been drawn at a threatening angle, and David has added some lines above the snake's eyes to make it look more sinister and sleek.

In our final figure we see scales not only along the body, but on the lower part of the tail and around the eyes. Note that David drew a thick line under the eye but did not add a pupil or highlights. Eyeballs tend to humanize figures, whether they are human or not. For some reason, characters *without* eyeballs are very difficult to empathize with, and, as snakes are generally regarded as evil, untrustworthy, and unlikable, this one is portrayed without eyeballs.

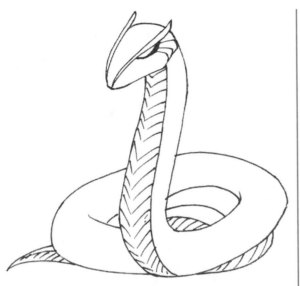

**Finished figure.**

Think about it. There is a reason in movies that zombies and other undead characters seem to lose their pupils, as do aliens and people who are in some way possessed. The same principle applies to those sort of characters as it did to the snake.

# Ant-Art-Trick

**The beginnings of an ant shape.**

David tackles the insect world in this series of figures. Insects aren't particularly easy to relate to, or *anthropomorphize*, so insect reference is good to have.

On the other hand, since insects are so alien and hard for us to relate to, insect-type creatures make for excellent aliens and sci-fi bad guys.

In this figure we don't have much more than the beginnings of an ant back. Nothing to see here, move along.

**Manga Meanings**

To **anthropomorphize** an object is to ascribe human characteristics to it. We do it all the time to our pets, and artists often do it to nonhuman characters to make them more likable or sympathetic.

**Multiple limbs added.**

Now we see this creature's multiple limbs. At this point, it's kind of hard to tell what we're dealing with, but I am confident David is working from some reference and knows where he is going with this.

The ant takes shape.

And here we finally see our ant taking shape, with various-size ovals and circles to represent the segments of the insect's body. The head is a half oval, given big buggy eyes and adorned with antennas on the top. The limbs aren't even remotely human, but a series of long, thin, spiky objects.

Here's our finished ant figure, off to move that rubber tree plant. This figure has a neck added, and more details to his antennas and joints.

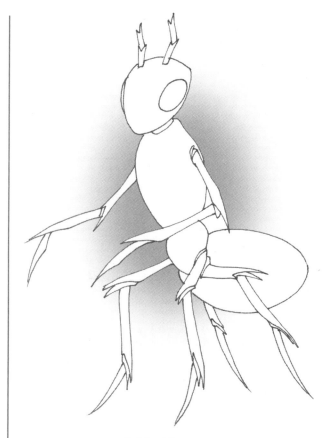

Finished figure.

Remember our discussion about eyeballs and the snake? It's the same principle here, as David leaves out eyeballs to accentuate the creature's alien aspect. But if you've seen movies like *Antz* or *A Bug's Life*, you'll recall those ants and bugs all had big ol' eyes. It humanized them, and made them characters we could relate to, and like. This ant here is inhuman, alien, and thoroughly creepy.

Again, insects (particularly spiders) make great bad guys. Grow them to human size, and the threat is even more horrible. Or nuke them with some radiation and let them grow 50 stories high—that makes for some monstrous good manga fun!

# A Whale for Your Tale

A single line depicts the whale's back.

Another very different type of animal to draw is fish, since they are neither quadrupeds nor bipeds, fowl nor fi—oh, wait a minute, they *are* fish. Fish are generally sleeker, with a body shape that is little more than an oval that comes to two points.

For this series of drawings, David is tackling the gentle giant of the sea, the whale, although you wouldn't know it from this single line depicting its back.

By the way, I am well aware that whales are technically mammals. Fish, in this case, is just shorthand for most of the critters that swim in the ocean. If you want to get technical, refer to a book on oceanography, whydoncha!

### Sketchbook Savvy

A reference alternative: For the artist on the go who might not have the time or desire to head to the library or the bookstore, there is always the World Wide Web. Google image searches can get the reference you need to you in seconds. That is, provided you have a computer and web access.

Fins and tail come next.

The next step in this figure is to add fins and a tail. Or, at least, mark where these parts are going to be.

The whale takes shape.

From our rough body outline, our whale takes shape in this figure, as we see its body, its tail, fins, eyeball, and underside. A line above his head marks the whale's blowhole.

Even a whale, which is more complex than the typical fish, is still basically a long almond-oval, with fins and a tail.

Here's our finished figure, with no added detail, just the removal of the guides, which were erased after David committed the figure to ink.

There is no eyeball on this figure. Again, David is preserving the inherent disconnect between humans and sea creatures, and David keeps them alien and different from us by not humanizing the eyes with pupils and highlights.

Finished figure.

# Introducing Mr. Octopus

A perfect circle captures the head of this creature, and two horizontal ovals outline what will be this beastie's many legs.

**A straight line begins this creature.**

In this figure David will go the opposite route he did with the whale, taking a sea creature that could not be more alien and inhuman, and making him comically sinister and even oddly likable by anthropomorphizing him.

We begin this upright figure with a simple straight line.

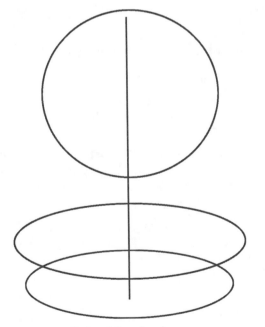

**Circles define the shape.**

**The creature takes on an octopus shape.**

The character takes shape, with eyes in the center of the face and upturned tentacles coming down from the head and facing outward all around the creature.

Finished figure.

In the final figure, David adds some shadows below the head and underneath the legs. However, what is surely most noticeable on this finished figure is the addition of the pupils, highlights to the eyes, as well as the thick eyebrows.

Although octopuses are certainly every bit as strange, alien, and ugly as an insect, fish, or serpent, this is a good example of how by keeping the design of the creature simple (such as, in this case, the perfectly round head) and adding humanlike facial features, you soften what could potentially be a very unfriendly looking creature into something less dangerous and alien. As it is, this could end up being the gruff but ultimately lovable sidekick in some seafaring fantasy or oceanographic adventure.

## The Least You Need to Know

- Because animal characters have radically different anatomy than humans, and have radically different anatomy from one another, a different drawing approach applies.

- You'll need to take differences in anatomy into account when designing your character. Having a visual reference on hand is highly recommended.

- Anthropomorphize animals and other creatures by giving them human characteristics in their facial features and body language. This can be done most easily by giving them large and expressive eyes.

- Conversely, you can make a creature seem more alien and unknowable and unapproachable by leaving the eyes blank and giving the creature no pupils.

## In This Chapter

◆ Just how creepy do you want your creature to be?

◆ A mélange of monsters, aliens, and creepy-crawlies

◆ Threatening attributes that make the monster

◆ How to introduce your creature to readers

# Chapter 16

# Creature Feature

We focused on critters in the last chapter, drawing members of the animal kingdom, both real and unreal. We looked at ways to anthropomorphize them and make them more sympathetic and "human," which is especially effective for sidekicks and pets. We looked at approaches to take when building differently shaped animals, like birds, insects, and fish. But there was one sort of animal we conveniently ignored: the *creature*. The scary monster or slimy alien. The sort of weird creeps and outer-space killers you don't want to anthropomorphize, because you don't want your readers to empathize with them … you want to scare the pants off your readers instead!

Yes, monsters and aliens are popular in manga. Keep in mind, Japan is the country that has been exporting *giant* monsters on film to America for a half-century, monsters such as Godzilla, Gamera, Mothra, and King Ghidora. Monsters also play a popular role in horror and sci-fi manga stories (although giant monsters are not as fashionable as they've been in movies). And, as long as we are talking about The Bad, The Deadly, and The Ugly, we'll lump in killer aliens along with the scary monsters, since killer aliens are, after all, just scary monsters from another planet.

# Making Monsters

Before designing your monster or alien, think about how it fits into your story. Exactly *how* alien do you want it to be? Is it a humanoid sort of alien, and does it come from a civilized and technologically advanced alien race? Does it wear clothing or uniforms? Does it carry weapons? Or is it savage and animalistic, a race that we would never be able to communicate with, or understand—or make peace with? In sci-fi movie terms, is it an Alien … or a Predator?

Think about the body shape you want. Is it a humanoid-shaped biped? If so, when you are building the body, build it more or less like you do the human body, with a thin line to represent the spine and the motion of the figure, and smaller lines to determine the limbs. Give the body form with geometric shapes and then tighten up your sketch as you pencil with details and definition.

If the body is nonhuman in shape, then you'll have to take a similar approach, but use an appropriate body shape, like we did in the last chapter with the kitty, the brontosaurus, the pterodactyl, and the ant.

Most likely, your creature will be based on features of different real-life animals, or maybe a composite of several. Maybe it has multiple legs like a spider, claws like a crab, or both. And, of course, always try to take things from animals that are scary, creepy, or weird. Mixing a sweet kitten with a fuzzy bunny isn't going to have the same effect, if your intention is to present your creature as a threat.

# The Uglier the Better

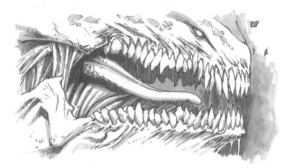

Here's a face only a monster could love.

For monsters and aliens, at least scary ones, which is what we are concentrating on, a good rule of thumb is the uglier the better. Forget clean lines and smooth circles and shapes. A creature's features are craggy and complex, shaped more organically, and packed with nuances and detail. These sort of creatures tend to be drawn in greater detail, since a detailed figure generally looks more realistic than a simplified or cartoony one. And something realistic, obviously, is scarier than something unrealistic.

Keep in mind, too, that to make something scary, it has to seem threatening. The most obvious way to do that is size. Just as the big kid picks on the little kid in the schoolyard, the biggest species always seems scarier, so make your monster taller and stockier and more imposing than your human characters—or it isn't going to be much of a monster.

Similarly, focus on the aspects of the creature that make it dangerous or threatening, such as teeth, claws, fangs, or long limbs. You know, things that could *hurt* you, that could bite, rip, tear, or rend one part of your body from the other.

In the previous drawing, David focuses on the teeth for this ugly ol' monster face, adding reptilian eyes and serpentlike blotches on the face, as well as numerous crags and lines on the chin (along with some slime and dripping saliva). Another nice touch is the area below the tongue and between the upper and lower

part of the face. This part of the creature looks like muscles do, implying this creature has a particularly strong and savage bite.

### Sketchbook Savvy

Many people are creeped-out by insects, reptiles, and arachnids. Try giving your creature some of their "scary" characteristics, such as scaly skin, pinchers, multiple limbs, multiple eyes, fangs, or stingers.

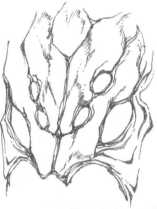

Bone face.

A different monster face is shown above, this time with multiple eyes, like that of a spider. The facial components are broken up in sections, which makes this figure look like it has a protective layer, possibly of bone, or some other damage-resistant exoskeleton.

## Mixing It Up

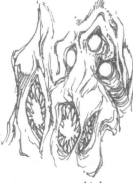

Monstrous multiples.

Another nifty trick to make a character less human is to alter human characteristics. It's bad enough to see a snarling monster with razor-sharp teeth, but it is twice as bad when the character has two mouths. In this case, David's alien has three mouths, three eyes, and a face that is both scary and hideous. If this figure is *actually* a face, that is. It could very well be the torso of the alien, or something found on one of the creature's limbs. And that is even weirder!

Insect-like creature.

This creature has an insect-like appearance, with a centipede-like, multi-segmented neck. In addition to oversized teeth and sharp fangs, it also has some pincer-type teeth jutting out of its lower jaw.

This creature also has some stuff hanging from it, although exactly what is unclear. As a rule, monsters are scarier when they are dripping or oozing.

### Mangled Manga

Don't skimp on the pus and ooze and slime. Bodily fluids are gross enough, but they take on an entirely new disgusting aspect when they come from a creature we can't identify or understand.

**Another monster with a toothy grin.**

In this monster face, similar to the first figure presented in this chapter, we see more sharp and deadly teeth. Note the nose is shaped like the nose holes of a human skull. Skulls, obviously, remind us of death. A monster that can remind us of our inevitable mortality is an effective monster, particularly one that *threatens* our mortality.

Not only does this next creature's head have multiple eyes, but the features we would normally associate as human have been moved about. Here, the "nose" is at the top of the face, while the eyes are below the nose and directly on either side of it.

**If Picasso designed an alien, it might look like this fellow.**

**Monster teeth.**

A close-up here on some monster teeth. Note that in addition to being oversized and pointy, the area above the teeth looks like a skeleton or mummified skull. Again, this is death imagery, which will make the monster or alien seem scarier.

**Why settle for teeth *or* tentacles when you can have both?**

Tentacles instead of bipedal limbs are effective additions to your wild and weird aliens. A pair of teeth at the end of each tentacle is creepier still.

### Sketchbook Savvy

There are plenty of unbelievably weird and creepy thingies that dwell in our planet's oceans. Consult some books on oceanography for reference on giant squids, octopi, and other alien-looking tentacled wonders that live in the watery depths.

And finally, David leaves us with a barely comprehensible monster, a mass of gnashing teeth and tentacles. This big, ugly monster simultaneously has the body shape of an octopus or squid, along with tentacles that have teeth *and* claws. The upper half of the body is divided into three parts, each covered with veins and a single very eerie eyeball in the center. The three

segments each resemble the mouth of a prehistoric fish. Clearly, David took a lot of disparate components and combined them to make this freaky thing that is purely an element of his imagination.

One more word about it: yuck!

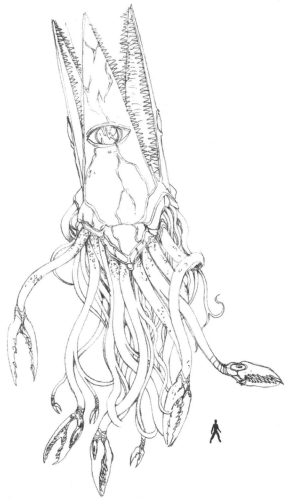

**What the ... ??**

# Introduce Your Alien

There is a final piece of advice to give you regarding your alien, monster, or creature. As much as you enjoyed creating it, and likely want to parade it around, it's a good idea to resist showing it. At least, you don't want to

show it right away. The best advice I ever got as a comic book writer was from comic creator Tom McWeeney, who said, "You only get one chance to introduce your character." This goes for heroes; this goes for villains; and this especially goes for monsters.

**Say What?**

There is only one universal passion: fear.
—George Bernard Shaw (1856–1950), British dramatist and playwright

There is the reason you don't see the shark until the last half hour or so of *Jaws*. Sometimes what is unseen is more powerful than what is seen; our imaginations have a way of scaring us more than reality ever can. Keep your creature in the shadows, keep it obscure and mysterious, and you will give your story more tension and suspense. Keep your readers on the edge of their seats and then reveal the character with a big and unforgettable introduction. Your comic will be much more powerful—and scary—as a result.

## The Least You Need to Know

- Design your creature to be threatening. Accentuate its horrifying or dangerous aspects.
- Creatures are drawn in more detail than less threatening critters. Detail equals realism, and realistic is scarier than unrealistic.
- Creatures should have characteristics of things that scare or repulse us, such as reptiles, insects, arachnids, or skeletons.
- Creatures might also be a composite of *several* different things that scare or repulse us.
- A creature might have multiple features from what we usually associate with the human face, placed in different places than the standard human face.
- Never show your creature right away. Keep it in shadow or out of sight, at least initially, to build suspense.

# Manga Nuts and Bolts

Manga is more than just drawing characters. After you've got a handle on drawing people, you're going to want to put them into a story, and in this part we show you some of the more technical aspects to enhancing your story. We explore ways to make your pictures appear three-dimensional, and other ways to give your drawings realism. We look at light and sound, angles and approaches, words and pictures, and the peculiar, unique, and ubiquitous manga storytelling element known as the speed line.

Remember, your goal is to make a comic book that you can be proud of and that people will want to read. Some of the advice we give you in this part is universal to all comics, and some of it is exclusive to manga. In either case, your comic—and your artistry—will grow stronger a result.

# In This Chapter

- ◆ The importance of perspective
- ◆ Perspective and scale
- ◆ Vanishing points and horizon line
- ◆ Points of perspective
- ◆ Useful perspective tips

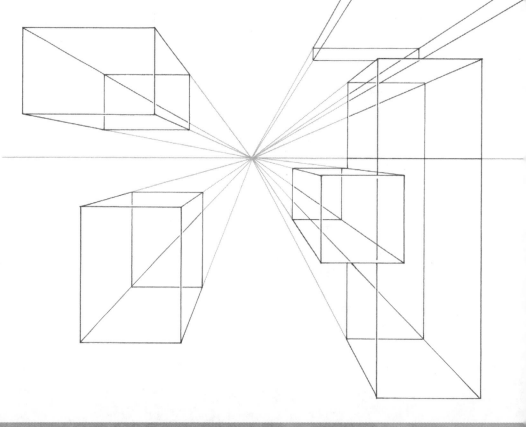

# Put It Into Perspective

Fair warning: You're going to need a ruler for this chapter!

We're moving on to the nuts and bolts of manga now. I've given you a good starting point and reference to create dynamic characters, so now it's time to talk about how they interact with their worlds. From an artistic perspective, that is.

Of course, by "artistic perspective," I mean from the artist's viewpoint. Conveniently, perspectives and viewpoints just so happen to be the subject of this important but somewhat technical chapter.

## What Is Perspective?

We'll discuss throughout this section of the book ways to make pictures and panels in your book more believable and real. This can be done with light and shadows. It can be done by simulating movement and effectively conveying expressions and emotions. And it can be done by capturing the proper *perspective*.

**Manga Meanings**

**Perspective** is the technique for representing three-dimensional objects to produce the impression of distance and relative size as perceived by the human eye.

Perspective is the way, in comics, to show distance. It's a way to give a two-dimensional drawing the illusion of depth. It's a way to let your pages appear to contain three-dimensional space.

Look into the distance. Something near you appears larger than something farther away from you, even two things you know to be of equal size. This chapter is devoted to figuring out perspective and to show you some of the strengths proper perspective will bring to your drawings.

# Points of Perspective

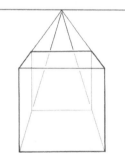

**Simple one-point perspective.**

This figure is an example of one-point perspective. What is the point of this, you ask? It's to give a square dimension, so we see it as a cube. If we were staring at it straight on, it would simply be a square. But from this perspective, it is a cube. It is a structure rather then just a shape. It has three-dimensional space to it.

To do this, David started with his *horizon line*, a straight horizontal line running the width of a panel. Below it, he draws a square and

assigns a vanishing point to the square, a place where the parallel lines of each corner of the square recede into the horizon. A second, smaller square is added behind the first square, and its corners fall along the same path as the parallel lines on their way to the *vanishing point*.

**Manga Meanings**

The **horizon line** is the line where the horizon and sky appear to meet. The **vanishing point** is, in perspective, where parallel lines appear to converge on the horizon line.

Where the previous drawing was an example of a single object in one-point perspective, we see in the following figure that you can also draw *multiple* objects in a one-point perspective. The receding lines of all the objects converge upon a single point.

Note, too, that objects can be above or below the horizon line, and they can be much differently shaped. This perspective might come in handy if you were following vehicles racing down a highway. Or, if you put objects above and below the horizon line, it makes for a dramatic shot of a group of spaceships all headed toward a single destination, hundreds of light-years away.

A one-point perspective is the most basic sort of perspective, the most limited way to give an object dimension. But it still makes for a more dynamic angle than staring at a boring old square head-on.

The next figure is an example of two-point perspective. As you might have guessed from its name, there are two vanishing points where two different sets of parallel lines converge.

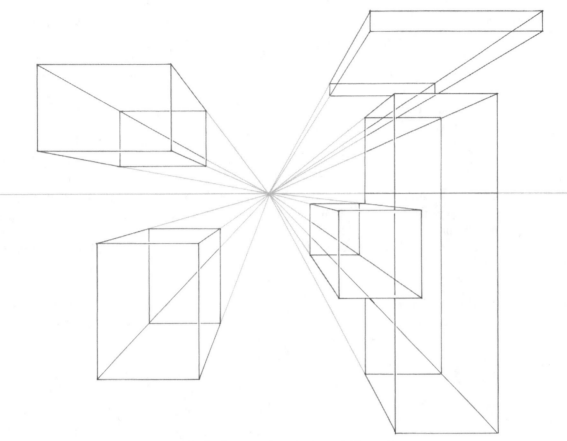

Multiple objects with a single vanishing point.

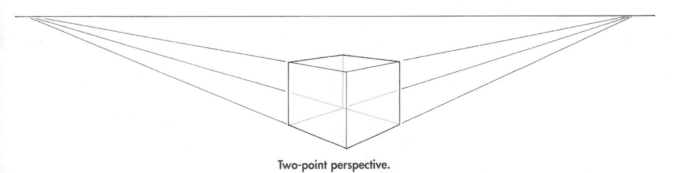

Two-point perspective.

Two-point perspective gives an object even more dimension. Where in one-point perspective we saw the front and top of a cube, here we see the top, as well as two sides.

This shot is particularly good for cities and vehicles. However, if you decide to draw every building from the same two-point perspective, it will not appear completely realistic, because rarely are buildings and city streets completely uniform. A better alternative would be to draw several of the buildings from one two-point perspective and several others from a different, two-point perspective. It's more work and will involve lots of erasing of different vanishing points, but it's the best way to achieve a realistic cityscape.

### Sketchbook Savvy

Horizon lines do not need to be perfectly horizontal. You might try putting your horizon line at an angle. It might even be vertical, depending on what you are drawing.

Shown below are multiple objects, this time in a two-point perspective. In this case, the various rectangles are solid, rather than "see-through," to give us some idea of how this might look as objects with form.

On the next page is our last type of perspective, three-point. In this case, we have our two points, one on each side of the horizon line, and have added a vanishing point going straight into the ground. This gives the figure an additional level of dimensionality. It appears we are looking down at the figure from above. Naturally, this perspective would be ideal for seeing a city, object, or character from a high vantage point, such as from a plane, helicopter, or flying through the sky.

You could also draw this so the third vanishing point extends into the sky. That would change the perspective from looking down to looking up and might be most effective for a child's point of view, a small character in a large world, or someone entering a great forest or looking up at a mass of impressive skyscrapers.

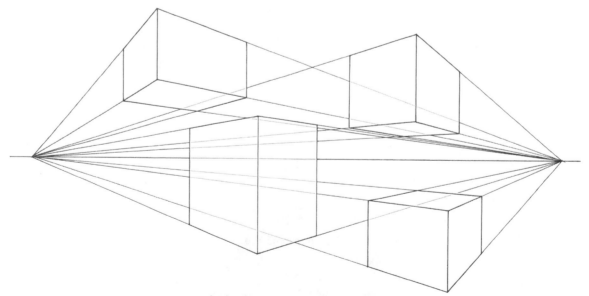

**Multiple objects in two-point perspective.**

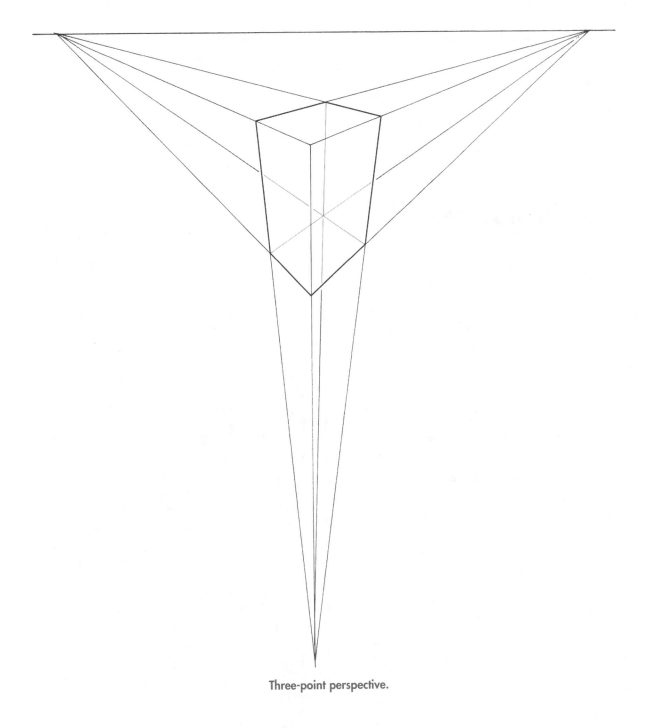

**Three-point perspective.**

### Mangled Manga

Although it is technically possible to draw things in four- and five-point perspective, and even higher, there is no need to. We exist in a three-dimensional reality, of height and width and depth. Adding other points of perspective will add nothing to your drawing.

# The Bisected Square

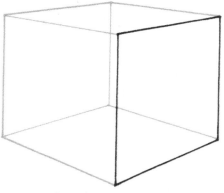

**Three-dimensional cube.**

We are going to show you some helpful ways to accurately determine scale and illustrate how a different perspective can change a shape. Both examples require you to "cut up" a square into pieces, so we're going to illustrate that first.

Here we begin with a standard three-dimensional cube.

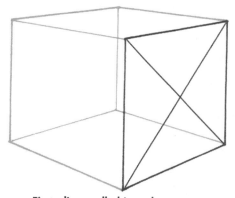

**First, diagonally bisect the square.**

The first thing to do is diagonally bisect the square, drawing two straight lines from one corner to its opposite corner. It will look like you are drawing a big "X" on one side of the cube.

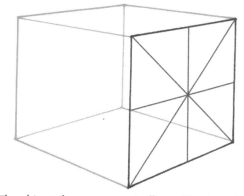

**Then bisect the square vertically and horizontally.**

The next step is to bisect it vertically and horizontally. This will look like a "plus sign" laid atop of your "X," with all points intersecting in the middle.

# Perspective and Scale

As we said, objects appear smaller the farther they are away from you. Here's a trick that will help you maintain scale and keep things proportionally in perspective. We begin with a bisected square, heading off to a one-point vanishing point on the far right.

Here we add a new line. This line begins at the far corner of the square. It intersects with the horizontal line, bisecting the square, and then continues outside the square, until it intersects with the top vanishing point line.

See the point where the new line now intersects with the top vanishing point line? If you draw a vertical line from that point, you will have a new square, perfectly in perspective and proportion with the first square.

After you've made the second square, you can follow the same step and make others. Note that each square is getting shorter, and thinner, as the vertical lines are closer together the farther away they are.

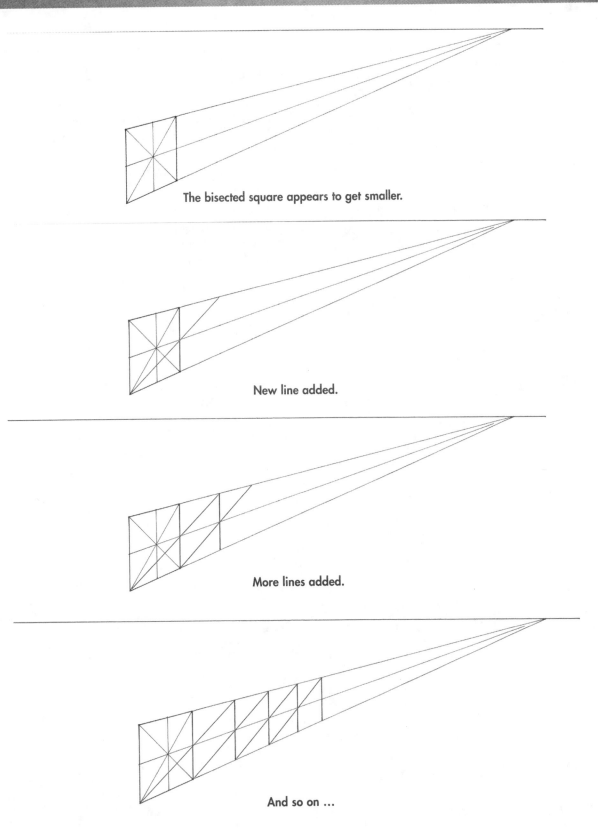

The bisected square appears to get smaller.

New line added.

More lines added.

And so on ...

You can continue this trick until the lines are so small you can barely make them out. This is valuable to know if you are doing something repetitious, like making uniform windows on a building, or if you want the back wheel of a vehicle to be in perspective and scale with the front.

Of course, wheels are generally circular, not square, so we'll talk about that next.

### Mangled Manga

Don't draw your perspective lines too dark. They are just guides and will eventually be erased.

# Circles in Perspective

Perspective does not just alter scale, it alters shape as well, and the following figures should illustrate this point. We begin with a square in a two-point perspective, bisected vertically, horizontally, and diagonally.

Circles are often tricky to draw in perspective, and here is a trick to do so accurately. Using the square and the lines bisecting it as guides, David draws a circle, the outermost curves of the circle intersecting with the vertical and horizontal split in the square.

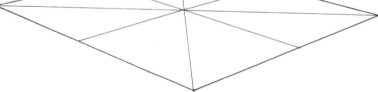

Begin with a square in two-point perspective.

Add a circle in the square.

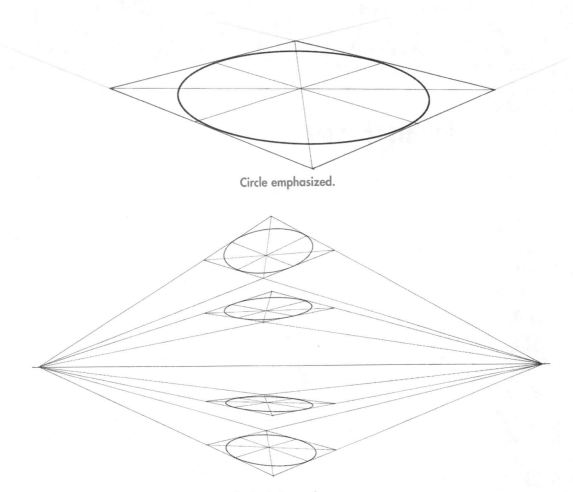

Circle emphasized.

Multiple circles and squares.

In the top figure, the circle is emphasized to get a better idea of its shape. Of course, a circle in this perspective is more of an ellipse, a circle that is stretched, with slightly longer, flatter sides.

The next figure better illustrates how circles and squares change their shape based on their perspective. This figure features a variety of squares, and circles within, drawn from a two-point perspective.

Note that the closer to the horizon line and the flatter the squares appear, the skinnier and less circular the ellipse.

## The Least You Need to Know

◆ One-, two-, or three-point perspective adds dimension and realism to your work.

◆ Vanishing lines converge upon a horizon line, sometimes from multiple points.

◆ Objects farther away from the viewer will appear smaller.

◆ Objects will appear to change shape based on the direction from which you are looking.

# In This Chapter

- ◆ Choosing your shot

- ◆ Medium, close-up, and long shots

- ◆ The establishing shot

- ◆ Dynamic angles: bird's-eye view, worm's-eye view, and rotated angle

- ◆ Dramatic foreshortening

# Chapter 18

# All the Angles

Back in the chapters in which we explored faces, we stressed the need to vary the angles in which you present the faces, for the sake of keeping things visually interesting. This applies to not just faces and figures, but *all* aspects of your visuals. Remember, your job, and your goal, is to keep the readers interested, to compel readers to want to continue to read page after page. Comics are visual storytelling, so never forget: *Keep the visuals interesting*.

A great way to do this is to vary your shot. We're going to use a lot of movie lingo in this chapter, and that's completely appropriate. Creating a comic is like directing a film, especially how you choose and frame each shot and angle. But it's so much more than that. You're not just the director, but also the cinematographer, the film crew, the editor, the entire cast of actors—even the screenwriter.

One of the primary benefits to making a comic is that you are in total control of your story. Of course, the downside is you won't make the millions of dollars that Steven Spielberg does on his latest summer blockbuster, or George Lucas with his most recent prequel, but just think of your special effects budget! If you want to blow up a planet, you can. If you want a high-speed chase in your story in which you total a dozen Lamborghinis, you can. If you want a vast battle scene that features a thousand soldiers, you can. Just so long as you are willing to draw all of it, that is.

So in this chapter, we're going to put on our filmmaker's cap and settle into the director's chair. It's time to explore shots in manga and how to choose the most effective shot for your scene. Now, quiet on the set. Lights … camera … action!

## Three Basic Shots

There are three crucial types of shots in comics, just as in movies: the *wide-angle* (or *long*) shot, the *medium* shot, and the *close-up*. All have different strengths and purposes, but each is a crucial part of your overall drama.

A comic book panel is going to be one of these shots, most likely, and the majority will be medium shots and close-ups, so we'll discuss and contrast them first.

**Manga Meanings**

A **wide-angle** or **long** shot is one that takes in a lot of space and shows a lot of area. A **medium** shot moves the "camera" in on the character, so we get a better look at him or her. It still maintains some distance, so it usually shows the character from the waist or chest up. A **close-up** is a tight shot of a character, usually just the face.

A medium shot.

This is a good example of a medium shot. We are close enough that we see two characters. We aren't so close that we can't see what the figures are wearing or how they are standing or moving in relation to each other. However, we're also not so far we can't see the expression on the characters' faces.

This is a great type of panel if you want two or more characters interacting with each other or speaking to each other, as this type of panel generally leaves plenty of empty space for dialogue balloons for each character.

A close-up.

And here is an example of a close-up, as the "camera" moves in from the previous shot, and we find ourselves face-to-face with the injured boy from the previous panel.

Close-ups most often center on just one character. It is an effective shot to spotlight

that character, to focus on him (or her, but not in the case of this particular panel) as he delivers some crucial bit of dialogue, or has some pivotal reaction.

Obviously, since this is the closest we see a character, it is this shot in which we see the most of the character's features and get the best sense of his (or her) emotions. The close-up is the shot with the most intensity and immediacy.

### Sketchbook Savvy

A close-up does not need to just be a face. You can focus on any object or body part in a close-up. A nervous hand inching toward a gun. A valuable book on a table. Maybe even some cleavage that a randy character cannot tear his eyes away from.

Here's another example of the medium shot; this one is more wide than tall (comic shorthand for this is *widescreen*, another term lifted from moviemaking).

In this case, this widescreen medium shot allows us to see several characters placed more or less side-by-side. There is also plenty of room for dialogue balloons, in case this crew is feeling particularly chatty.

On the next page is a second example of a close-up. In this case, it does not focus on a single character. Rather, we move in on the entire group. This is a good example of how we can get a much better look at the characters' faces and, hence, a better sense of what they are thinking and feeling.

Of course, the downside to using a close-up is there is less room for dialogue, so that's something to think about when drawing every page and panel.

### Mangled Manga

Always take into consideration when designing each panel the amount of dialogue on that panel. You'll need to leave enough room for the dialogue, or you're going to end up with dialogue balloons covering your art when the book is lettered.

A widescreen medium shot.

A group close-up.

## Getting Extreme

There is one last type of close-up we have not yet mentioned, and that's the extreme close-up. As the name suggests, this is a shot in which you move in very tightly on a character, and this shot is so tight and so close that you see one only aspect of the character's face, such as the eyes or the mouth.

And just as the close-up ratchets up the emotional intensity, the extreme close-up is even more powerful. As the art takes up the majority of the panel, there is very little room for dialogue, so it is best kept to a minimum, like a short declaration, threat, or promise—something brief but important to the character. It's also a great device to add to a suspenseful atmosphere, as you focus on a furrowed brow and a look of pure determination, or beads of sweat on a nervous or scared character, or the pursed lips of some femme fatale or seductress.

**An extreme close-up.**

## Going Long

A wide-angle shot allows us to take in the character's entire body, or multiple characters, as well as the character's surroundings. In this shot we see three characters, the entire bodies of two of them and three-fourths of another, with plenty of room in the panel for a great amount of dialogue, as well as a good idea of what is around the characters (of course, if you cover the panel with dialogue you will lose the surroundings, so pick which is more important in this particular panel or find some middle ground).

As the next figure illustrates so well, a wide-angle shot is also an ideal way to convey a sense of scale to the reader. Depending on the story, these soldiers are either leading that injured kid through a very big door, or all three characters have somehow been shrunk very small.

In this wide-angle shot we pull back even farther to show our three characters, who seem very small against the gigantic door of this

humungous building. Again, this shot definitely shows the three characters in relation to their surroundings. The downside to such a wide shot is that the characters are very small and hard to make out, but sometimes that's the intention.

Wide-angle shots are especially good for an establishing shot, which is a shot that shows you the exterior of the building or place where the action is taking place, before moving inside. This puts the scene into perspective for the reader and is a great way to keep your story clear and avoid confusion.

### Mangled Manga

An establishing shot of a building or place may seem boring, but if you do not establish where your characters are from one scene to the next, you are going to have a very muddled and confused story. A good idea is to have an establishing shot at or near the beginning of every new scene.

**A wide-angle shot.**

Another example of a wide-angle shot.

Rotating the same image slightly.

The bottom image is not radically different from the top one. However, you'll note the image has been rotated to the side slightly, and we are looking at it from a lower perspective. We're going to talk about that next, but for now, please compare the previous two panels and notice how with these subtle changes, David has made the image of the giant building appear more interesting, as well as more sinister and foreboding, in this figure.

# New Views for You

There are other ways to keep your shots dynamic and fresh and interesting, beyond rotating between wide, medium, and close-up shorts. Here are a few more angles to choose from, in the interest of giving your visuals a fresh perspective.

The following shot is what's known as the bird's-eye view. As the name suggests, this is an overhead shot, looking down from above. This particular shot is a medium shot, but often bird's-eye view shots are wide-angle shots and can convey a sense of scope and size—but from a far more dramatic point of view. There is a sense of detachment to these sort of angles, as well as some *omniscience*, as if we are "stepping away from it all," and able to take it in from a more impartial perspective.

You've probably seen this image in a dozen movies: Somebody has been shot and is lying on the ground, and the camera pulls back—up, up, up—and we see the corpse from overhead, as the blood slowly pools out from the body. Pulling back from a dramatic shot is an effective way to give your reader two perspectives on a very emotional event. The close-up puts you as close to the character as possible, and helps you feel what the character is feeling. As you pull back, you detach the reader, in effect, forcing them to say good-bye to your character whether they want to or not. First you make

the reader feel the suffering of the character, then you isolate the character to suffer all alone. Both are devices to make your reader empathize with your character.

### Manga Meanings

The **omniscient** narrator is all-knowing, getting into characters' heads and knowing their thoughts and feelings. An omniscient viewpoint shows us an angle that cannot be seen by the characters or shows us something the character cannot know or see.

The opposite of the bird's-eye view is the worm's-eye view, which is a shot from the ground, looking up. In a panel such as this, one can look up to a medium or wide-angle shot and get a sense of the scale of skyscrapers, tall trees, or mountains. This is a more personal type of shot, as we see things not from an omniscient point of view, but more as an everyman.

This can also be a very forceful and dramatic shot. Put a character in the foreground, in close-up, roughed up, injured, and trying to crawl away, while some thug is towering over him threateningly. That's a very dramatic and dynamic example of this type of shot.

Another type of shot is the rotated angle. This wide-angle shot is slightly off-kilter, tilted, and helps emphasize the chaotic movement in a fight scene or a chase. An angle such as this contributes to an atmosphere of pandemonium and helps the reader relate to the character, throwing the reader off balance in the same way the character is.

### Mangled Manga

Dynamic angles such as the bird's-eye view, the worm's-eye view, and the rotated angle should not be overused. Use them too much, and these angles will lose their effectiveness.

A bird's-eye view.

A worm's-eye view.

A rotated angle shot.

# Foreshortening

Foreshortening is another device that can make a panel very dynamic and exciting. It is a trick of perspective, in which the part of a figure or object closest to you is drawn larger. It's a very in-your-face effect, particularly effective during action sequences, when kicks and fists are flying furiously.

In the following figure we look up at a character who is leaping away from us (or possibly leaping toward us). Her foot and leg are closest to us and appear much larger, and the rest of the figure gets thinner and smaller toward the head, giving us the sense that that part of the figure is the farthest away.

### Mangled Manga

Foreshortening can be tricky and requires a lot of practice, as well as an understanding of perspective. Get it wrong, and your character will simply appear to have grossly disproportional limbs. Again, this technique will lose its effectiveness if you use it too often.

Next we see another example of foreshortening, from a reverse point of view than the previous figure, this time from a bird's-eye view. In this case the fingers, hand, and forearm are much larger than the rest of the body, and the lower body gets progressively smaller, appearing to be the farthest away from us.

## The Least You Need to Know

- Varying the type of shot you choose is crucial to keeping your story visually interesting.

- Close-ups and extreme close-ups are good ways to convey the intensity of a character's emotions. Medium shots are an ideal way to show several characters interacting. Wide-angle shots convey a sense of place and scale.

- Using an establishing shot at the beginning of each scene helps keep the story clear to the reader.

- Dynamic angles such as rotated shots, bird's-eye, and worm's-eye can be extremely and dramatically effective but are best used sparingly.

- Foreshortening is tricky and requires knowledge of perspective but is another great way to make your panel different and exciting.

An example of foreshortening, from a worm's-eye view.

An example of foreshortening, from a bird's-eye view.

# In This Chapter

◆ How speed lines add intensity to a drawing

◆ Radial and straight speed lines

◆ How to make speed lines

◆ Special techniques to convey motion and energy

# Need for Speed

There are few stylistic devices more unique to manga (and anime) than speed lines. Although lines to indicate motion are often used in American comic books, they are usually used sparingly and intended to make a more literal point, such as to re-enforce the direction or flow of movement.

Speed lines in manga are very different, and to someone unfamiliar with manga, perhaps a little difficult to understand. This is because while speed lines are used to show movement, they are also used to express emotion or intensity, sort of the Japanese visual storytelling equivalent of the English written word's exclamation mark. And don't let the name fool you. Speed lines often have nothing to do with speed.

Speed lines have no one definitive meaning, but as we explore different types of speed lines in this chapter and compare panels with and without speed lines, you should get a better sense of how this unique stylistic device can help give your panels and pictures intensity and pizzazz.

# To Speed or Not to Speed?

Here's an example of a panel without speed lines. Clearly, we are viewing a tense situation, and we are either in the middle of a deadly firefight or a standoff that might potentially lead to one.

Next we see the same panel, but with speed lines added. In this case, these are *radial* speed lines, spreading out from a circular radius, centered behind the three gunmen, whose predicament is the primary focus of the panel.

Again, the speed lines have the effect of a visual exclamation point, adding intensity and immediacy to the shot. In this case, the speed lines are intended to re-enforce the tension of the situation. Speed lines can make an action sequence more exciting, but as we will see, they can also be used to emphasize *internal* drama.

### Manga Meanings

**Radial** speed lines extend outward from a circular point. **Straight** speed lines are, well, straight.

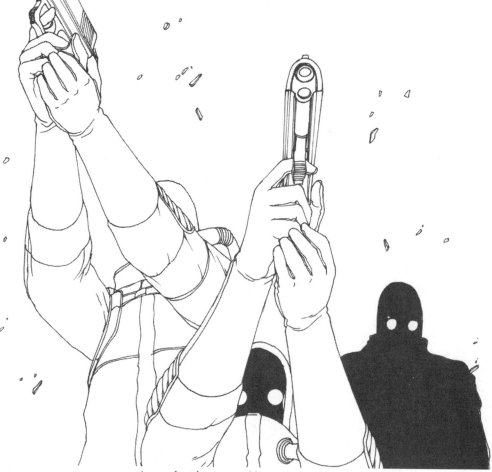

A panel without speed lines.

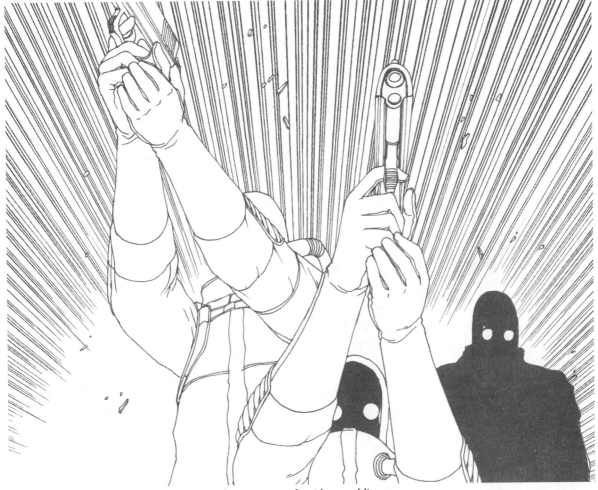

**The same panel, with speed lines.**

On the following page is another panel without speed lines, although this panel is not so much action-oriented as simply dramatic. Perhaps it is a villain making some dire threat or a general rousing his troops to war.

Next we present the same panel, but with speed lines added. In this case, the lines are *straight* (as opposed to radial). They are vertical and heaviest and most numerous as they head away from the character.

Again, in this case, the lines add dramatic emphasis to whatever this character is doing or saying, letting you know that whatever is going on in this panel or being said is a little more important than the average panel or throwaway line of dialogue.

Why did David choose straight speed lines in this case, rather than the radial lines of the previous figure? There is no specific reason. It is a stylistic decision and, as the artist, it's your decision to make.

A panel without speed lines.

The same panel, with speed lines.

We're going to show you other types of speed lines and their effect throughout this chapter, and they are yours to do with whatever you want. It's your decision, and there is no firm rule about speed line usage, or even whether or not to use speed lines.

You don't have to use speed lines at all, if you have some adversity toward them. Just know that speed lines are a very popular effect in manga, and you will find them in a great, great majority of the manga books you read.

### Sketchbook Savvy

Don't worry about overusing speed lines. Some artists use speed lines nearly every page, others use them sparingly to emphasize very dramatic moments. How *often* you use them is a matter of personal preference, as is whether you choose to use them at all.

And then there are times in a book when nothing action-oriented is happening, and no dialogue of earth-shaking importance is being uttered. But here there is a different sort of dramatic emphasis, in which something is going on with a character internally. Maybe it is a reaction shot, a grand epiphany, or some matter that's at least as urgent as being shot at or roused into war. Or, at least, it's that important to your character and has a similar sort of dramatic or profound effect inside your character's head.

In the case of the next shot, we see a plain panel, and a reaction shot of a character. Maybe this character has been told his girlfriend is dumping him, or something like that.

Next we see the panel with speed lines. It intensifies the dramatic effect. Perhaps not only is this chump being dumped by his girlfriend, but she is telling him she is getting a sex

change—and also intends to marry an alien from outer space. In this case, David has chosen radial speed lines to emanate outward from the face (the face, remember, is the most expressive part of the body, and hence the focal point of emotion).

You might note that these radial speed lines are only a half circle and radiate outward farther away from the character than the radial speed lines of the men with guns. Again, this is a stylistic decision, partially determined in

order to leave more blank space around the face. It's also determined by the shape of the panel, which has less *negative space* around the upper panel and left panel than the picture of the men with guns.

**Manga Meanings**

**Negative space** is exactly what it sounds like: space in a panel either filled completely black, with a tone, or completely white.

A plain panel without speed lines.

Speed lines give this panel more intensity.

The same panel, with different speed lines.

Here is another take of the same panel, this time trying a different approach to speed lines. The lines are still radial, extending out from a circular point behind the character. Only this time the lines are curved and fill more of the initial panel's negative space.

Which do you like better? There is no right or wrong here, just multiple options. Go with what you feel works and looks best, even if that is nothing at all.

Taking the previous panel out of context, we have no idea whether the character is reacting to a literal threat or person or event, or whether this is simply an emotional response. It could be equally effective either way. In this case, David chose straight lines, extending from a center point clearly below the girl and *off-panel*.

**Manga Meanings**

**Off-panel** is something that happens outside of the comic panel. Sometimes it is dialogue coming from a character not featured in a panel. Sometimes it is an action that is intentionally left unseen.

Now here's the same panel, with a different approach taken to the speed lines. These lines are curved and less concentrated, with a center point closer to the face. And because it's closer to the face, your character's emotive center, it's likely that this is a more emotional response, or a response based on internal fear or worry.

Another panel with speed lines.

The same panel, with different speed lines.

Speed lines don't have to be as thick and/or concentrated as we've seen in the previous examples. Sometimes, as in the case of this extreme close-up, art is taking up the majority of the panel, and you will not want to cover it up.

In this panel, however, we get another look at our intense friend whom we met when discussing extreme close-ups in the last chapter.

Close-up without speed lines.

Close-up with speed lines.

With just a few lines, you can dramatically intensify the atmosphere, without covering or adversely affecting the art. In this case, with just a few strategically placed straight speed lines coming from the center point of the face, our featured character seems to be focusing intently on something or someone. In the case of this panel, the action could be external; perhaps he's drawn a gun at the same time as an enemy and is now staring him down, wondering who will pull the trigger first. Or … the action could very well be internal. He's just had a bright idea that will make him a fortune and allow him to rise to the top of his dog-eat-dog corporate ladder.

It should be noted that speed lines are not just for people; they also can be used for things. Specifically, *vehicles* in motion.

In this figure, David has given us a bird's-eye view of a vehicle. However, there is nothing in this figure to indicate that it is actually in motion.

To achieve an effect that won't become clear until the next panel, David has added some parallel lines to denote the shadow underneath the car.

And in the final shot, David adds straight parallel lines to the rest of the panel's negative space. The speed lines overlap into the lines of the shadow, making the shadow stand out as darker than the rest; otherwise the shadow would be lost in the figure. Another option would have been to simply ink the shadow solid black, but I believe this is a cooler visual effect.

With speed lines added, this panel now conveys the idea that this car is racing at a furious speed and turning at a breakneck pace.

Bird's-eye view of car, without speed lines.

Same panel with speed lines added.

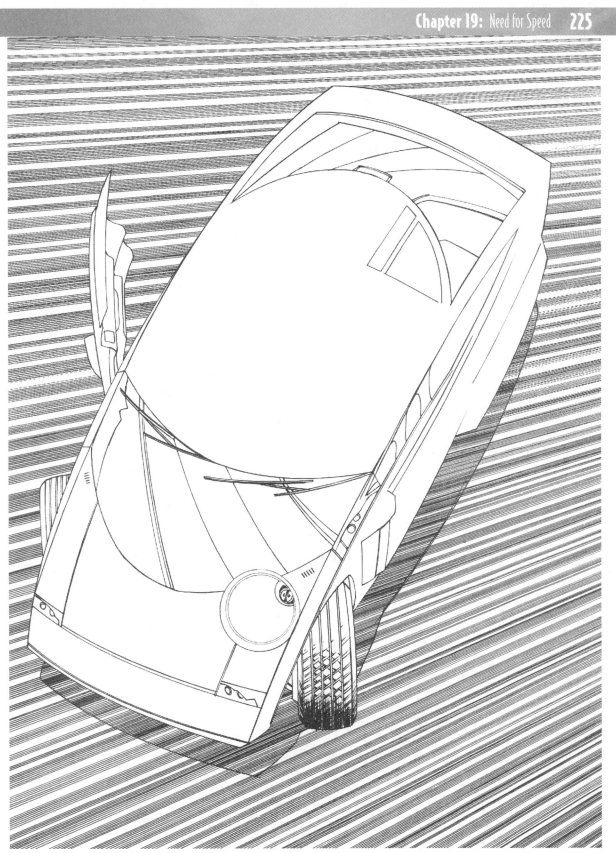

More speed lines added to convey motion.

# Speed It Up

Here David offers his technique for making speed lines. David goes straight to ink for speed lines; no mussing with pencils. (Although you certainly *can*, if you want.)

David keeps the lines straight, anticipating his desired length ... and then he flicks his wrist backward at the end of the stroke to give the line the effect of tapering away into nothingness. Your lines will not be perfectly consistent, but that's okay. As you see from the previous speed line examples, the speed lines are all different lengths, shapes, and thicknesses, even within the same panel.

Using a rolling ruler allows you to keep your lines parallel.

# Walking the Fine Line

Horizontal speed lines.

The same lines, but tapered.

Same lines with white spots added.

Horizontal speed lines are good for conveying movement, particularly if a character or vehicle is in motion from one side or the other.

As we said, lines can be a variety of thickness and concentration. In this case, the lines are the same thickness, although spaced at different lengths from each other. Keeping them the same length would be too difficult and might take away from the spontaneity of the effect you are trying to achieve.

Next are the same lines, adding the tapering effect we just showed you how to do. Again, there is no right or wrong way to these; however, the tapering of the lines gives them a blurred quality and suggests even higher speeds than the previous figure.

David takes the previous figure and adds some small, random dollops of white ink or White-Out. This is a nice effect to use when a character is speeding through an urban area, as it suggests the character streaming by city lights at a furious speed.

# Burst of Energy

"X" marks the spot.

Here David walks us through the steps of making radial speed lines. We start with an "X." Easy enough, right?

Draw a circle around the "X."

Next, a circle is made around the X. It doesn't have to be a perfect circle. It can be any circular shape you desire, taking into account where you want to place it in relation to the particular figure and panel on which you are working.

In the next step, we are not asking you to draw a thumbtack. It is simply a tool to keep the lines centered. In the case of radial speed lines, a handy trick is to grab a thumbtack from your desk drawer or bulletin board and put it in the center of your X.

Add a thumbtack.

Swivel around the thumbtack.

Using the thumbtack as an anchor, swivel your ruler around and make lines that all extend outward from a single and consistent center point.

**The inked speed line figure.**

These speed lines are thick and dense, each line tapering off toward the center. (This tapering effect can also be done with a brush, not just a pen, although it requires some fluency with a brush and ink.)

**The final speed line effect.**

David fills the remainder of his figure with ink. That's because this particular speed line drawing is very dense. Whether you choose to do this will depend on what your lines look like

and what effect you are trying to achieve. This particular speed line effect does not mean one particular thing. While it could indicate a burst of physical energy, it could also be an outburst of *emotional* energy. It all depends on the context of the drawing the lines are put in.

## Last Line

So now that you know about speed lines and how to make them, try photocopying a panel and trying different types of speed lines, straight and curved, thick and thin, horizontal and vertical, radial and parallel. Some choices might work better than others, depending on the shape and composition of the particular figure or panel, but you're not going to figure out what you like best on your own stuff until you give it a try.

### The Least You Need to Know

◆ Speed lines are an effective device to add intensity to an action scene, as well as an emotional scene.

◆ Speed lines are not always used to show speed. They are often for dramatic emphasis, both external and internal.

◆ Some speed lines are straight, some are curved. Some are parallel, others extend out from a circular point. Which one to use depends on personal preference.

◆ The face is the focal point of a character's expressions and emotions. Radial speed lines around the face often signal a character's internal emotional turmoil.

◆ Making speed lines is an imperfect science. The lines will vary in size and length, and that's okay.

◆ Horizontal speed lines are ideal for conveying motion, while radial speed lines are best for indicating physical and emotional energy—both bursts and outbursts.

# In This Chapter

◆ Light and shadows as mood enhancers

◆ Consider the (light) source

◆ Lots of lighting examples

◆ Silhouette techniques

# Light Up Your Life

Light and shadows are valuable tools to add realism to your book, as well as dimension and atmosphere. Everybody knows that lighting (more specifically, *lack* of lighting) is a crucial aspect to making a successful horror movie. Gangster movies and crime noir are typically blanketed in shadows, while children's movies are bright and light and happy.

Light and shadows play just as important a role in comics, particularly in the black-and-white world of manga. The proper lighting effect can make a character appear more mysterious or sinister. Light and shadow can also give your book a more realistic aspect and make the figures and the world you are creating seem a little more three-dimensional.

## Source, of Course

Any time you are dealing with light, or shadow, the first and most fundamental thing to consider is your light source. What is it? And where is it? Are you outside on a partly cloudy summer day? Hovering around a raging campfire at night with the full moon overhead? In a room with a mass of fluorescent overhead lights? Or is there but a single flickering candle? In each of these cases, the light will be a different intensity and coming from a different direction or directions (hence the term "light source"). And just as the light will consistently differ between time, place, and circumstances, so will shadows, growing longer and shorter, even lighter and darker, and falling in every direction.

# Illuminating Illumination

A shadowless shot.

Lit from the side.

We begin with a control shot, a three-quarter angle of a girl, with no shadows on her. Keep in mind as you read this chapter, nobody is saying you are required to draw shadows. However, in the examples that follow, you'll get a pretty good idea of how shadows can affect and enhance a picture.

Also note that David left the eyes hollow, with no detail or highlights to the pupils. He did this knowing he would be doing several versions of shadows falling across the girl and wanted to experiment with different lighting effects on the eyes. No one effect is correct; he is merely offering options and alternatives.

For this figure David has added a tone to the parts of the face where shadows will fall. Looking at this picture, and the subsequent ones, we'll be able to tell where the primary light source is, as well as sources of other light, and ambient light.

In the case of this figure, the light source is coming from the right side, which casts a shadow on the other side of her face, as well as behind her hair, and various parts of her braids that are not facing the light source.

In this image David colored the eyes the same tone as the shadow, where he adds black to the pupils and highlights in the next image. This is purely subjective on David's part, just a matter of personal preference.

## Sketchbook Savvy

Don't just consider a light source, consider whether there are *multiple* light sources. Often there is more than one in a particular place.

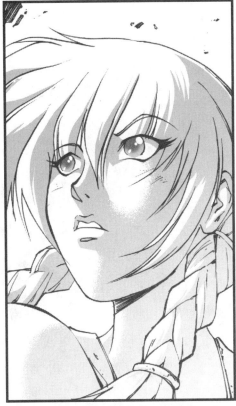

**Sunset or dimly lit room.**

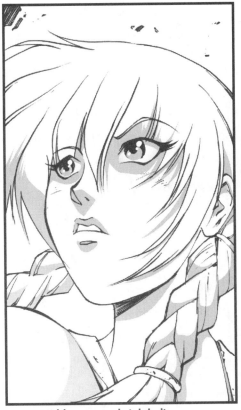

**Midday sun or brightly lit room.**

There are not a lot of shadows falling across this figure's face, so it is safe to assume it is a relatively bright day out (or she is in a relatively bright room). Shadows fall beneath the character's hair, nose, and mouth. Likely the sun (or other light source) is high in the sky overhead.

Here is a figure with a dimmer light source, possibly a sunset, judging by the soft edges between the light and the shadow. Dave achieved this effect in Photoshop.

By the way, we should note that all these shadowed images are based on the original unshadowed image. David scanned that picture and has manipulated the shadows on the computer, rather than trying to redraw the same piece over and over again.

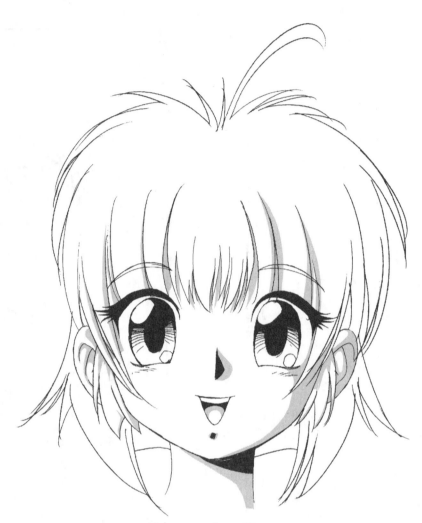

**Light source from above.**

We'll explore shadows on a different image now, this time a frontal close-up shot of a young girl. This is another image where the light source comes from above and a little to the left (our left, the girl's right). We can tell the light source is not directly overhead by the shadows falling across the lower left side of the girl's face, in addition to the shadows caused by the hair, nose, and chin. Her left ear has more shadows across it than her right ear, too.

**Say What?**

Where there is much light, the shadow is deep.

—Johann Wolfgang von Goethe (1749–1832), German poet and dramatist

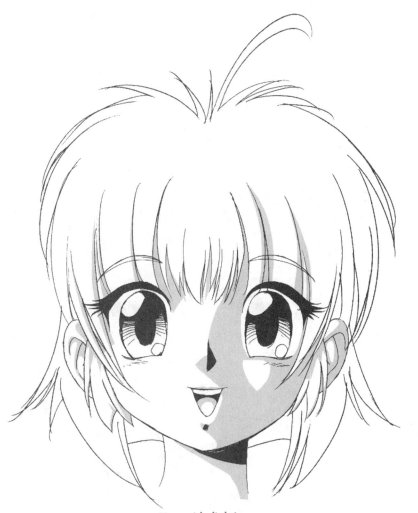

More side lighting.

Here's another example of a light source coming from one side. In the case of this figure, David does not strive for complete accuracy. The right ear, if we were tackling this realistically, would likely be completely in shadow. However, David was concerned the ear would get lost in the shadow, so he added some highlights to help bring it out.

There is only a slight difference between the next figure and the figure above. In the next figure, David has added some additional tones, a darker tone in the right ear, the left eyebrow, and under and to the side of the nose. The second tone gives the figure a bit more dimensionality and complexity.

Also, note, in this figure, David has altered the hairline, just to give you the effect different hairstyles and hairlines will have when you are dealing with light and shadows.

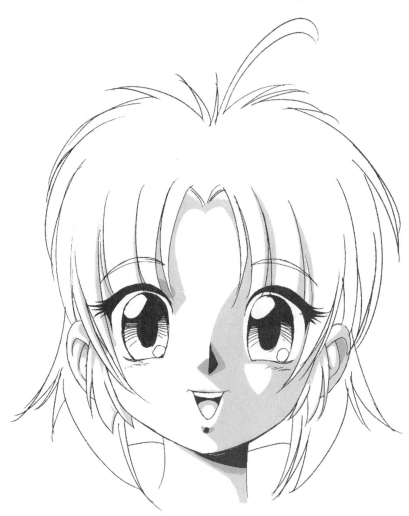

**Additional tones added.**

Following is the character with *backlighting*—and her original hairstyle! Backlighting can be a very effective dramatic device. It is often used when you want to introduce a character and make them slightly mysterious, or perhaps have sinister connotations.

For the backlit character, the shadow falls across almost the entire figure, except for some bits of light *around* the character (known as *rim lighting*). That bit of light comes from behind the character, around the shadow falling across the front of the character; hence the term "backlighting."

### Manga Meanings

A **backlit** figure is a figure with a light source emanating behind it. **Rim lighting** is the depiction of light on the side, on multiple sides, or all around the outside, of a figure.

Backlighting.

Second tone added.

Here is the same figure, with a second tone added. This second tone is under the hair, in the ears, and to one side of the nose. Again, this second tone gives the figure more dimension, as it suggests there are some areas, even within shadow, that are even darker than others.

Here is another example of backlighting and rim lighting, as we see a figure who is primarily in shadows, except around his outer shoulder, back, the side of his face, and around his neck. Sometimes, such as in the case of this character's neck, lighting can be used to help sculpt a figure or highlight their features and/or musculature.

Rim lighting.

Lit from the front.

Here is another figure, lit from the front. He is heavily shadowed, including the front of his face, where there is still a light source, just not a particularly strong one. Perhaps this character is in a darkened room, in front of a flickering TV screen or computer monitor.

Again, this is a case where lighting helps dramatically accentuate the curves and lines of the character's face.

**Lit from the back.**

Here is the same figure, lit from the back and a bit to the side. In the back of the head, notice David has used light and shadow to sculpt more definition to the character's hair.

**Under-lit.**

This figure is severely under-lit. Again, this may be the case of a character in a darkened room looking at a monitor, but it is even more dramatic than the previous front-lit image.

In this case, lighting is just used to provide highlights to the character's face and clothing. It makes for a very dramatic and possibly ominous look, too.

# Silhouetiquette

*Silhouettes* can make for very compelling and dramatic images. Most often, they are full-figure shots, allowing the body language of an ink-covered figure to tell the story, rather than a look on a character's face.

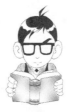

**Manga Meanings**
A **silhouette** is an outline of somebody or something filled in usually—but not always—in black.

Silhouettes are also very effective when you want to take the focus off the silhouetted character and draw the reader's attention to something in the background, or *around* the character. In the case of this panel, we see a figure approaching in the background. The use of a silhouette tells us that this character's approach might ultimately be more important to the story than the character in the fore-ground.

It should also be mentioned that silhouettes can be handy in a jam. They are a quick way to finish a page if you find yourself facing down the barrel of an ugly deadline. But don't get in the habit of overusing silhouettes. People will sense you are "cheating" and call you a lazy artist.

Figure in silhouette.

Rim-lit silhouette.

The previous figure is a silhouette with rim lighting, which adds a new and dramatic dynamic to the image. Of course, this is a little more time-consuming than a simple black silhouette. It certainly adds flair to the image. In the case of this image, with the bright lights of the city in the background, it also adds a certain realism.

As always, the decision to use silhouettes is totally subjective. But you don't want to use them in a case where you need to see a character's facial expression, obviously.

You might try silhouettes using multiple characters, too. In a fight scene in which both characters' body language speaks volumes, a silhouette of two people applying some martial arts moves on each other might make for an effective fight panel—as well as save you some time when it comes to finishing the page!

### Sketchbook Savvy

Experiment with your silhouette, filling it in with a gray tone, a graduated tone, even leaving the inside of your silhouette white. There's no reason to do it just in black, and different toned silhouettes can be equally effective depending on their surroundings and circumstances.

## The Least You Need to Know

◆ Lighting and shadow—or the absence of lighting and shadow—can affect the atmosphere of a comic, making it more dramatic, scary, moody, or tense.

◆ Always take into account your light source. Sometimes there are multiple light sources.

◆ Silhouettes are an effective dramatic device, and sometimes a timesaver. You don't necessarily have to make a silhouette only in black, either.

◆ If you use a silhouette, the body language of the character is important, because you cannot see your character's facial expressions.

## In This Chapter

# Chapter 21

# Words and Pictures

Comics are a visual medium, a unique marriage of words and pictures. One of the reasons manga has become so popular in America is certainly due to its accessibility, *because* it is a visual medium. An American comic reader with little or no knowledge of Japanese culture can pick up a manga book and at least enjoy *half* of it—the cool pictures—even if that reader has no idea what is going on or being said. When the books have been translated, it becomes even more appealing, even if some aspects of Japanese culture and storytelling are, well, *foreign* to us. Fortunately, the process of making Japanese comics readable for an English-speaking audience isn't something you will have to worry about. But there is still plenty to learn on the subject of dialogue and art, and the relationship between the two in comics.

In this chapter we'll look at methods of incorporating words with your pictures in ways that can enhance the reading experience without distracting from the art. Comics are, after all, a marriage of words and pictures, although usually readers don't pay much attention to how and why the word balloons (also called dialogue balloons) and sound effects have been designed, or where they have been placed. Sadly, this is something that many comic book creators sometimes ignore, as well.

It is said that nobody notices good lettering and dialogue placement in comics, and that's exactly how it's supposed to be. But when it's done incorrectly, the clarity of your story can suffer tremendously.

# Exported Manga

To produce a comic from Japan for America is quite easy. The Japanese text is removed, the content *translated* and *localized* to sound like colloquial English, and American text is added back in. There are also more and more comics created in a manga style by native English speakers, and thus no translation process is required. After all, isn't that why *you* bought this book?

**Manga Meanings**

**Translation** takes the words of one language and puts them into another, although it does not always sound natural. **Localization** takes the rough translation and finesses the language to make it sound natural and native.

# Talking About Talking

We've been striving in this book to give you the knowledge and skills to make the most authentic manga you can. However, there is one fundamental difference to Japanese manga that is simply unavoidable, and when you make a manga comic, no matter how authentic you strive to be, it is simply best to do it the American way.

We're talking about word balloons. In Japan, as we've discussed, books are read right to left. Their text is read differently too, as Japanese characters are read vertically, top to bottom, and *then* right to left. This is radically different from the English-language way of left to right, from the top horizontal line to the next horizontal line below.

You can make a judgment call and decide whether you want to arrange *pages* so a book can be read either left to right or right to left, but if you try to arrange your words and characters in the same way as the Japanese do, you are going to end up with an unreadable mess.

Therefore, we're going to look at word balloons in this chapter, as well as some other visual effects, and discuss the best approach to take, even if it is not the most completely authentic.

# Shaping Your Balloons

Typical word balloon in manga.

This is the shape of a typical manga word balloon. Because Japanese characters are read vertically, these balloons are usually long and thin. They also have a more organic and imperfectly circular shape, which, as you will see, differs from the typical American balloon.

The problem with these balloons is, when you translate the text to English, the balloons are too narrow for American words and paragraphs.

The next balloon is designed to fit more dialogue into it. A typical balloon only has room for a sentence or a very short paragraph. But when a character has more to say, understandably you need to give that character a larger balloon (or more balloons) to say it all. Authentic Japanese manga books tend to squish two tall, thin balloons together, as you see in this panel.

**Double balloon in manga.**

Again, it is difficult to lay some typical English sentences into this, because the balloons are simply too narrow.

**Typical balloon for English-speaking comics.**

The typical balloon for an English-speaking comic, as seen here, is shorter, fatter, and more perfectly rounded. It is shorter and fatter out of necessity, because our words and sentences read horizontally, rather than vertically. It is also more perfectly rounded, which is more of an aesthetic difference between American and Japanese comics.

**Mangled Manga**

DON'T LET THE TEXT IN THE BALLOONS GET TOO CROWDED.

**Double balloon for English-speaking comics.**

And here is the English equivalent of a verbose balloon, to allow multiple sentences and short paragraphs. The balloons again are shorter and fatter and more circular, but unlike the Japanese balloons, they are clearly separated from one another.

However much you might want to make an authentic manga comic, balloon shape is simply one compromise you will have to make. Unless you want your characters to speak in three-word sentences and monosyllables, the tall, thin balloons simply do not work for English words and characters.

A happy medium?

We offer this balloon as a happy medium, taller and thin, but not quite so thin as the Japanese balloons, to allow for the placement of English text.

Making this balloon perfectly round was simply an aesthetic choice David decided upon. However, if you prefer the rougher, more imperfect balloon shape, go for it.

**Sketchbook Savvy**

MAKE SURE TO LEAVE PLENTY OF SPACE AROUND YOUR WORDS!

# Balloon Effects

Sometimes words are not enough. Everybody has a different voice, and often a person takes a different tone based what he or she is feeling. Comics, both manga and other comics, have invented certain visual cues and tricks to help differentiate different types of voices.

One way to do this is by varying *fonts*. Much of today's comic book lettering is done by computer, Adobe Illustrator being the preferred program. Different styles of fonts can be purchased (or built from scratch, although that is a completely different discussion).

**Manga Meanings**

A **font** is an electronic typeface, used in comics when creating dialogue or sound effects by computer. If you have a word processing program on your home computer, it likely has a set of different styles of fonts.

Another way to do it is by altering your balloon shapes. In the following pictures we will show you a few examples of this. Keep in mind that these are created in a more Japanese balloon style, tall and narrow, and to work better for English comics, they might be slightly shorter and fatter.

A balloon that is wobbly and unsteady is a good effect for either a spooky villain, such as a ghost, demon, or some other supernatural creepy-crawler. It works equally effectively as a "scared" effect, for a quavering, cowardly, or frightened character.

Scared or spooky effect.

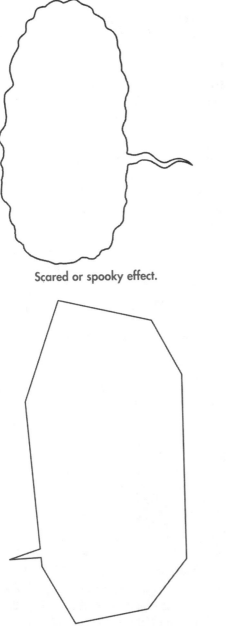

Balloon burst.

This balloon is known as a burst and is used to express extreme emotion, such as fear, excitement, or anger. When doing a burst such as this, it's often advisable to make the words inside the balloons bigger, **bolder,** or ***bold italic.*** The point is this is an expression of excitement, and usually this character is yelling, so enlarged text helps reinforce the idea of a shout.

## Every Balloon in Place

The science of balloon placement is one too few people take into account, particularly inexperienced creators, when creating a comic. As a former comic editor, a comic writer, and a letterer, this humble author can tell you that balloon placement is very, very important and can make the difference between a book that is clear and readable and one that is a muddled mess.

Mechanized voice effect.

A balloon like this, with sharp lines and angles, suggests a geometric precision, something you might associate with a robot speaker or some other sort of synthesized voice. This is also a good "electronic" balloon, for use when a character is hearing something from a phone or a walkie-talkie, or even a television or radio.

When balloons are placed badly, the reader may be confused about the reading order, and the story will suffer as a result. Conversely, well-placed balloons can help make the story more clear and actually improve the reading order, even if the art is not as clear as it should be.

Panel 1 shows an example of a page on which the balloons are placed properly and which flow properly. English readers will naturally read the top panel first and then drop down to that tall second panel, just as they would read the next line of a sentence. The reading order is quite clear, as is which panel should be read first, second, third, and so on. Comic letterers often say that it is their job to do work that goes unnoticed. This is because it's only when balloons are placed poorly that they are noticed—and that's often when confusion results.

As we have said, native Japanese manga books are read right to left, and hence the pages are flipped, and the balloon flow is reversed. This can be *very* hard for the English-speaking manga reader to get used to, and because we're not planning on making manga in native Japanese, we're simply going to ignore this issue.

Panel 2 shows improper balloon placement. That is to say, this is the *wrong* way to do it. The first major difference is between Balloon 1 in the two panels. In Panel 1, we put the balloon in the mostly empty space to the right of the character. In Panel 2, it is to the left, where it covers some of the character's cloak. Now, sometimes you will have no choice but to cover art with a balloon, but here we do have a choice. If you can avoid covering art with your balloons, that is always preferable.

In Panel 2, note how Balloon 2 jumps out of the border. There is nothing fundamentally wrong with having a balloon halfway in one panel and halfway in another, as long as that other panel is the next panel, and there are no other balloons in the first panel.

Imagine for a moment this page without numbering in the balloons. In the case of this example, it would be very difficult to tell whether you are supposed to read Balloon 2 and then Balloon 5 or Balloon 2 and then Balloon 3. And, because of the way 5 and 6 are placed, there would be still more confusion about how Balloon 6 fits into the reading order.

### Mangled Manga

Try not to cover art with word balloons. Balloons over hands and feet are particularly a no-no.

Panel 3 serves as another example of what to do. It shows a situation in which it is perfectly fine for a balloon to be between one panel and the next, because it leads the reader's eye in the way it is supposed to.

Balloons 4 through 7 feature two characters each with dialogue (one talking more than the other). In this case, Balloons 4 and 6 were connected, and three of the four balloons sit in the panel's negative space, showing as much of the character's silhouettes as possible. The last balloon is placed over the character's legs, but in such a way that it is as unobtrusive as possible.

Panel 4 is another example of what *not* to do. In this panel, two balloons break the panel border between the first and second panels. However, because we read left to right, we're likely to read Balloon 2 first. If you must break the panel borders here, better to put Balloon 1 in the place of 2 and 3, and Balloons 2 and 3 behind the hooded guy's shoulder in Panel 2.

Another problem with Panel 4 is Balloons 4–7. The balloons still go to the same speakers as the previous panel, and it is clear who is talking and in what order. However, because of the placement, much more of the silhouettes are obscured, and we've already learned from the previous example that it can be done a better way.

Much of balloon placement is trial and error, and you really need to be willing to experiment to find the best way to make your page clear and readable while sacrificing as little art as possible.

Panel 1: Well-placed word balloons help "steer" the reader's eye to where and what the reader should read next.

Panel 2: The same panel with poorly placed balloons.

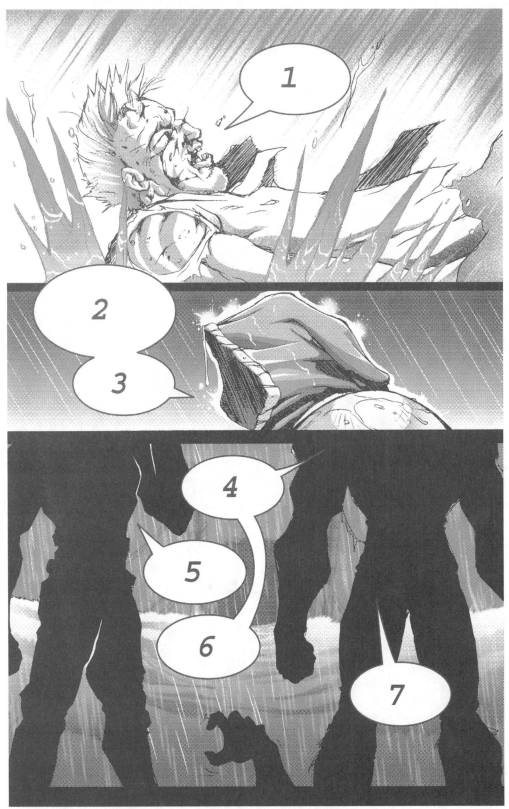

Panel 3: Another example of proper balloon placement.

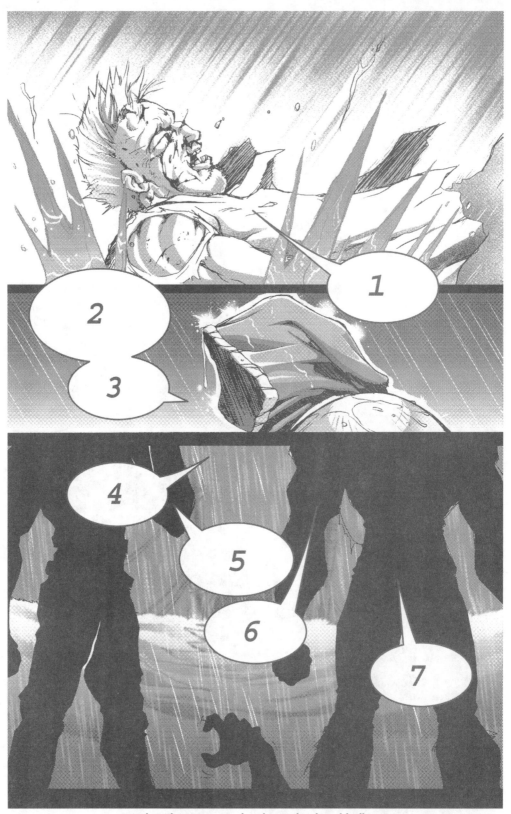

**Panel 4: The same panel with poorly placed balloons.**

# Sound Off

*Sound effects* are popular in both Japanese and English comics. Because many manga books have sound effects included in the art, it is difficult, if not impossible, to remove them for American translation (as opposed to text in balloons, which can easily be removed with a computer, without compromising the art). In the case of translated manga, often English-speaking readers have a Japanese sound effect with its English equivalent nearby in the same panel.

Of course, in the case of this book, we are talking about making manga books in English, from scratch, so we don't need to talk about Japanese sound effects. We can skip straight to English.

**Manga Meanings**

A **sound effect** is a word or words used to express a noise that isn't communicated in dialogue or narration.

A typical sound effect.

Sound effects are popular in fight scenes, or action sequences like explosions or gunfire. But they can be used to convey an almost limitless number of sounds, such as a phone ringing, a door knocking, even a breeze blowing.

In the high-tech digital age we live in, many people make sound effects on the computer as they are lettering. Other people prefer hand lettering, as well as adding sound effects into the art as they are penciling and inking the page. There is no right or wrong on this; whatever method works best for you is fine.

Splash effect.

There is an art to making sound effects, just as most other aspects to making comic books. One method used in lettering is to make a sound effect that looks like the sound it is describing. In this case, the "splish" is drawn to look like drops of water.

Explosion effect.

Again, this is an effect drawn to look like the sound it represents—in this case, an explosion. The effect grows larger in the center, as though to suggest this sound grows louder, while it visually suggests an outward expansion, perhaps the expansion of smoke and flame and debris you would encounter during an explosion.

Rumble effect.

In this effect, David gave each letter a drop shadow, as well as drawing each character irregularly, to give the balloon a shaky, unsteady aspect.

### Mangled Manga

Keep in mind there is no one definitive way to make a sound effect. Sound effects—even the *spelling* of sound effects—are purely the invention and the prerogative of the artist.

**Another explosion effect.**

Here is another effect, possibly for an explosion, possibly for a fight scene. Notice how the effect grows in size, to indicate its rising force and decibel level. It is also tilted slightly, which expresses movement.

**The sound of a tire going flat.**

Not all effects are for great, ear-splitting noises. This could be a "quiet" sound effect, to show the air being let out of a tire or a snake hissing. Balloons often depend on the context they are being shown in, as the same sound effect placed into one panel could have a completely different meaning if put into a different panel.

### Sketchbook Savvy

In general, the larger the sound effect, the louder the noise.

**A nonsense effect.**

In this case, we want to show you that the words do not necessarily matter. This effect is nonsensical, but what we what to emphasize is how much design and presentation can add to an effect. Of course, ideally you do want the words, or sounds, to work in tandem with the design of your effects.

## Visual Effects

Thus far, we've spent the chapter talking about the relationship between words and pictures. Now, suddenly, we are going to talk about pictures *without* words. But this is not as strange a transition as you would think. Manga, in particular, excels in visual shorthand, summing things up very quickly in one picture, which might take a much longer time to explain otherwise.

Often this is done by exaggeration. As we will see, most of the visual effects seen here are not to be taken literally. That is, a character who is in love does not literally have stars in her eyes, but these sorts of exaggerated visuals help a manga reader quickly ascertain the mindset of the character about whom they are reading.

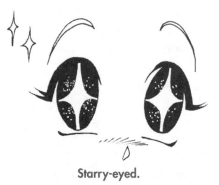

**Starry-eyed.**

This is a popular manga effect for a character, most often a female, who is love-struck, in awe, or extraordinarily happy. Not only does the character have stars for pupils over a background that looks like a starry night sky, but there are also a few little stars floating around the character's head.

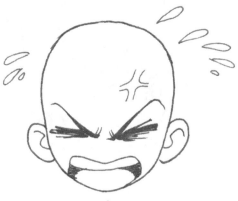

**Angry.**

This face is an angry one, with a throbbing temple and beads of sweat jumping hotly from the character's brow. Something to keep in mind in this exaggerated picture is that the characters might only appear like this for one panel, to show that they are reacting intensely. In the panel before or the panel after, the character might be perfectly fine. Again, this is a case in which Japanese manga readers are willing to suspend disbelief and accept something that is a little less realistic, to quickly understand the intense emotion, reaction, or mood of the character.

This sad character appears to be literally crying buckets. Of course, it's ridiculous to assume the character is *actually* doing this, even though that's what the picture is showing. Still, it makes for a more interesting visual effect, doesn't it? And we've said time and time again that this is what manga is all about: interesting visuals.

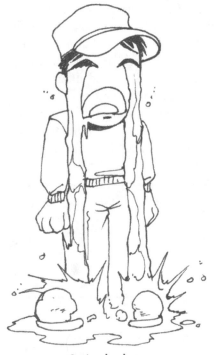

**Crying buckets.**

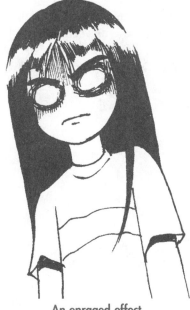

**An enraged effect.**

A nice effect for an enraged character is a flat, slightly downturned mouth and a flushed upper face. The eyes are the focus of this panel, large with thick black circles around them. Remember when we talked about a lack of pupils giving a character a less human aspect? In the case of this picture, the character is *so* angry that she takes on an inhuman aspect, like her sole focus is rage or vengeance.

**The comic faint.**

Sometimes it's most effective to not show your character's face at all. In this case, we have a curly-Q line and a foot. To show a reaction of surprise or shock, the character appears to faint dead away. This is more of a lighthearted reaction, perhaps one of a schoolboy who just got asked to a dance by the girl of his dreams, or somebody who just found out they won the lottery.

**Mind blown.**

Here's an exaggerated visual of someone's mind being blown. Again, this is not to be taken literally. Neither the manga readers nor the other manga characters will think this character suddenly has pinwheels for eyes and is being hit by a giant mallet. Still, this is a great way to show a character who has just received some terrible bit of news. Maybe he's just been dumped by his girlfriend or flunked out of college. Or it could be something completely different: Maybe this fellow was just out for a night on the town and is now drunk out of his skull. Like sound effects, visual effects have several uses and meanings and depend on the story's context.

## The Least You Need to Know

◆ Native Japanese comics are translated and then "localized" to sound like conversational English. Since you will create your own comics, no translation or localization will be necessary.

◆ Word balloons are differently shaped between Japanese and American comics, because the words and characters are read differently.

◆ Correct placement of balloons is important. If you place the balloons incorrectly, your story will become muddled and unclear.

◆ Sound effects are a great way to add atmosphere to a panel, and there are many ways to craft an effective balloon.

◆ Manga often exaggerates the visuals to some cartoon effect to convey a character's intense emotion, but these are not to be taken literally.

# Round Out Your World

Manga is a vast and multi-faceted universe, and in our final part we are going to explore the various corners of this universe, looking at the objects that help make your story complete. Often this means finding the correct background, giving your characters the right wheels, or equipping them with what they need to defend themselves.

We also look at objects that are natural and manmade and focus on manga's fascination with all things mechanical and technological. In the end, you'll have all the tools you'll need to dream up a vast and multi-faceted manga universe of your own.

## In This Chapter

◆ The difference between mech and mecha

◆ Future mech: robots, cyborgs, and automatons

◆ Mech for common objects

◆ The importance of reference materials in military mech

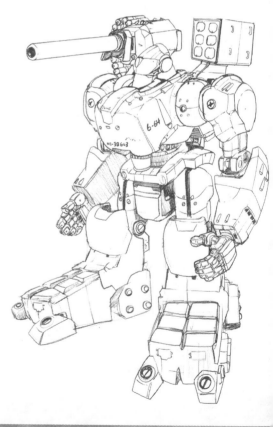

# Chapter 22

# Make It Mech

We've referred to mech in previous chapters, but we are finally ready to discuss it in greater detail. Now that we've talked about faces and figures and offered tips and tricks for drawing manga, we're going to explore ways to round out your world. That is, show you other things your character might encounter, or might use, other popular or important aspects in manga's vast and varied universe. And because mech plays such a great role in manga, we'll start there first.

All of this begs the question: What *is* mech? If you research this (as I have) you will find there are several different definitions, but for the purpose of this book, we're going to give it the widest definition possible, describing mech as pertaining to all things mechanical. And with this definition, you can see how mech is so integral to manga, particularly in futuristic stories with spaceships and laser guns, androids, and giant robots.

However, just so we're clear, we're talking about mech as a verbal shorthand for "mechanical," and this could very well also mean a 2006 model Volkswagen, an early supercomputer in some 1960s laboratory, or a WWII tank.

## Mech vs. Mecha

*Mech* is also not to be confused with *mecha*, although some people use them interchangeably. Mecha, as we define it, refers to the very popular anime and manga genre of giant robot comics. Many of these robots have successfully been imported to America as cartoons, comics, and toys, such as *Transformers*, *Robotech*, and *Shogun Warriors*.

**Manga Meanings**

**Mech** pertains to things that are mechanical. This is different than **mecha**, which pertains to giant robots.

As long as we are splitting hairs on definitions, we should mention that purists point out there is a difference between robots and mecha; mecha are robots that are piloted by humans. Purists will also claim that size matters in mecha. A person wearing a powered armor suit is wearing mech, but not mecha. That person would say mecha is anything large enough to have a cockpit, for example a pilot in a small control room in the head or chest of the giant robot, acting as its "puppeteer."

This is all a little too anal for me. In my mind, and for this book, giant robots are all mecha, whether they are piloted or not.

**Mangled Manga**

Not all mech is mecha, but all mecha is mech. All robots are mech, but only *giant* robots are mecha. And, if you want to get technical, only *piloted* giant robots are mecha.

## The Marvelous Mechanical World of Manga

Let's get back to mech (and just mech!) Clearly, technology plays a huge part in our lives today, and it's generally agreed its role is only going to get bigger. Mech and tech go hand-in-hand. What is something mechanical, after all, but applied technology? We see it daily with our cell phones and laptop computers, on the Internet, on the road, and in the skies.

Mech has an even greater presence in manga as your stories get a bit further from daily life. Spies have the latest in high-tech gadgets and weapons; soldiers have cutting-edge armor and guns.

And futuristic stories? Fuggetaboutit! Unless your characters are H-bombed back to the stone age, mech is going to be rampant in sci-fi tales, as mech can be robots, androids, cyborgs, computers, virtual reality, spaceships, star fighters, laser pistols, laser swords … the list is literally endless, limited only by your imagination.

## Robo-Babe

**Rough sketch of mech character.**

Here David has roughed out a mech-based character. Like mech itself, this will prove to be a character with infinite possibilities, as you will see. For now, though, we see a rough of a young adult female figure. We also see outlines for parts of the character's costume or design, the most obvious being something on the shoulders and some things on the left arm, as well as what appears to be a weapon holstered to the left leg. Surely we will have a better idea of exactly what we are seeing as David tightens up the pencils.

Next the figure is honed and we get a much clearer look at the character's shape. We also see clearly defined lines on the character's limbs and torso, although it's unclear exactly what these lines are intended to denote. Take this picture out of context from the others, and it would appear to be some aspect of the female's costume (especially when you consider how often female outfits in manga and comics in general are skintight).

Also note: The elements outside the limbs we saw in the previous figure, located on the shoulders and the arms, have not been embellished in this panel. However, they have also not completely been erased, either.

**More details are added to the figure.**

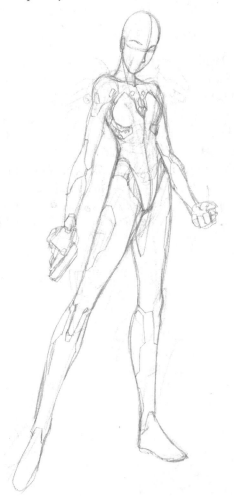

**The figure is finessed, with even more detail.**

More details emerge as David continues to work on this character. In this case, we see more lines on the character's limbs, and their smooth, sharp-angled geometric shapes suggest this character is wearing some sort of mech, a type of high-tech futuristic bodysuit.

Close-up of a human female face.

David details the face now, in all appearances a normal human female drawn, in the manga style, at a three-quarter angle.

And here is the figure with even more detail, and we see what appears to be the finished penciled drawing of an attractive young girl-with-gun in a futuristic, form-fitting outfit. As we said, the lines on the limbs suggest this suit has some mech elements to it, as do the small squares around the chest and shoulders, which look like they could be microchips.

Normally, David could look at this figure, decide he was satisfied, and then move to the inking phase. Except this time he's not finished with this drawing.

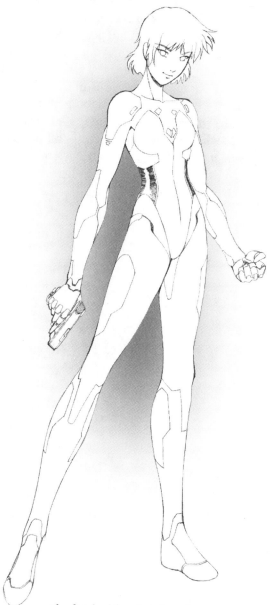

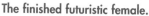

The finished futuristic female.

Clearly, David was planning ahead when he was designing this figure, intending to show us a figure that looked like a normal girl, which we could later compare against this mech version. If David was doing *character turnarounds*, he would definitely keep these side by side, so he could reference the character each of the ways she appears, in her fully human and partially robotic form.

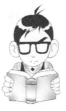

### Manga Meanings

**Character turnarounds** are different shots of a character that can later be used for reference. They usually include three full-body shots of a character in costume, front, back, and profile, as well as a couple of close-up head shots.

Of course, looking at the finished female figure, you don't know if the character is a partially robotic cyborg or a full-robotic automaton. That raises an interesting point. We've offered you the valuable advice of giving your character the proper introduction and holding off showing a monster until you have built some suspense.

Here's another good piece of advice, which shares some similarities to the other: *Know more than your reader.* That is to say, know your character more than your reader does, and your story, too. Don't show them everything, or tell them everything, at least not immediately. If you have a girl who is a robot or cyborg, let the reader think it is a *normal* girl, and when the time comes to reveal she is not totally human, your reader will be surprised and shocked. Sure, you can drop some hints along the way, but it's always a good idea to keep readers on their toes by offering twists they did not expect. It will keep them coming back for more.

**Some mech surprises are hidden up her sleeve.**

Now we see what David was getting at in the first panel, what those rough outlines in the first figure were all about. Those lines we saw are not actually part of the character's suit, but parts of her *body*, which extend and transform to show various mechanical parts. On the calves of the figure is what looks like tiny jets; the left arm is a weapon; and within her shoulder is what appears to be some sort of camera.

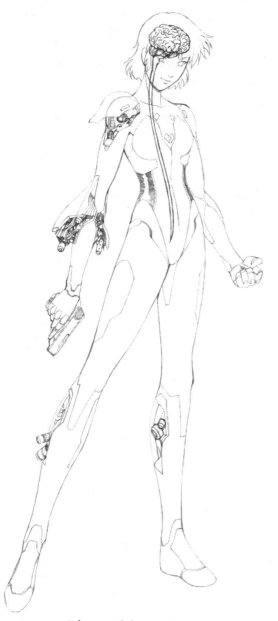

**Cyborg with human brain.**

Since comics are a visual medium, it's a good idea to show a secret to a reader when the time is right, rather than tell them. Clearly, David had a plan up his sleeve when he designed this character. She would appear as human until the time was right, and then all sorts of mech contraptions would pop out of her body, and she would reveal she is indeed not human.

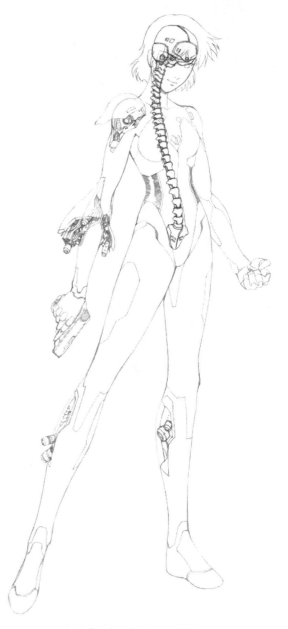

**Robot in a human shell.**

Here David adds another design element, to take things a bit further. Here we see the character with a robotic brain. This is not a partially human cyborg; it's pure robot. Ideally, we would surprise the reader with this even further into a story. Perhaps the readers think this is a girl, until they see she has robotic parts.

Then maybe they think she is a cyborg, until she gets her face blown off, and we see beneath that attractive exterior is a cold, computerized brain. You see? Another surprise, another twist to keep your readers interested, and you keep them interested *visually*. Plan ahead for this, even if you don't share your secret with the reader until the very last page.

# Mecha Man

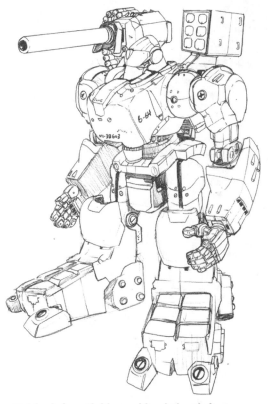

**Finished, formidable, and loaded with firepower.**

**Rough sketch of a monstrous mech.**

Here is a rough of a more obviously mechanical creation. Notice, when creating it, that it is still roughed-out with a combination of shapes in the form of a biped human. But for this figure, rather than circles and cylinders, the shapes (other than circular joints), tend to be squared, rectangular, and blockish.

Here is the finished figure, a formidable piece of mech as anyone can see. But is it *mecha?* Well, that depends on the *size* of this thing. Since we aren't seeing it in context with anything else, we have no idea of its scale. If this is a person wearing this as a suit, then it is mech. If it's a man-sized robot, it's still mech. But if this thing is a few hundred feet tall and swatting down skyscrapers like sandcastles, then it is mecha—especially if there is a guy somewhere in the suit (or even a remote location outside of the suit) pressing buttons and giving the marching orders.

### Say What?

One machine can do the work of fifty ordinary men. No machine can do the work of one extraordinary man.

—Elbert Hubbard (1856–1915), American author

# Common Mech

Gray tones give this figure a metallic appearance.

Some gray tones were added to the phone to give it more dimension. Highlights were added as well. If this isn't incentive enough to try your hand in Photoshop, consider this: Photoshop preset grads (short for "gradients") give any object the appearance of metal. That, certainly, will come in handy when it comes to making mech.

# Military Mech

As we said, not all mech is fictitious, and sometimes you are going to want to make your mech as accurate as possible. We've talked until we are blue in the face about the importance of reference, and we're not going to stop here. To capture something like this, find some good references on military history. There is certainly enough of it out there, in libraries, bookstores, and on the Internet.

Close-up of a futuristic communicator.

Not all bits of mech are as intricate as female androids and battle-armored mech. Some are as mundane and commonplace as a cell phone. Of course, it's always a good idea to try to make it a little more interesting than the standard cell phone, especially if your story takes place in the future, where the styles most certainly will have changed. The object in this panel is clearly a cell phone, or some sort of futuristic communicator, but David keeps it interesting by altering the shape of the device, as well as its buttons.

### Sketchbook Savvy

An invaluable source of reference for a writer and an artist is a visual dictionary, which shows a picture of an object along with some terminology of the object's components. It doesn't go into a tremendous amount of detail, but it's a good way to get a quick look at a great many things.

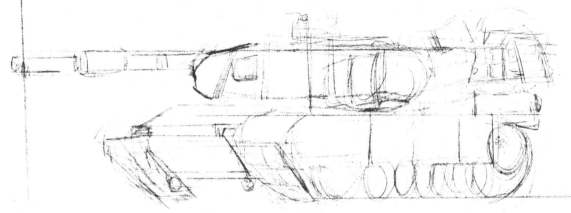

Rough sketch of a piece of modern mech.

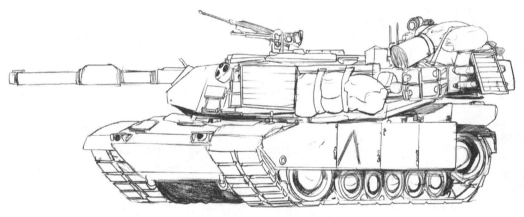

Finished contemporary tank.

Unless you are an expert at tanks, there is simply no way to draw something like this from memory. You are going to have to dig up some reference if you want it to appear remotely realistic.

## The Least You Need to Know

- Mech is verbal shorthand for "mechanical." The possibilities for mech are limited only by your imagination.

- Mech is prevalent in manga, no matter what time setting, but it is especially crucial in stories set in the future.

- Mecha, featuring giant robots, is a popular genre of manga and anime.

- Try to have some twists and surprises planned ahead to keep your readers interested in a story.

- Books on military history are a great reference for finding real-world mech, as well as a starting point and inspiration for your own futuristic mech creations.

## In This Chapter

- ◆ Weapons, characters, and story
- ◆ Formidable firepower
- ◆ Swords and other close-quarter combat weapons
- ◆ Special weapons

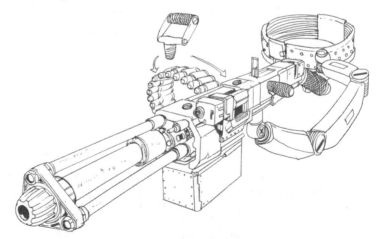

# Chapter 23

# Draw Arms!

Chances are, if you're creating a manga story with action, it's going to have weapons. Of course, this might not apply to certain stories, like high school romances or sports dramas. However, could you imagine a war story, a spy adventure, a sci-fi space opera, a fantasy quest, or a gangster crime noir *without* weapons? Not a chance!

Even martial artists who fight with their fists and feet are likely to encounter unscrupulous ninjas with *sais*, throwing stars, nunchucks, or fighting staffs. Clearly, if you want to tell a story with action and conflict—and I'm betting you *do*—weapons are something you are going to have to be prepared to draw.

# Finger on the Trigger

You are not mistaken. Guns *are* mech, and we could just as well have included them in the previous chapter. However, considering the prevalence of weapons in manga, we thought they deserved their own spotlight.

Approach drawing guns the same way you would with mech. That is, you will likely need some reference, at least for complex weapons such as the one pictured in this figure, even if you are just using the weapon as a starting point. Roughly construct the weapon with shapes. In this case, a lot of circles, rectangles, and cylinders comprise this amazing-looking chain gun.

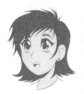

### Say What?

He will win who knows when to fight and when not to fight.

—Sun Tzu (approx. 400 B.C.E), ancient Chinese military tactician

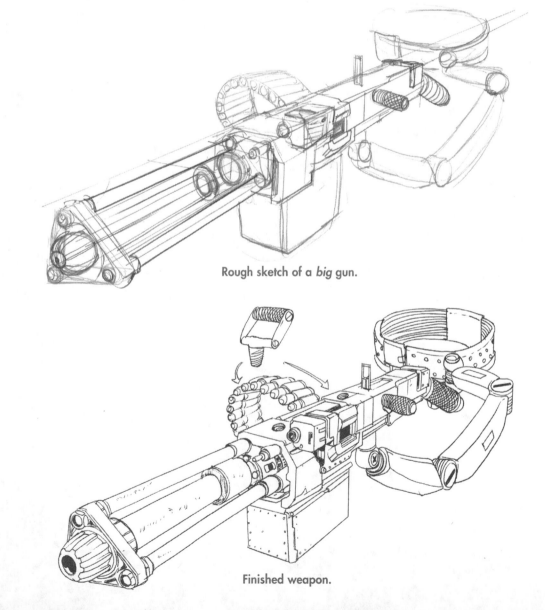

Rough sketch of a *big* gun.

Finished weapon.

The finished weapon has lots of crisp lines and clean detail to give it a mechanical look. Remember our discussion in Chapter 16 about making monsters as threatening and formidable looking as possible? This also applies to weapons, especially weapons carried by bad guys. It's always best to give the impression that your bad guys have the capability of kicking your hero's butt, as it will add suspense. A good way to do that is to equip them with a formidable piece of firepower.

The relationship your protagonist has with his or her weapon says a lot about them and helps define their character. Is your character eager to use the weapon? Does your character have a bloodthirsty streak and an itchy trigger finger, or is that character reluctant to take another life? Or maybe your character learns to embrace firepower as he or she goes on a vengeful quest against those who have wronged them.

Your character's choice of weapon, assuming they have a choice, might reflect this as well. Certainly Dirty Harry would not have been so fearsome a vigilante cop if he threatened punks with a pearl-handled .22. And James Bond would not be able to hide a machine gun in his ankle holster. The guns they choose reflect both their personality and the situations in which they are going to find themselves.

### Say What?

Nothing in life is so exhilarating as to be shot at without result.

—Sir Winston Churchill (1874–1965), British statesman

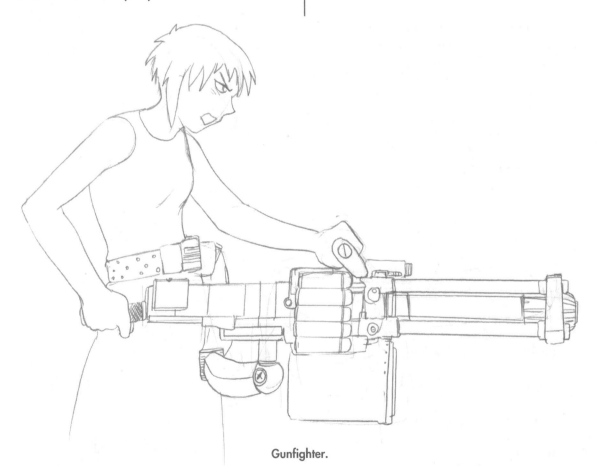

**Gunfighter.**

Another big gun.

Here's a different finished figure of a big gun. There are plenty of gun references out there, from *Guns 'N' Ammo* type magazines to books on military history and contemporary warfare. Science fiction movies and television are another terrific source to get inspiration on futuristic weapons. And have we mentioned that it's perfectly acceptable to get inspiration from *other manga?* Just so long as you don't steal other people's ideas and designs, that is.

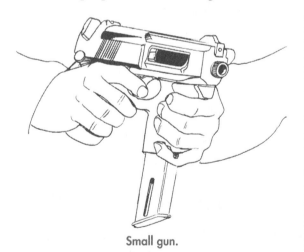

Small gun.

Pistols and small guns are even easier to invent than larger guns. Basically, as long as it has a handle, a barrel, and a trigger, it will look like a gun, and you can go nuts coming up with whatever sort of cool and futuristic design you like. Again, base your design on some pre-existing model and then experiment with tweaking the design.

# Close-Quarter Combat Weapons

Of course, not all weapons are ranged weapons, or sophisticated pieces of mech. Some stories call for hand-to-hand weapons, so let's spend a bit of time talking about *mêlée weapons.*

**Manga Meanings**

As any experienced gamer or role playing game (RPG) player can tell you, **mêlée weapons** are handheld, nonranged weapons, such as swords, knives, bats, and clubs.

Rough sketch of sword.

Here is a rough for what might be the most fundamental of handheld weapons, the sword. Obviously, these types of weapons are less complex than guns and easier to draw. The figure is basically T-shaped, coming to a point at the bottom.

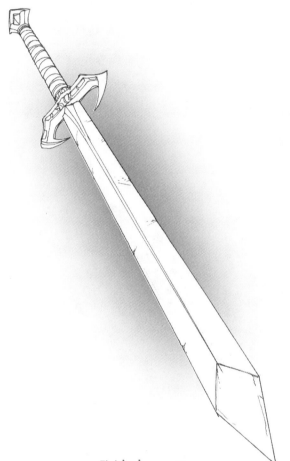

**Finished weapon.**

The finished figure isn't much different than the rough. It is a simple object, with fewer components and, hence, less detail.

Swords and handheld weapons are a more personal weapon for your character than a gun, at least in most cases. A character might have some sort of connection to a weapon like this, perhaps he or she forged it, or it was kept in the family and passed down through every generation. For a weapon that has some special connection to a character, give it something special to differentiate it visually from other weapons of the type. Perhaps it has some unique jewel at its hilt, or a family crest, or some symbols etched on the side of the blade.

David roughs out a scimitar here. This figure is little more than the rough shape of the blade.

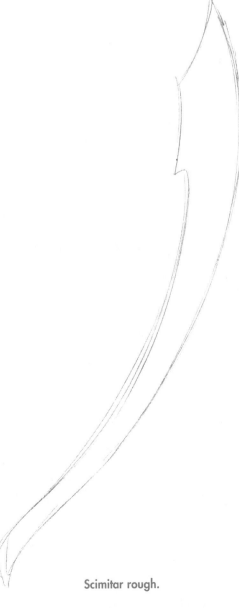

**Scimitar rough.**

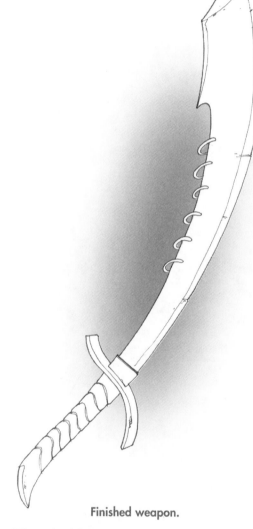

**Scimitar with details penciled in.**

David adds detail to the figure in pencil, including the hilt and some decorative rings on the dull side of the blade.

**Finished weapon.**

The inked figure looks similar to the finished pencil drawing, with a line inside the blade that gives the edge the appearance of sharpness. The rings are purely decorative, to make this weapon more memorable and unique.

# Oddball Armaments

Often a unique weapon makes for an effective plot-driving device known as a *MacGuffin*, an object that the characters are trying to find, control, or maintain. An example of a handheld weapon MacGuffin would be a magical sword in a fantasy story. A MacGuffin in a more modern setting might be a prototype weapon in a spy story. Or it might not be a weapon at all, just a unique piece of technology or an item of great value that everybody—hero and villain—is trying to get a hold of.

### Manga Meanings

A film term coined by British film director Alfred Hitchcock, a **MacGuffin** is an object, artifact, or weapon that is being pursued, something that creates motivation or drive for the characters. Often it is something that both heroes and villains are racing to find or control first.

Consider equipping your figure with an odd or uncommon weapon, something to make that character stand out from all the others. Plenty of books out there cover handheld mêlée weapons, and it's not difficult to come up with something that's a little more off the beaten path, visually. Try giving your heroic fighter character a halberd, a scimitar, a mace, or a flail rather than the standard generic long sword. One of the reasons Indiana Jones seemed so cool and memorable certainly had something to do with his hand-to-hand weapon of choice, the bullwhip!

Rough sketch of sickle.

**Finished weapon.**

Here is a finished sickle (seen most often carried by the Grim Reaper, the personification of Death). In the ink phase, David added a long highlight to the black handle, making the staff appear sleek and shiny. Two groups of thin lines on the sickle give the blade an impression of a metallic sheen.

## The Least You Need to Know

- Complex weapons are built using a combination of shapes, just like figures, as well as other mechanical constructs.
- Exaggerate your weapon for dramatic effect, particularly in futuristic war or sci-fi stories.
- The choice of weapon might reflect a character's personality or the context of the character's situation.
- Consider your character's relationship with their weapon. Some characters will be forever associated with their weapon.
- A weapon makes for a good MacGuffin, a plot-driving object after which the characters are chasing.

## In This Chapter

◆ How different vehicles help define your
   characters

◆ Four-wheeled wonders

◆ Road hogs

◆ A wing and a prayer

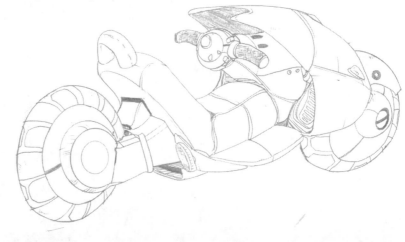

# Chapter 24

# Manga's Driving Force

Vehicles play an important role in manga, more so than in American comics, where, except for the occasional Batmobile or Invisible Jet, most characters get around by flying, leaping, and teleporting. But manga's fascination with all things mechanical certainly extends to mech to ride, mech to drive, and mech that breaks speed limits and sound barriers.

Japan is not quite the car culture that the United States is. Japanese cities are denser and more heavily populated, and they simply don't have the room we do for a car or multiple cars in every household and garage. Still, that doesn't diminish an appreciation for a sleek hot rod.

This appreciation shows through; manga (and anime) seem to have more in common with Hollywood than U.S. comics, at least when it comes to an affinity for cool cars and high-speed chases. Perhaps driving mech is prevalent in manga because manga uses decompressed storytelling more than American comics. After all, it's easier to make a suspenseful high-speed chase if you can do it in thirty pages instead of three.

# Hot Wheels

David begins to draw his vehicle with a rectangular shape, after picking the perspective. At this point David is already thinking ahead to what the car is going to look like, and we see some preliminary guidelines for the car, such as the rounded front.

The car takes shape in this tight penciled sketch, and we can see this vehicle will be some stylish sports roadster.

Please note: You're going to find reference particularly invaluable when drawing vehicles. Fortunately, there are plenty of magazines and book sites and websites available. Cars are difficult to get right, and having a picture in front of you of the car you are trying to capture can make your job a whole lot easier.

Not only that, you can even use reference for vehicles that don't exist, vehicles that you are inventing. Use a picture of a car to get the basic size and perspective right, but then feel free to embellish the basic design into something new, fantastic, and cool.

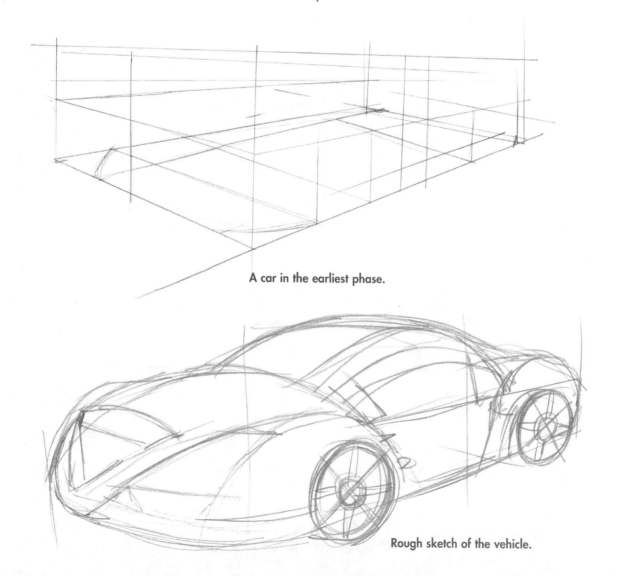

A car in the earliest phase.

Rough sketch of the vehicle.

**Say What?**

No other manmade device since the shields and lances of the knights quite fulfills a man's ego like an automobile.

—William Rootes (1894–1964), British automobile manufacturer

I have one artist friend who is a stickler for details. He has learned various 3-D computer programs and builds a model for his vehicles and buildings on the computer. That way, he later can look at his 3-D image and use it as reference from any angle he desires. Of course, this is a very time-consuming process, and certainly well beyond the call of duty, but it raises an interesting point. As an artist, you should not just be prepared to practice and practice, you must also be willing to *research*. Research and reference go hand-in-hand, as does reaching *for* reference.

Here is the final figure, inked, with smooth, clean lines and dark, tinted windows to give the car a more ominous and mysterious look. Keep in mind, when designing or choosing your vehicle, it can tell a lot about its owner, as well as the world you are creating.

As car commercials love to tell you, a car can help define you. That is, some down-on-his-luck character might be driving a ratty, rusty junker, while a snooty rich person, VIP, politician, or CEO might be carted around in a chauffeur-driven limo. And if you are dealing with a trendy teenage character, there are certainly "cool cars" for every era and generation, from the souped-up hot rods of the 50s, the muscle cars of the 70s, even the tricked-out *The Fast and the Furious*-type street racers of today. In this case, the car commercials are actually right, at least when it comes to your characters. What he or she drives can say a lot about the character, and by giving your car some personality, you can help give your character personality.

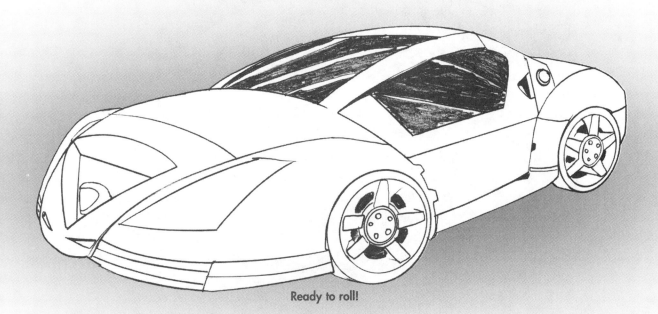

Ready to roll!

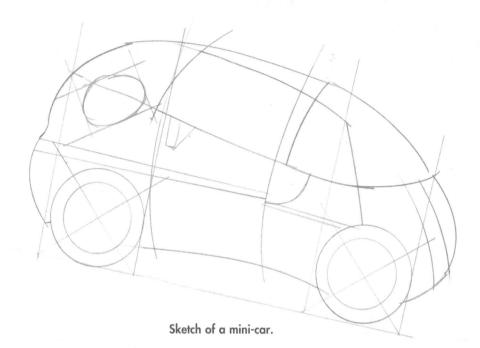

Sketch of a mini-car.

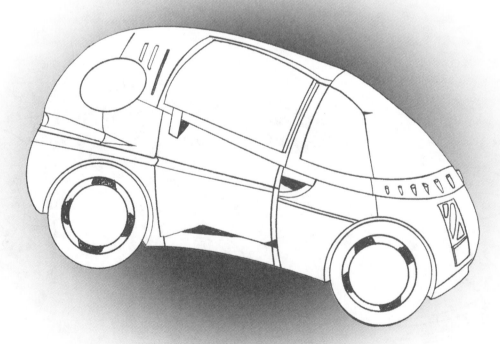

Another marvel in motoring.

David is going for a different type of car in the previous figure, a space-saving, fuel-efficient mini-car. The design of your vehicle can also be used to help define the world in which your character is living. This is particularly helpful in the case of futuristic or alien worlds. First and foremost, the cars can help define the technology. Do they have wheels, or are they gravity-defying hover-cars? Do they rocket down the highway at 95 miles an hour—or Mach 3?

Vehicles can tell more subtle things about a society, too. An affluent society might have a vehicle or two in every garage (or hover-port), while a poor society might have sparsely populated roads, only traveled by those few who can afford it. Dense populations might use smaller vehicles, like the mini-car David inked in the previous figure, to accommodate the teeming masses of civilization. And an oppressed, unhappy, dystopian society might have roads clogged with traffic jams and slow-moving, ugly, and lumbering vehicles that belch out

smoke and pollution and help contribute to the bleak or oppressive atmosphere.

Even in pencil, we can see that this car is heavily photo-referenced, and it certainly appears more realistic than the other cars at which we've looked. How realistic you want to go is a subjective choice. Comic, fun, and fanciful stories often portray things more iconic and cartoonish, while a grim-and-gritty detective or crime story might strive for realism—and part of a realistic atmosphere is capturing things like backgrounds, buildings, and vehicles in a more accurate fashion.

Often manga is a mixture of both. A car might look completely realistic, and an artist might have taken great pains to capture it as perfectly as possible, but driving the car might be a character with a wild, cartoony, exaggerated expression on his face.

Manga's mixture of real and unreal is one of its defining attributes, and certainly part of its charm and appeal.

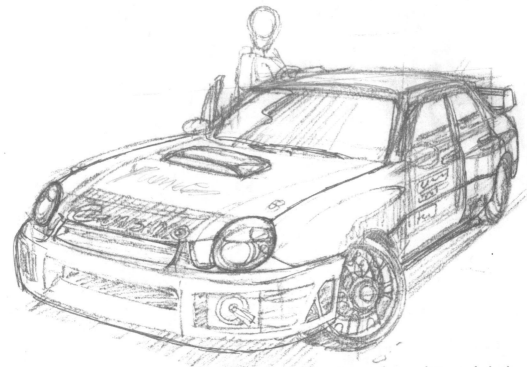

**A more photo-realistic set of wheels.**

# Happy Trails

David offers his rough designs for a motorcycle here. Like cars, motorcycles can be easily adjusted in their design to appear faster and more futuristic.

And, like cars, the design of a motorcycle can help say something about the character who drives it. In fact, just the fact that your character drives a motorcycle says something about his or her recklessness or fearlessness. Let's face it, motorcycles are more dangerous than cars. Motorcycle riders are more exposed and, hence, closer to harm's way.

Motorcycles can also make for better drama, can do more spectacular jumps and stunts, and

are able to get in and out of small places more easily. You can also get a better look at your character and their expressions and emotions (especially if the character goes without a helmet). Best of all, a character's body is more free to hold a weapon, to turn and shoot, as well as duck and dodge an oncoming barrage.

### Sketchbook Savvy

In addition to books and magazines on motorcycles and motocross, a source of reference might be reality TV. In recent years several TV shows have appeared featuring mechanics altering, customizing, and rebuilding motorcycles. Watch these shows and be inspired by their unique designs.

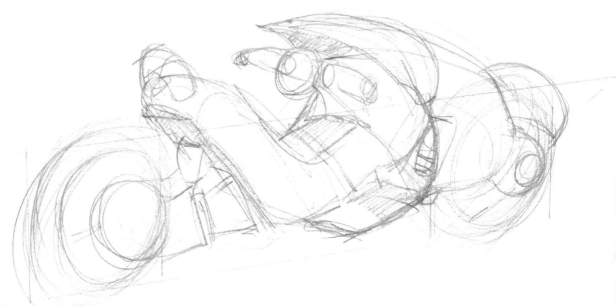

Sketch of a two-wheeled wonder.

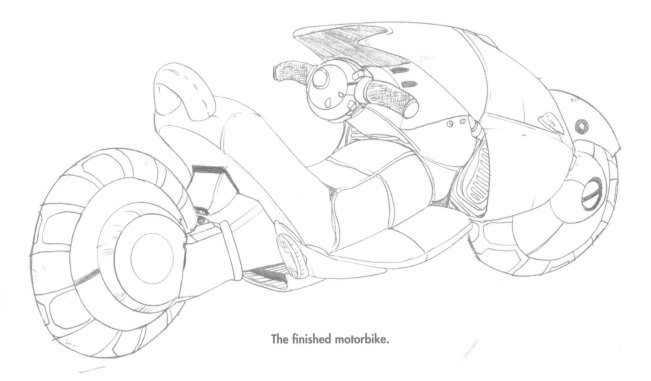

**The finished motorbike.**

In this final figure, we're able to get a better look at David's design. This particular bike is long and low to the ground, which makes the bike appear faster and more aerodynamic. The exposed wheel in the back gives the bike a futuristic feel, while the large rounded windshield offers a degree of protection. Likely this is a bike that is made to ride into trouble and then get out of it fast!

## Keeping the Skies Safe

Just as with human or animal figures, it's a good idea to rough out the vehicle you are drawing. In the following figure, David sketches out the basic shape of a jet fighter, including, roughly, where the cockpit will be, the wings, and the engines. It doesn't matter what vehicle you are dealing with, car or bike, truck or plane, boat, starship, or aircraft carrier. This is the ideal starting point.

David tightens the sketch in pencil, adding detail and definition. Needless to say, you're gonna need references if you want to get it right. But plenty of military books out there are devoted to this sort of aircraft.

A pilot is a popular archetype in manga. And every pilot has an emotional attachment to their jets, since their aircraft literally make the difference between life and death, success and failure, when doing battle in the skies. If your protagonist is a pilot, try to differentiate his (or her!) craft from all the others by adding special details to the jet. As we have said, giving a vehicle personality helps give its owner personality.

**Say What?**

I owned the world the hour I rode over it … free of the earth, free of the mountains, free of the clouds, but how inseparably I was bound to them.

—Charles A. Lindbergh (1902–1974), U.S. aviator

A rough sketch of a jet.

More details are added.

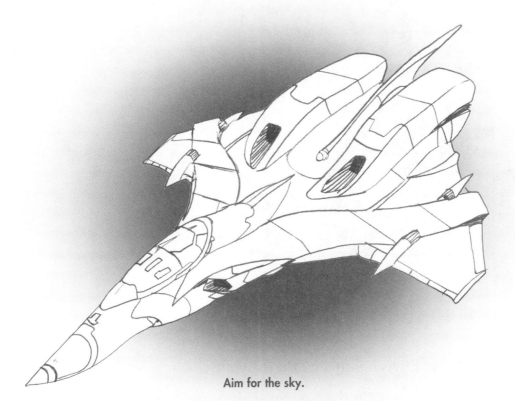

**Aim for the sky.**

Here is the finished jet. As with other vehicles, you might use an existing vehicle as a starting point and then embellish it with things to make your vehicle more unique, high-tech, or futuristic. In this case, the front end of the jet looks very much like current U.S. Air Force fighters, while the back half of the vehicle, the wingspan, tail, and enlarged back jets, come purely from David's boundless imagination.

## The Least You Need to Know

◆ Vehicles are popular in manga, and the high-speed car chase is a standard action sequence.

◆ Reference is particularly important, even as a starting point for a futuristic or ficti-tious vehicle. Fortunately, reference on vehicles is readily available.

◆ It's often best to use a real vehicle as a starting point for the vehicle you invent. Base your vehicle on a real design and expand upon that design in unique and creative ways.

◆ As an artist, you must also be ready to research the things you will draw. Half of drawing an effective page is coming to the drawing table prepared.

◆ Vehicles can be more or less realistic, depending on the tone of your story. Darker stories tend to strive for more realism.

◆ Choice and design of a vehicle reflect the personality of its driver or owner. They might also reflect the society in which your story is set.

## In This Chapter

- ◆ Envisioning a world for your characters
- ◆ What's in the background
- ◆ Drawing trees, plants, and grass
- ◆ Contemporary, futuristic, and ancient settings
- ◆ A few parting words

# Chapter **25**

# World Piece: Backgrounds and Environments

We're in the home stretch now. We figure you have a good handle on figures, faces, and character types and now have some of the skills you need to make an entertaining manga comic. At least, you will with enough practice. We've given you every tip, trick, and technique we know to round out your manga world, and now it's time to *give* you the world.

Comics are more than characters with cool outfits, vehicles, sidekicks, enemies, and weapons. When you create a comic, you must envision a world for your character, whether you are re-creating your contemporary hometown, traveling to the far reaches of some outer space outpost, or going back in time to the days of the samurai. And part of this world-building means coming up with your setting, what kind of building your character lives in or works in, the land he or she is traveling in, the type of civilization the character lives in, as well as the technology available.

In short, you need to come up with a back-story, even if the explanation in your head is never explained on the page. "God is in the details," as the saying goes, and the more you know about the world you're creating, the richer and more nuanced your comic will be.

## Overlooked Art

The details should come across in the backgrounds of your panels, the stuff that's *behind* the characters while they are in the forefront of the action. Although backgrounds help round out a panel or page, they are, as their name suggests, background. Mostly they are unimportant to the story, and just provide nuance and atmosphere. In general, people only notice backgrounds when they are consistently absent from panels. You don't need background in every panel, but if you skimp too much, you will look lazy as an artist and a storyteller.

But, like lettering, backgrounds are something to which people don't pay particular attention, so you should not put *too* much time into them, at least, not on every panel. Try to find a middle ground, putting in backgrounds, but not spending an inordinate amount of time on them. Also, consider this if you are working from a completed script: Backgrounds get covered by word balloons (see Chapter 21), so if you have a panel with an excessive amount of dialogue, that is even more incentive to keep backgrounds to a minimum.

## Backgrounds at the Forefront

Of course, we don't want to give the impression that every piece of your world will be relegated to unimportant background status. There will be shots without figures, when the focus is on the environment your character is in—*without* focusing on the character. Establishing shots are a good example of this. As we've said before, it's a good idea to "set the scene" with an establishing shot each time you transition from one scene to the next.

Sometimes you might want to give even more room to an important environment. Sometimes this means a natural environment; sometimes this means a city (which is why we will talk about both in this chapter). Cities, certainly, have a grandeur to them, as does nature, and there will be times you want to convey the scale and magnificence of a setting with a *splash page* or *double-page spread*. A good example of this would be the entrance to the Emerald City in *The Wizard of Oz*, if that film were a comic. Or perhaps the first time we see the Death Star in the movie *Star Wars*.

### Manga Meanings

A **splash page** is a single full-page panel devoted to just one image, usually one that is particularly memorable or dramatic. A **double-page spread** is two full pages devoted to a single one-panel image. This is reserved for the most dramatic shots of all.

## Making the Outdoors Great

The basic tree trunk.

Drawing plants is a more imperfect science than drawing people. That is, you don't have to worry about proper proportions, since every tree is different (and you certainly don't have to concern yourself with capturing the tree's emotions!). In this case, David begins with the tree's foundation, the trunk, and adds limbs at various angles as he desires.

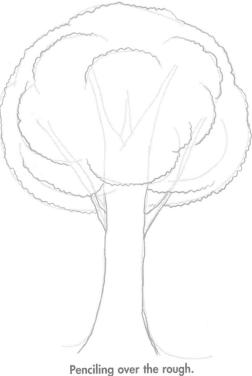

**Penciling over the rough.**

**Roughing out leaves for your tree.**

The next step is to add some curved lines around the top of the tree to indicate leaves.

### Sketchbook Savvy

Keep in mind what season your comic is set in. Trees will be their fullest in the spring and summer, have fewer leaves in the fall, and none at all during the winter. Of course, this varies from tree to tree, as certain trees (like pine trees) retain their leaves year-round.

David fills in the circular leaf curves in pencil, making them squiggly. This is an effective way to indicate that we are seeing multiple leaves, without wasting a lot of time drawing individual lines.

In the finished and inked tree, David has added differently shaped lines irregularly placed on each side of the trunk, giving the tree a rough texture. He has shaded the bottom of the tree based on an overhead (and to the left) light source. Note that the bottom of the tree is not filled in totally black like the shadows on the right side, which give the tree some added volume and dimension.

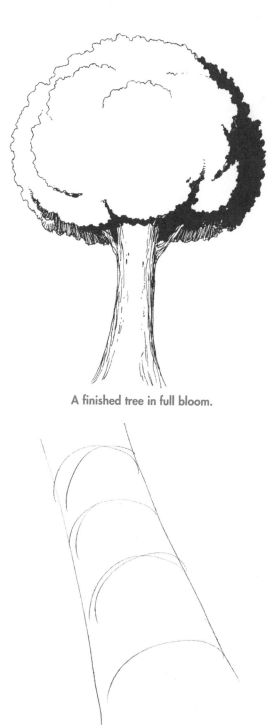

A finished tree in full bloom.

trunk gets smaller as it ascends. This is partially a trick of perspective, showing the highest part of the trunk is the farthest away from us (see Chapter 17 for more on perspective).

Branches are added.

Here David adds some branches, as well as more detail to the trunk. Again, there is no correct way to make a tree, as they all vary in shape and size, as do the number of their branches and their growth direction.

Texture is added to the trunk and branches. The lines of the trunk are vertical, but curvy, to show the irregular texture of the bark. Lines around the branches both roughly parallel the branches and encircle them.

Remember: With trees, there are branches within branches within branches, each getting smaller as they extend out from one another.

Sketching a tree from a different angle.

Here are the beginnings of a tree from a more dramatic angle, this time a worm's-eye view. Again, David starts with the trunk. The

In the final inked tree, the light source comes from above (after all, plants get their nourishment from the sun). This is why, in a worm's-eye view, the leaves we see are primarily in shadow.

### Mangled Manga

Don't waste time and effort worrying about things like what kind of tree you are drawing. Your reader is not even going to notice, unless it's an important story point.

**An idea is planted.**

For a plant, David starts with a circle, with some larger curved lines coming out of the center, leaning outward around in a circle. The circle is cut into "pie slices," with tiny lines to denote blades of grass.

**Leaves and grass are added.**

**Barking up the right tree.**

**Adding ink and detail to finish the tree.**

Leaves are added, using the curved lines in the center of the figure as a guide. Smaller leaves are added, around the base of the plant, and the "grass" around the pie slices is given more length and volume.

**The finished plant.**

Here is the inked and finished plant. Notice the difference between the plant and the grass surrounding it. The plant has wide, smooth leaves, and the grass is smaller and shorter and more dense.

Next we see the same plant as previously, sprouting up across a small plain. Note that you don't have to cover the plain with the plants to get the point across that the plain is overgrown.

The same picture is shown next, inked. Not a lot of difference between these pictures, other than that there are some more lines to indicate grass on either side of the plants, small lines that lean slightly away from the plant.

**Sketchbook Savvy**

Gardening magazines are good references for cool flowers and foliage. Travel magazines such as *National Geographic* are also good for showing exotic natural wonders.

Penciling a plain.

Completing an overgrown plain.

Penciling a more barren plain.

A finished grass landscape.

For a simple grassy plain, you need to do little more than make a horizon line and a few lines to indicate slight curves and grades on the ground. On these lines are some very loose squiggles. Grass can be a bunch of m-shaped squiggles, or a bunch of tiled l-shaped chicken-scratches. Whichever you chose, or whether to chose both, is your own personal preference.

And here is the finished and inked plain. Note the penciled horizontal guidelines have been erased. All we see is grass, but no lines to indicate ground. Hey, wouldn't a tree in the center of this little meadow look nice?

# Cities of Manga

From nature we move on to civilization, which is arguably more important than natural settings. That is, unless you are doing a prehistoric or Tarzan-like tale, you're going to need to capture civilization in your comic. You can fudge a tree or a waterfall (especially since they are so imprecise to begin with), but buildings and cities are more exact and much less forgiving—particularly modern cities, which your comic book readers know about firsthand and see every day. Of course, there's more latitude to futurist cities and ancient cities ... even foreign cities.

On the following page, we see David's picture of a modern cityscape, created with shapes (primarily squares and rectangle) and thin, smooth lines. Make sure you get your perspective correct. With cityscapes more than anything else, bad perspective sticks out like a sore thumb.

In this case, lack of shadows gives the city a high-tech, very modern luster.

### Say What?

The true test of civilization is not the census, not the size of cities, but the kind of man that the country turns out.

—Ralph Waldo Emerson (1803–1882), American essayist and poet

A modern downtown view.

Laying out a contemporary city.

In David's rough for a contemporary city, we've come full circle, all the way back to our first chapter, where we talked about building things using different shapes. See, I *told* you squares would come in handy when it came to drawing buildings.

Below is the penciled version of the modern city street. Here is one of the best examples of

the value of reference, particularly photo reference. Your average city block assails you with untold signs and messages and has tons of details, such as parking meters, telephone poles, and mailboxes. Taking a few snapshots of a city street is a good way to "keep it real," to capture details you might forget when drawing a street from memory.

Final picture of Anytown, U.S.A.

Needless to say, there is considerably more latitude to drawing cities set in the future. Skyscrapers can extend as high as you want; buildings can float; architecture can defy gravity. This rough drawing is little more than some ill-defined shapes, with a vanishing point in the middle right side. (Actually, this is angled from the same perspective as our contemporary street—maybe it's the same street as seen hundreds of years in the future.)

Rough sketch of a science fiction future.

And here is David's penciled vision of the future, where the ill-defined shapes have become oddly shaped buildings. In this case, the architecture of the buildings is rounded, and this is reflected in the window design, which is round as well.

One way to keep the future from becoming too incomprehensible is to mix futuristic technology with things we recognize from our modern era. In this case, we still see some signs advertising places or products, even if we don't know exactly what they are. We see an arrow painted on the street, which looks like it could belong in a twentieth century or early twenty-first century street as easily as it could the far future. And David tops it off with a flying car driving down the road. It's still easily identifiable as a car, only it is hovering above the ground, and no wheels are visible.

As I said, this drawing is recognizable as the future, but likely a future set on Earth, and the time is not so distant that aspects of it are unrecognizable. How you choose to design your future city is limited only by your own imagination.

**The finished futuristic city.**

In addition to modern and futuristic archi-
tecture, there are period settings, architecture
set in the past, whether that means 20, 200, or
2,000 years in the past.

I'll stop recommending magazines for refer-
ence, since by now it's probably obvious they
are a good source of reference on just about any
subject. In this case, history books are an even
better reference for whatever period in which
you are setting your story. As I have said, DK
Publishing's *Eyewitness Books* are fantastic for
reference, particularly in historical categories.

Here David is going to draw an ancient ruin.
In this case, David picks his perspective and
roughs the drawing with some very basic
shapes. This particular shot is modeled after
some actual ruins in Europe, referenced from a
book on monasteries and abbeys.

### Sketchbook Savvy

Can't afford all the magazines I
keep recommending for reference?
Try borrowing them from your local
library.

**Begin with a rough sketch.**

David supplies additional detail, rocks on the ground, most notably parallel lines that will become bricks in the finished drawing.

The inked and finished drawing, dramatically lit and lovingly detailed. For the ruined and dilapidated parts of this drawing, David erased the original section where he wanted the rocks broken away (which had no sign of deterioration in the rough) and scribbled to achieve the "deterioration effect." He sharpened this in the inking phases, making sense out of his scribbles, to where they looked like they belonged.

Details let this ruin take shape.

To show the bricks in shadow, David went in with a quill and white ink and made some lines to denote the shadowed bricks.

We should also point out, since we've been talking about background in this chapter, that this is far too detailed a drawing to use as a background. That is, as a comic book creator, you are often racing against the clock or a deadline, and if you put too much detail into a background, it's going to take you forever to finish a book. A drawing with this much detail should be done when it is a featured part of a page or a panel, not a throwaway background.

**The shadowy, textured, finished figure.**

In this second ruin rough, David starts with an outline of the area rather than geometric shapes. This panel, inked with just a bit more detail, would make for a sufficient background. You should draw backgrounds most of the time, but again, they do not need to be terribly detailed.

David has added more parallel lines, indicating where the bricks will be in the finished work.

**An outline serves as your guide.**

Add details in pencil.

Here is the finished, inked figure. In this case, David has taken what was originally black shadows on the ruins on the right and left and applied a light-to-dark graduated tone to it. It changes the lighting dynamic of the drawing, giving it the effect of a sunset. Light is clearly closer to the foreground ruins and farther from the background ruins.

The finished ruin at sunset.

David takes a different approach to the same figure, keeping the foreground shadows black, and instead doing a light-to-dark grad in the background shadow. He did this to achieve a different sort of lighting/atmospheric effect, this time to imply some mist in the distance, like this shot is taking place on some foggy Scottish moor, or an equally moody or spooky environment.

**Another view of the ruin shrouded in mist.**

We should also add that for both the previous two pictures, *all* the shadows were inked in and were originally totally black. David scanned the picture in and selected the black area, or areas, to which he wanted to give a grad (gradient). In the first drawing he selected the black shadows on both sides of the figure and applied a grad to the shadows. In the second figure he selected the black shadow in the center of the image and applied the grad to it. The end effect of *both* images is to separate the ruins between foreground and background planes, giving it much more dimension than it would have if it was all black shadows.

# Just the Beginning

And so we reach the end of our great manga adventure. Or perhaps this is just the beginning of yours. We leave you with plenty of stuff to practice drawing. And one and only one word of advice: practice. You won't become a good comic book artist overnight, no matter how much you want it. Of course, wanting it really badly and working hard for it is an ideal combination.

*Ideas*, however, are up to you to come up with. And, as always, the better the idea, the more unique your stories, concepts, and characters, the better your comic will be.

Good luck to you … and see you in the funny pages.

*Sayonara!*

## The Least You Need to Know

◆ Backgrounds are simultaneously important and unimportant. Your book will look stark without them, but backgrounds are not something people pay much attention to, so don't spend too much time on them.

◆ Put more detail into a setting when it is important to the story, or when your character is interacting with the environment.

◆ Drawing things in nature adds a realism to the book, but don't worry about being *too* realistic. Your reader won't care what type of tree is in the background.

◆ Photo reference is a great way to capture all the nuances of the modern city, and history and architecture books are good for older, ancient, and historical buildings and civilizations.

◆ Succeeding as a comic book artist takes hard work, patience, practice, and lots of imagination.

Appendix **A**

# Glossary

**¼ angle**   A shot in which the person or object is captured at a 45-degree angle (either to the left or right).

**acting**   A comic book character persuasively and believably conveying their emotions and feelings.

**androgynous**   Characters whose mannerisms and appearance deliberately blur the line between male and female.

**anime**   Japanese animation, which shares most of the elements and visual style of its printed counterpart, manga.

**articulation**   The connection of different parts by joints.

**avian**   Creatures that are birds or have the characteristics of birds.

**backlighting**   A figure or object with a light source emanating behind it.

**bipeds**   Creatures that walk on two legs.

**blue line**   A drawing that is literally done with a blue pencil, which will not reproduce when photocopied in black and white.

**character turnarounds**   Different shots of a character that can later be used for reference.

**close-up**   A tight shot of a character, usually just the face.

**comic** (or **comic book**)   A periodical or book of sequential art; a story told in a combination of pictures and words.

**decompressed storytelling**   A short event stretched out into a longer scene for dramatic effect.

**double-page spread**   Two full pages devoted to a single one-panel image.

**dystopian future**   Where things have gone terribly wrong, and some or most aspects of this future have made things much worse for humanity.

**establishing shot**   A shot that shows the exterior of the building or place where the action is taking place. A very effective way to transition between scenes.

**eye-width**   The horizontal length of the eye. An informal unit of measure, a good gauge when positioning the eyes in relation to one another and the face.

**font**   An electronic typeface, used in comics when creating dialogue or sound effects by computer.

**foreshortening**   A dramatic trick of perspective in which the part of a figure or object closest to you is drawn to appear larger.

**graduated tone**   When a color starts as one color and slowly transforms into another color.

**graphic novel**   A thick comic book, sometimes a lengthy original comic book "novel," other times a collection of traditional American comics repackaged to be appropriate for the bookshelf.

**Hentai manga**   Adults-only manga, sexually explicit or adult-themed books.

**horizon line**   The line where the horizon and sky appear to meet.

**inking**   To go over finished pencils in ink, making the art permanent and inerasable.

**iris**   The colored portion of the eye, which controls the amount of light that passes through the pupil.

**localization**   To take the rough translation and finesse the language to make it sound natural and native.

**MacGuffin**   An object, artifact, or thing that is being pursued; something that creates motivation or drive for the characters.

**manga**   A type of comic and comic visual style native to Japan, which is growing increasingly popular in America.

**mech**   Things that are mechanical.

**mecha**   Pertaining to giant robots.

**medium shot**   The shot between a long shot and a close-up, which still maintains some distance. Usually shows the character or characters from the waist or chest up.

**mêlée weapons**   Handheld, nonranged weapons, such as swords and clubs.

**negative space**   Space in a panel either filled completely black or with a tone, or completely white.

**noir**   Genre of crime literature and film featuring tough-talking and cynical characters, bleak settings, and generous use of shadows.

**off-panel**   Something that happens outside of the comic panel.

**omniscient narrator**   An all-knowing narrative voice, getting into characters' heads and knowing their thoughts and feelings.

**omniscient viewpoint**   An angle that cannot be seen by the characters or that shows us something the character cannot know or see.

**penciling**   Drawing a page or figure in pencils, elaborating and expanding upon a rough sketch.

**perspective**   The technique for representing three-dimensional objects to produce the impression of distance and relative size as perceived by the human eye.

**pinna** (or **auricle**)   The visible portion of the ear.

**points-of-articulation** (or **anchor points**) The areas on a body that move, such as the elbow, knee, neck, or hand.

**pupil** The black circle within the iris, which expands in size when a character gets excited.

**quadrupeds** Creatures that walk on all fours.

**radial speed lines** Speed lines that extend outward from a circular point.

**rim lighting** The depiction of light on the side, on multiple sides, or all around the outside, of a figure.

**rough** A page or figure that is penciled in a preliminary stage.

**Sayonara** Japanese for "good-bye."

**sclera** The whites of the eyes.

**Shojo manga** Literally "girl's comics," these stories geared toward girls are often more cerebral.

**Shonen manga** Literally "boy's comics," these stories showcase action and adventure.

**silhouette** An outline of somebody or something filled in, usually—but not always—in black.

**sound effect** A word or words used to express a noise that isn't communicated in dialogue or narration.

**Spandex** Shorthand among comic book readers to describe the outfits of the American superhero set.

**splash page** A single full-page panel devoted to just one image.

**straight speed lines** Speed lines that extend outward parallel to one another.

**tragus** The little projection of cartilage in front of the inner ear.

**translation** To take the words of one language and put them into another.

**utopian future** Where everything is better than it is now, perhaps even perfect.

**vanishing point** In perspective, where parallel lines appear to converge on the horizon line.

**wide-angle shot** (or **long shot**) A shot that takes in a lot of space and shows a lot of area.

**Yakuza** The Japanese criminal underworld, Japan's mafia or Cosa Nostra.

Appendix **B**

# Recommended Reading

Here is a sampler of some of our favorite manga books, noteworthy because they have great art, or great stories, or both. Some are translated from Japanese, and some were created by English-speaking comic book creators. All are in English, and available in the United States—either online, in bookstores, or in your local comic book store.

Please note: Many of these books have several volumes, and can span anywhere in length from a single volume to several dozen different books in the same series.

## Manga

*Akira*. Katsuhiro Otomo, Kodansha Ltd., 2002.

*Batman: Child of Dreams*. Kia Asamiya, DC Comics, 2003.

*Battle Royale*. Koushun Takami, Viz, 2003.

*Blade of the Immortal*. Hiroki Samura, Dark Horse Comics, 2004.

*Blame!* Tsutomu Nihei, Kodansha Ltd., 1998.

*Blue Monday*. Chynna Clugston-Major, Oni Press, 2001.

*Domu*. Katsuhiro Otomo, Dark Horse Comics, 2001.

*Eagle: The Making of an American President*. Jiro Taniguchi, Viz, 2000.

*Eater*. Masatoshi Usune, Jump Comics Deluxe, 1991.

*Ghost in the Shell: Manmachine Interface*. Masamune Shirow, Kodansha Ltd., 1995.

*Junction 17: Black Wave*. David Hutchison, Antarctic Press, 2004.

*Neotopia: The Enlightened Age*. Rod Espinosa, Antarctic Press, 2004.

*Oboro*. Megumu Okada, Kadakowa Shoten Publishing Co., Ltd., 2003.

*Real Bout High School*. Reiji Saiga/Sora Inoue, Kadokawa Shoten Publishing Co., Ltd., 2000.

*Sidekicks*. J. Torres/Takeshi Miyazawa, Oni Press, 2001.

*Steam Detectives*. Kia Asamiya, Viz, 2004.

*Twilight X*. Joseph Wight, Antarctic Press, 2003.

*Wolverine: Snikt*! Tsutomu Nihei, Marvel Comics, 2003.

# General Art

Here are some other books that we recommend to educate and inspire you. These books are about manga, comics, and art, and many not only explore exceptional manga artists, but exceptional artists who specialize in a variety of mediums.

Bresman, Jonathan. *The Art of Star Wars Episode 1: The Phantom Menace*. Ballantine Publishing Group, 1999.

Dean, Martyn. *The Guide to Fantasy Art Techniques*. Paper Tiger, 1988.

Dini, Paul, and Chip Kidd. *Batman: Animated*. DC Comics, 1999.

Hamilton, James. *Arthur Rackam: A Biography*. Arcade Publishing, 1994.

Hogarth, Burne. *Dynamic Figure Drawing*. Watson-Guptill Publications, 1996.

Kawarajima, Koh. *The New Generation of Manga Artists Vol. 1*. Graphic-Sha Publishing Co., Ltd., 2002.

Kent, Steven L. *The Making of Final Fantasy: The Spirits Within*. Brady Publishing, 2001.

Martin, Gary. *The Art of Comic Book Inking*. Dark Horse Comics, 1997.

McCloud, Scott. *Understanding Comics*. DC Comics, 2001.

Mead, Syd. *Oblagon, Concepts of Syd Mead*. Kodansha Ltd., 1996.

Peck, Stephen Rogers. *Atlas of Human Anatomy for the Artist*. Oxford University Press, 1982.

Sadamoto, Yoshiyuki. *Der Mond*. Kadokawa Shoten Publishing Co., Ltd., 2001.

Schodt, Frederik L. *Manga! Manga! The World of Japanese Comics*. Kodansha International, 1992.

Shirow, Masamune. *Intron Depot*. Seishinsha Co., Ltd., 1988.

Sonoda, Kenichi. *Kenichi Sonoda Artworks 1983–1997*. Mediaworks, 1999.

Terada, Katsuya. *RakugaKing*. Aspect Corps, 2002.

Toriyama, Akira. *Dragonball Daizenshuu 1— Complete Illustrations*. Shuueisha Publishing Co., Ltd., 1995.

# Online Resources

CG Networks (computer graphics community): www.cgnetworks.com

Comic Book Resources (comic news): http://comicbookresources.com

Craig Mullins (digital matte painter): http://goodbrush.com

David Hutchison (our esteemed artist's website): David-Hutchison.com

The Drawing Board (artists' community): www.sketchbooksessions.com/shanesboard

Dreamwave Productions (comics publisher): http://dreamwaveprod.ca/!newsite/pages/home.htm

Feng Zu (conceptual artist): http://artbyfeng.com

Makoto Shinkai Fan Web (animator, creator of "Voices of a Distant Star"): http://daike.hp.infoseek.co.jp

Newsarama (comic news): www.newsarama.com

Pulse (comic news): www.comicon.com/pulse

Sumaleth's Link Archive (artist and reference links): www.sumaleth.com/links

System Apex (links to Japanese artists' websites): http://apex.syste.ms

Team GT (conceptual design community): www.teamgt.com/index2.htm

Tokypop (manga publisher): www.tokyopop.com

Udon Entertainment Corp. (comics publisher): www.udoncomics.com

VFXworld (animation and visual effects community): http://vfxworld.com

Viz (manga publisher): www.viz.com

# Index